RENOIR

A MASTER OF IMPRESSIONISM

TODTRI

This book was designed and produced by
Todtri Productions Limited
P.O. Box 20058
New York, NY 10023-1482

Printed and Bound in Singapore

Library of Congress Catalog Card Number 94-060372

ISBN 1-880908-11-5

Author: Gerhard Gruitrooy

Producer: Robert M. Tod
Book Designer: Mark Weinberg
Production Coordinator: Heather Weigel
Photo Editor: Ede Rothaus
Editors: Mary Forsell, Joanna Wissinger, & Don Kennison
DTP Associates: Jackie Skroczky, Adam Yellin
Typesetting: Mark Weinberg Design, NYC

CONTENTS

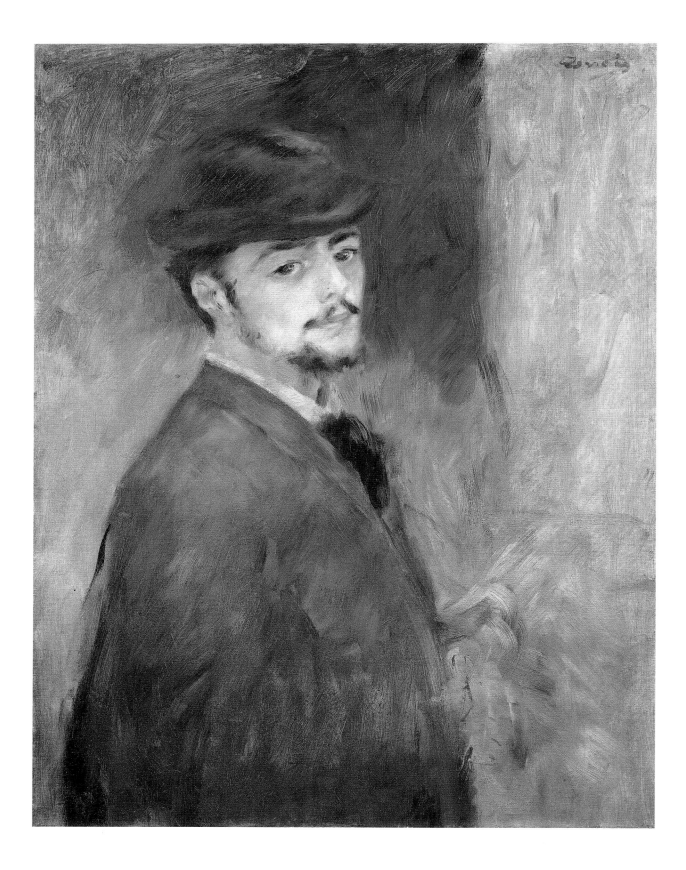

Self-Portrait at Age 35

1876; *oil on canvas;* 15 3/4 x 12 1/4 in. (40 x 31 cm.). Cambridge, Massachusetts, Fogg Art Museum, Harvard University.
*Only a few self-portraits of Renoir are known. At the age of thirty-five he depicted himself as a
casually-dressed man, although without revealing his profession through other attributes. His face, framed
by a narrow beard, expresses confidence, and the black bowler hat gives him the aura of a respectable citizen.*

INTRODUCTION

Pierre-Auguste Renoir was born in 1841, the third child of Léonard Renoir and Marguerite Merlet. Pierre-Auguste's parents, like so many other French citizens at the time, were experiencing a period of economic hardship. His father was a tailor, his mother a seamstress. The family lived in a town called Limoges situated in the heart of France. Limoges was then as it is now famous for its exquisite chinaware, which is often decorated with colorful flower patterns, circumstances which would prove crucial to Renoir's early artistic experience.

Because of the weak economy in the Limousin region, the family moved to Paris in 1846. Here Pierre-Auguste received a decent education at a public school and joined a church choir under the composer Charles Gounod, who also gave him voice lessons. As an adolescent Renoir began to draw with charcoal on the walls, his brother Edmond remembered years later. Thus his parents decided to place young Auguste with a painter of china so that he would learn a trade that could earn him a living.

The political and economic situation in France during those years was far from tranquil. In 1848 the revolutionary spirit, which swept the entire of Europe, ended with the expulsion of Louis-Philippe from the throne. He was replaced by Napoleon's more enlightened nephew, Louis Napoleon, who had presented himself as a candidate for the Second Republic. With the help of a plebiscite he was elected Emperor of France in 1852, taking the name Napoleon III. Under his rule the economy modernized, the railway system around Paris expanded, canals and ports improved, and suffrage was introduced. In matters of foreign affairs, however, Napoleon III was less successful. The Italian wars proved to be fruitless, and an unwise attempt to install the Austrian archduke Maximilian as Emperor of Mexico ended with the horrifying news of the protégé's execution in 1867. (Édouard Manet, a mentor of Renoir's, painted his famous work of this subject in the aftermath of the event.) But the worst blow for Napoleon III was the humiliating defeat in the Franco-Prussian War, during which he was taken prisoner by the Germans. The proclamation of the Third Republic in September 1870 permanently sealed the end of his reign.

Arum and Conservatory Plants
1864; *oil on canvas;*
5 1/4 x 37 3/4 in. (130 x 98 cm.).
Winterthur, Switzerland,
Oscar Reinhart Collection.
This work was done in a somewhat detailed, realistic style during Renoir's early years and after he had left the studio of his teacher Charles Gleyre. Either painted on commission or in hope of sale, it is a charming work with a carefully contrasted scheme of blue, yellow, and white flowers.

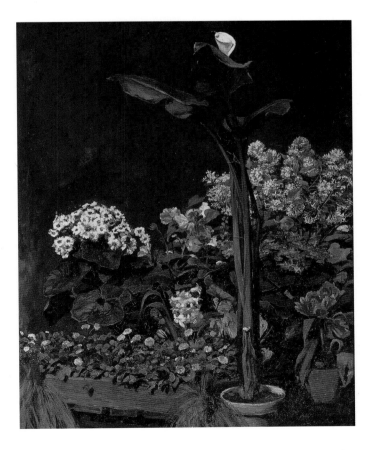

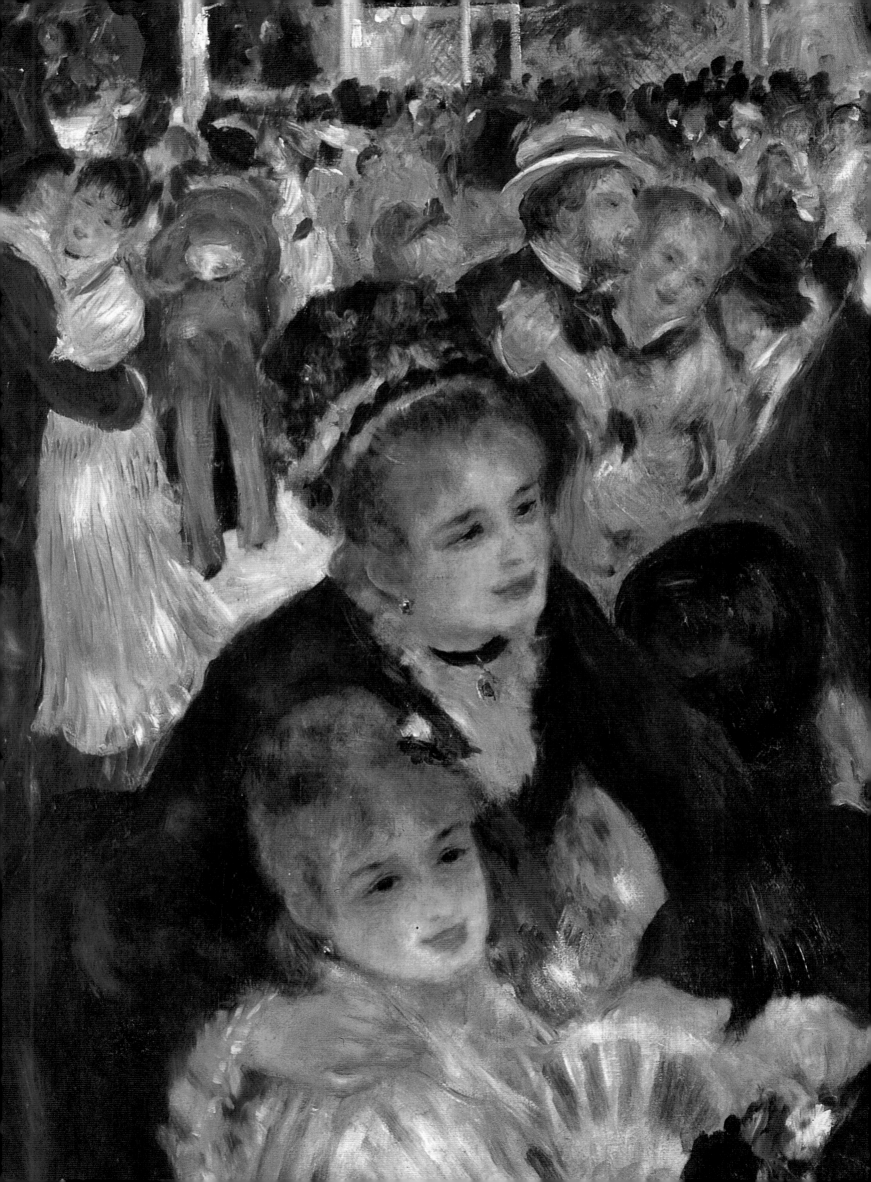

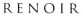

The rapid transformation brought on by the Industrial Revolution since the 1820s changed not only the method of production from a crafts oriented economy to a more and more mechanized system, but it also caused—as had occurred in England a few decades earlier—an enormous social shift. Untrained laborers in the factories formed a newly established working class of the underprivileged. Rural areas were abandoned in favor of the capital, where people sought any kind of work. The radical French Socialist Pierre-Joseph Proudhon, spread the ideas of Karl Marx and Friedrich Engels. Serious crop failures all over Europe in 1846 led to widespread hardship, the consequences of which were only gradually absorbed in the following years. This was in fact the very reason the Renoir family traveled to seek their fortune in Paris like so many other fellow citizens.

When young Pierre-Auguste entered the workshop of the Lévy brothers, a porcelain factory in Paris, the ambitions of the fifteen-year-old boy in this case proved successful. At first he was trained to copy decorative patterns of flowers, birds, and musical instruments for plates and vases. Eventually he was assigned to paint these embellishments on the objects themselves. In addition to his apprenticeship, he attended evening classes in drawing and also seems to have struck up a friendship with an older workman in the company who had a passion for oil painting. A conspicuous element of artistic training among apprentices and art students has always been the copying from reproductions of the Old Masters, and Renoir was no exception to this practice. At nineteen he registered at the Louvre as a copyist, and he continued for three consecutive years until 1864. Among the copies he made are two works by Peter Paul Rubens, whose influence in particular was vital during Renoir's later years after he had departed from Impressionism in its pure form.

At the age of twenty, Renoir's talent had distinguished itself so clearly that he left the china factory and entered the studio of Charles Gleyre as an art student. Charles Gleyre headed a studio at the École des Beaux-Arts, one of the most established and successful in all of Paris. Gleyre's success was based on training his students to prepare and submit works for the annual exhibitions of the official Salon, a government-sponsored event held in Paris each April. Its jury consisted of academic teachers and elected officials, who displayed an increasingly stifling

Ball at the Moulin de la Galette
detail; 1876; Paris, Musée d'Orsay
Ball at the Moulin de la Galette *seems to invite viewers*
to join the merry company and to simply enjoy themselves.

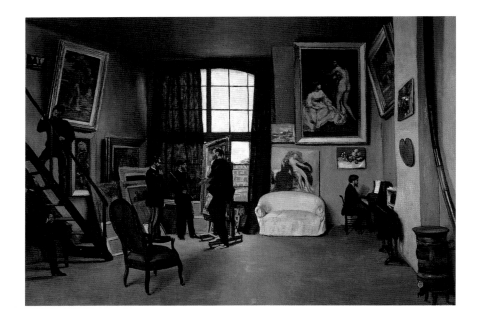

Frédéric Bazille
The Artist's Studio,
Rue de la Condamine
1870; *oil on canvas;*
38 7/8 x 47 in. (98.5 x 119 cm.).
Paris, Musée d'Orsay.
Bazille generously shared his
studio with Renoir, and also
with Claude Monet, since
neither artist could afford to
rent a room for themselves at
the time. On the walls of the
luminous and spacious room,
Bazille depicts his own works.
The figures from left to right
are: Monet, Sisley, Renoir,
Manet, Bazille, and Maître.

conservatism in the selection of the thousands of works submitted each year by artists from all over the country. The Salon had became so powerful and influential that potential art buyers used the shows as a consumer guide. For those artists whose works were accepted success was, if not guaranteed, at least a distinct possibility. Positive mention in the newspapers by the critics, on the other hand, could pave the way to fame and prosperity. It is therefore not surprising to find Renoir among the numerous contestants of the Salon for several years, until he joined the alternative showcase of the Impressionist exhibitions.

Despite the aura of an officially acclaimed artist, Gleyre did not fully adhere to traditional standard practice. His students paid only a nominal fee for the studio space and the models, and he renounced any charges for his teachings. It was the craft of painting that was at the center of Gleyre's program. His students were taught to draw from plaster casts, reliefs, and engravings, as well as from oil paintings and models. Although full training was offered inside the studio, Gleyre never inhibited his students in pursuing their own personal style and even encouraged them to paint landscapes *en-plein-air* (out-of-doors), something the artists of the Barbizon School—such as Theodore Rousseau and Charles Daubigny—were practicing. In exchange, his pupils respected and admired their teacher, and as late as 1890 Renoir declared himself at the Salon as a "student of Gleyre."

In fact, the teachings of Gleyre stayed with Renoir throughout his life. The framework of his paintings is based on clearly arranged compositions. Renoir adhered to the tradition of Academic Realism, preferring nudes and portraits as well as narrative genre scenes over pure landscape painting. Still-lifes are relatively rare in his oeuvre.

The most crucial and historically consequential event for the artist Renoir during this training period were the arrivals in 1862 at the Gleyre studio of Claude Monet, Alfred Sisley, and Frédéric Bazille. The four artists, all in their early twenties, soon became friends and founded the basis for what was to become the Impressionist movement. Renoir would receive much support from his new friends over the next two decades. Their group was enlarged the following year when Monet introduced to the "Gleyre group" Camille Pissarro and Paul Cézanne, who were both studying at the Swiss Academy in Paris. An excursion around Easter time to the Forest of Fontainebleau, a short distance from Paris, cemented the relationship between the Gleyre students. Wandering around the woods with their easels and knapsacks, the artists searched for motifs to paint. There they also met the painters Gustave Courbet and Narcisse Diaz de la Peña, two

artists who spent much of their time out in nature painting what they'd observed in front of their eyes.

In the summer of 1864, due to poor health, Charles Gleyre was forced to close his school. The following year, Renoir's parents moved to a suburb of Paris. For young Renoir this was the definitive moment when the patterns of student life came to an end. He began to live the life of a poor bohemian artist, with no roof over his head and little money, but full of hope that some day he would make his own way. Often he stayed with his friends of the Gleyre group and shared their studio space. He nurtured his connections with artists, dealers, patrons, and friends who were financially independent and who would frequently offer him shelter. Some gave him money to buy paint and canvases; others commissioned paintings, usually portraits or decorations for their city and country homes.

These economic constraints had their impact on Renoir's painting in a somewhat peculiar way, not unlike what Edgar Degas would experience a few years later. Renoir's style became twofold. A more detailed, realistic vein was intended for the Salon, done on commission or in hope of sale. The attractive still-life *Arum and Conservatory Plants*, for example, belongs to this group. Other works were executed in a freer, more painterly, impressionistic manner and were destined for his friends or connoisseurs of art. However, even the artist's more academic works were frequently rejected by the Salon jury or exhibited under unfavorable conditions.

When Alfred Sisley, with whom Renoir had lived for some time, got married, Renoir moved in with Frédéric Bazille. In a letter to his parents in Montpellier Bazille wrote: "I am giving hospitality to a friend of mine, a former pupil of Gleyre, who for the time being has no studio. Renoir, that's his name, works very hard, he is able to use my models and even helps me partly in paying them." Somewhat later Bazille announced that Claude Monet had also moved in with him out of lack of money: "Along with Renoir, that makes two needy painters to whom I'm giving shelter. It's a real infirmary."

During this time Bazille and Renoir painted revealing portraits of each other. The city and environs of Paris offered many occasions for out-of-doors painting, in which Renoir joined Monet. They painted along the picturesque embankments of the Seine River near the Louvre (e.g., *The Pont des Arts*) or again in the Fontainebleau Forest. There, in the summer of 1867, Renoir completed his large painting *Lise with Umbrella*. The work was accepted at the Salon for the following year, but it was received for the most part with derisive commentary, noting the influence of Édouard Manet.

Mother and Child
c. 1916, cast 1927; *bronze;* 21 x 9 1/4 x 12 1/2 in. (53.5 x 23.5 x 32 cm.). London, The Tate Gallery. *After the death his wife in 1915, the artist picked up the subject of Madame Renoir nursing her first baby, Pierre, born in 1885. This group was possibly intended as a study for a large commemorative statue to be placed on Mme. Renoir's tomb, a project which was never executed.*

The impact that Manet had on the young artists was indeed considerable. At gatherings at the Café Guerbois, only a few minutes away from Bazille's new studio in the rue de la Paix (later renamed rue de la Condamine), the older artist attracted a crowd of young adherents who would come to gossip about the latest news in the art world but, above all, to hear Manet's comments about the need for a modernized and innovative art opposed to the conservatism of the Salon. Some of the artists sitting around his table were soon to become household names in the art world: Monet, Sisley, Pissarro, Degas, Cézanne, and naturally Renoir. Included in this circle too were the painter Fantin-Latour, the artist-physician Paul Gachet (who would later on become Vincent van Gogh's doctor in Auvers), the photographer Nadar and the writers, Émile Zola, Théodore Duret, and Edmond Duranty, and others. Claude Monet described the atmosphere at these meetings in a newspaper article: "Nothing could be more interesting than those 'causeries' with their perpetual clash of opinions. They kept our wit sharpened, they encouraged us in sincere and disinterested research, they provided us with stores of enthusiasm that for weeks and weeks kept us up, until the final shaping of an idea was accomplished. From them we emerged tempered more highly, with a firmer will, with our thoughts clearer and more distinct."

Renoir's admiration for Manet was exchanged by a generous gesture, which illustrates the older artist's esteem for the young man. When Fantin-Latour painted a group portrait of the artists from the Café Guerbois, Manet insisted on being placed right next to Renoir. Apparently Manet found the soft-spoken Renoir, with his modest but charming manners, particularly sympathetic.

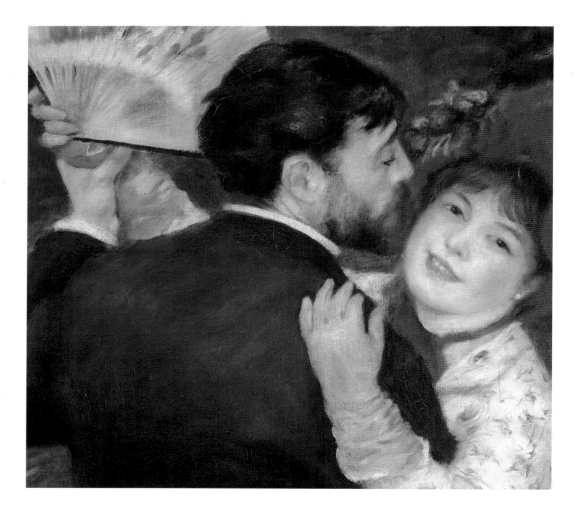

Dance in the Country
detail; 1883; Paris, Musée d'Orsay.
Happiness and contentment is expressed in the faces of this dancing couple. The woman's head is turned as if to invite the viewer to join this special moment.

Two Girls at the Piano
1892; *oil on canvas; 45 5/8 x 35 1/2 in.*
(116 x 90 cm.).
Paris, Musée d'Orsay.
Considered almost obligatory for young women of the middle and upper bourgeoisie, piano playing was a form of entertainment at parties or social gatherings. Two girls— one playing, the other looking at sheets of music—are observed with immediacy and great charm during a moment of practicing.

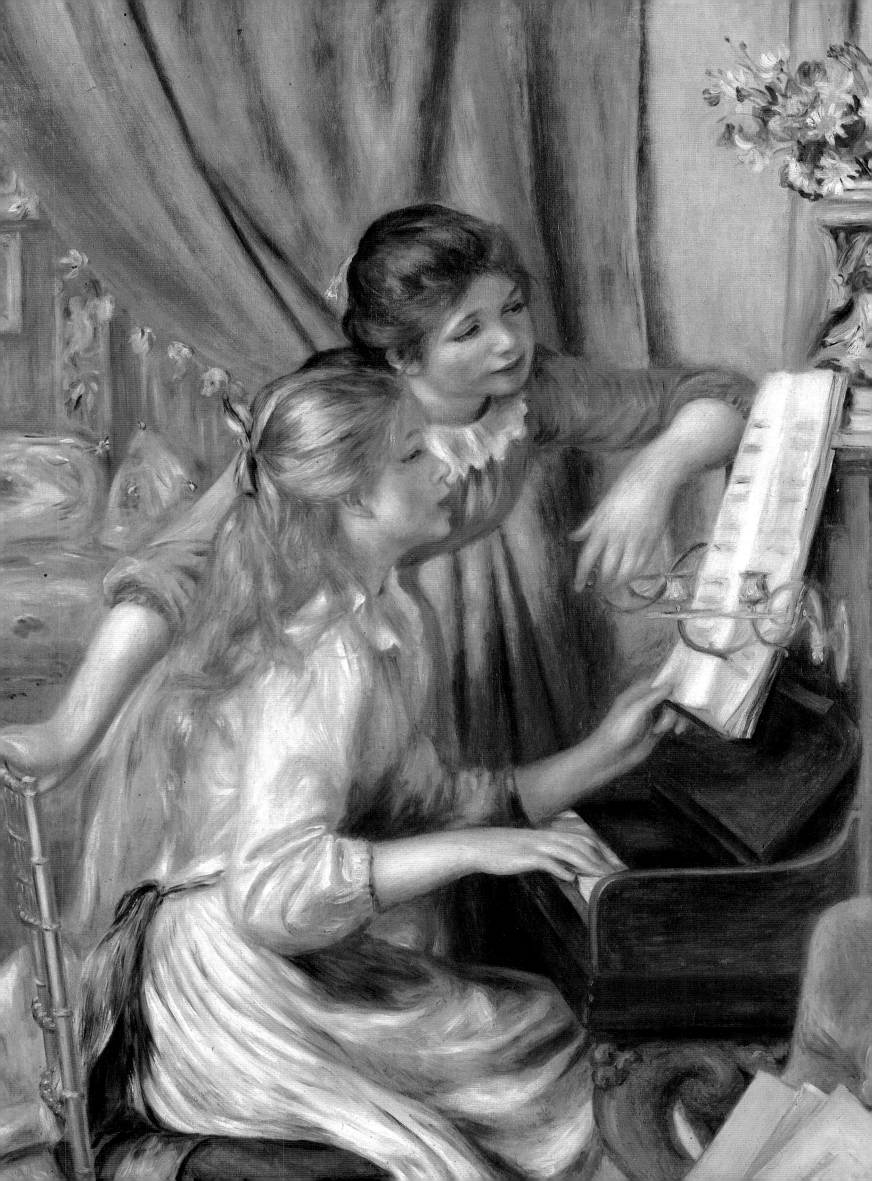

The Seine at Argenteuil
c. 1876; *Oil on canvas;*
12 1/4 x 15 3/8 in. (31 x 39 cm.).
Geneva, Musée du Petit Palais
Since the Monet family had moved to Argenteuil in 1872, Renoir went to visit his friend regularly in this town along the Seine, twelve minutes by railroad from the Gaire Saint-Lazare. Together the two artists explored the countryside around it searching for motifs. The predominance of the landscape is probably due to Monet's influence, who preferred it over the depiction of people.

During the summer of 1869 Monet and Renoir worked together at La Grenouillière, a popular outing site on the Seine near Chatou. Side by side the two artists painted the same motif with similar, yet distinct, results. Both, however, captured the flickering effects of light reflected in the water and the summer atmosphere of people bathing and in boats or simply walking with an umbrella to protect themselves from the heat. Their palettes were unusually bright and vivid, enhancing the luminosity of their subjects. These paintings may properly be considered the beginnings of Impressionism. Renoir was to explore this style further but, the following summer, the Franco-Prussian War interrupted his activities. Renoir was drafted and sent to Bordeaux, but he never had to fight. His closest friend Frédéric Bazille, however, who had volunteered to serve in a Zouave regiment, was killed in combat in November 1870. His promising career had thus ended tragically.

Shortly after the end of the war, civil unrest erupted in Paris and a regime of a socialist stamp attempted to replace the government. The reign of the Commune lasted for only two months, but it had support from prominent members of society. Among them was the painter Gustave Courbet, who abolished conservative artistic institutions like the

Academy in Rome and the École des Beaux-Arts in Paris. He also ended the elaborate system of medals and honors at the Salon exhibitions. The hardships Parisians suffered during the siege by loyal government troops made life extremely difficult in the city. Starvation, disease, and lack of coal for fuel caused a desperate situation. Renoir managed to escape to Louveciennes, not far from the capital, to which his parents had moved. There he met again Sisley and his family, and the two artists often painted together in the forest of Marly during this time.

In June, after the end of the civic upheaval, which had cost the lives of at least 20,000 Parisians, Renoir returned to the city. Soon he began to make contacts with collectors and art dealers in order to promote his career. Theodore Duret, a wealthy art critic, whom Renoir had met at the Café Guerbois, and the dealer Paul Durand-Ruel, whom Monet introduced to Renoir early in 1872, were to have a strong influence on Renoir's career. But for some time success would not come, and the economic decline during the mid-1870s marked perhaps the most difficult financial crisis in the artist's entire career. Renoir attempted, too, to make his success at the Salon, painting more conventional, realistic works of a large size for these annual exhibitions, with mixed results. Frequently, his works were rejected by the jury or, if accepted, they were so badly hung or lit—similar to the paintings of his fellow Impressionists—that the critics and the buying public paid little attention to them.

Renoir continued to gather a circle of friends about him—artists of lesser talents such as Frédéric Cordey, with whom he would travel to Algeria several years later, or men of other vocations like Georges Rivière, who worked at the Ministry of Finance in addition to being a journalist. These friends would frequently stop by his studio in the afternoon, then perhaps stroll down to the Café de la Nouvelle-Athènes, a brasserie where writers and other acquaintances would join them in discussions. This network was important for Renoir since it provided him with patrons and commissions as well as with models.

The persistent rejection from the Salon prompted Renoir, Monet, Sisley, Pissarro, Cézanne, and others to form a group which they named the Society of Painters, Sculptors, and Engravers. They started to mount their own exhibitions, beginning with a first show in April of 1874. Ten days after its opening the satirist Louis Leroy entitled his negative review of the show "Exhibition of the Impressionists," referring derogatively to the title of Monet's painting *Impression—Sunrise*.

Marthe Bérard (Little Girl with Fishing Net)
1879; *oil on canvas;*
23 5/8 x 18 3/4 in. (60 x 45 cm.).
Geneva, Private Collection.
The granddaughter of Paul Bérard, a banker and diplomat who was one of the most important patrons of the artist, is shown with a fishing net on the beach of Berneval, near Wargemont in Normandy. Renoir painted portraits of almost all the members of the Bérard family.

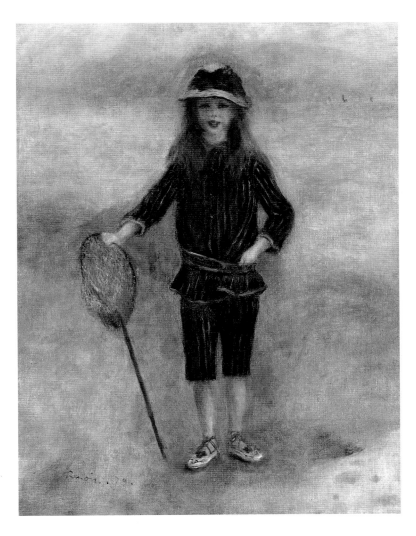

Other reviews were more favorable. Economically, however, the show was a failure, and only 3,500 visitors came compared to the 400,000 who went to the Salon during the same time. However, it did provide the artists with an opportunity to show their works to the public and the group would continue to do so for a number of years.

In 1875, Renoir began to work on his most ambitious and original painting up to that time, *Ball at the Moulin de la Galette*, which has since become an icon of the Impressionist movement. Painted primarily in the garden of his studio with friends posing for him, Renoir depicted the famous dance hall in Montmartre in the flickering light of a sunny afternoon. Shown at the third Impressionist exhibition, in 1877, it won some acclaim, but the overall result of the entire show was again disappointing as far as sales were concerned and Renoir found himself once more in an increasingly difficult financial situation.

Wary of being considered a radical both in art as well as politics, Renoir sought out contacts within the upper bourgeoisie, courting patrons such as Georges Charpentier, a wealthy publisher, or Paul Bérard, a diplomat and banker. Renoir began to distance himself somewhat from the Impressionist cause, but not from his artist friends, among whom Monet was his most faithful. Again Renoir's style became more academic, focusing increasingly on tangible forms, in particular in his portrait paintings, combining both Impressionist and Realist tendencies. He also made plans to exhibit once again at the Salon.

In the fall of 1879, at the age of thirty-eight, Renoir met Aline Charigot, a twenty-two-year-old woman from Essoyes in Burgundy. She did the laundry for a seamstress, and also for Renoir and Monet. Soon she became one of Renoir's models, and eventually his wife. This was also a time in which the artist enjoyed some success. His portrait paintings had provided him with a modest wealth so that by the early 1880s he was able to travel to Algeria, Italy, the south of France, and to the Channel Islands.

Luncheon of a Boating Party, which he finished in the summer of 1881, was his second large-scale masterpiece. Two years later Renoir executed three of his most stunning paintings: *Dance in the City*, *Dance in the Country*, and *Dance at Bougival*. Also in 1883 the artist had his first one-man show, at the gallery of Durand-Ruel—with, however, limited success. The economic crisis of those years led to the loss of old patrons and Renoir's financial situation was again precarious. Only with the help of some faithful friends and patrons did Renoir manage to continue his work.

With the birth of his first son Pierre in 1885, and the eventual marriage to Aline in 1890, Renoir's interests began to shift from the subjects of urban society to that of nature, family life, and motherhood. He spent much time in Aline's hometown of Essoyes, where the cost of living was much lower. But this was not the happiest time of his life. Then in his mid-forties, and with only a modestly successful career, Renoir's once relentless optimism had begun to give way to a more pessimistic view. Nudes and bathers increasingly became the focus of his paintings. In December 1888 Renoir suffered from his first arthritis attack, which in the following three decades would more and more hamper his life to a point where he was temporarily unable to paint.

The Mosque (Arab Holiday)
detail; 1881; Paris, Musée d'Orsay.
*The ambiguous title of this work is in part based on the group of dancers
at its center, who may indeed be performing during a holiday celebration.
Tiny strokes of paint define their figures in the bright light of North Africa.*

The early 1890s proved to be more successful for Renoir. He regularly sold his paintings—usually portraits—and finally even the government made its first purchase, with an 1892 work *Two Girls at the Piano*. The way for a lasting national and international recognition had at last been paved. Exhibitions of Renoir's work were held in Brussels, London, and New York. Besides his lifelong gallerist Paul Durand-Ruel, the dealers Paul Cassirer in Berlin and Ambroise Vollard and Alexandre Bernheim in Paris purchased his works. But at the same time, Renoir's health forced him to slow down his production. He spent more and more time outside Paris, particularly in Essoyes and on the Mediterranean coast at Cagnes, where he eventually built a house, called "Les Collettes." It was there that Ambroise Vollard suggested to the ailing Renoir that he make sculptures with the help of an assistant, an idea Renoir accepted. Over a span of several years, a number of large scale sculptures were executed under the artist's supervision. The famous sculptor Auguste Rodin paid a visit to Renoir at Les Collettes, and a first biography by the German critic Julius Meier-Graefe was published in 1911.

The outbreak of World War I slowed Renoir's energies. His sons Pierre and Jean were wounded, causing him and his wife considerable pain. In 1915 Aline Charigot, his companion of thirty-six years, died of a heart attack, leaving the seventy-four-year-old near-invalid alone at Les Collettes. For her tomb at the cemetery in Essoyes, Renoir prepared a portrait bust of Aline. In December of 1917 Pierre Matisse visited Renoir to interview him for an article. These recognitions and interruptions notwithstanding, Renoir suffered from loneliness in addition to the physical pain caused by his arthritis. He produced very little, since his crippled hands were practically unable to hold the paint brush. However, it was his art which kept up his good spirit.

After the signing of the armistice in November 1918, Renoir celebrated the victory with renewed energy in his final masterpiece, *The Bathers*. Here Renoir summed up his lifelong experiments with a synthesis of Classicism in form and composition and Impressionism in the flickering light and loose brushwork. He continued to make plans for new projects, which alas were never realized. Renoir died on December 3, 1919, at the age of seventy-eight. He was buried next to his wife Aline in Essoyes.

When Monet learned of Renoir's death he spoke for many when he stated, "It is a very great loss and a real grief for me." Since the 1920s numerous exhibitions have been held, and Renoir's work has remained popular up to the present day. It is true that criticism has repeatedly been voiced, especially about his later work. However, one can surely say that Renoir was truly the last great painter of the ideal sensuous figure, which had its forebears in Raphael, Rubens, and Ingres. He had shown that Impressionism was not the last word in art and many young artists such as Aristide Maillol, Matisse, and Picasso were influenced by his art.

The Comtesse des Pourtalès
1877; *oil on canvas; 37 3/4 x 28 1/3 in. (96 x 72 cm.). São Paulo, Museu de Arte, Assis Chateaubrianz.*
Renoir's contacts in the upper class provided him with regular commissions for portrait paintings, so necessary for his income. Seated at the center of this painting and somewhat removed from the picture plane, the comtesse is shown in an exquisite robe of velvet decorated with lace. Her face, however, retains a freshness and naturalness similar to that of Renoir's renderings of actress Jeanne Samary.

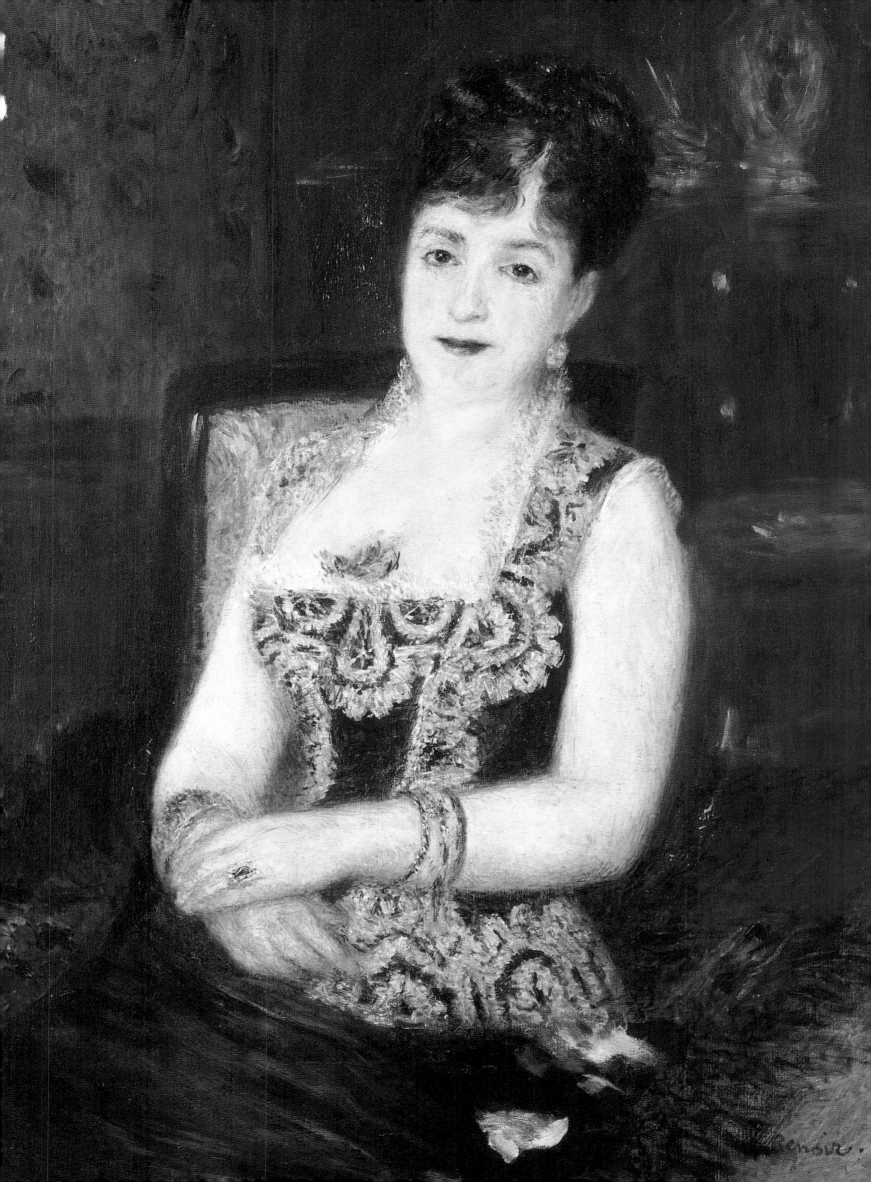

CHAPTER 1

EARLY YEARS AND IMPRESSIONISM

Renoir's artistic training began in the studio of Charles Gleyre, which he joined sometime in 1860 (the exact date is not known). There he learned the basic principles of the artist's trade. By all accounts he was an eager and hardworking student; however, Renoir later recalled: "My teachers were unanimous in finding my painting execrable." Things changed with the arrival of three new students at the Gleyre studio in October and November of 1862: Claude Monet, twenty-two years old and from Le Havre; Frédéric Bazille, twenty-one, from Montpellier; and Alfred Sisley, twenty-three, recently returned to Paris from London. The four students quickly became close friends and their association was vital not only for Renoir's own career, but altogether for the cause of Impressionism.

Together the four aspiring artists traveled at Easter time in 1863 to Fontainebleau Forest outside Paris to paint. There they met the painters Gustave Courbet and Narcisse Diaz de la Peña. Both artists painted out-of-doors, and the young students were eager to begin this practice themselves. Walking through the forest with

their portable easels, paintboxes, and knapsacks, they searched for motifs, inspiring and encouraging each other. The scenes Renoir painted then anticipated his later holiday outing theme. Figures in contemporary dress enjoy themselves in a free and relaxed atmosphere of sociability under a sun-filled sky.

In the spring of 1863 Renoir for the first time submitted a painting to the Salon, which was accepted, but it did not win him any recognition or acclaim. The following year Gleyre's studio was closed and when Renoir's parents moved to a suburb, his student life came to an end. Although Renoir had received some commissions by then,

Bather with a Dog
1870; *oil on canvas*; 72 1/2 x 45 1/4 in. (184 x 115 cm.).
São Paulo, Museu de Arte, Assis Chateaubrianz.
A woman is about to take a bath in a river. Her clothes are scattered on the grass in casual disarray and even her little dog has found a comfortable place to rest. The classical pose of the bather is reminiscent of antique sculptures such as the Venus Medici. *An odd feature is the reclining female companion in the background.*

Walk in the Garden
detail; 1870; Malibu, California, The J. Paul Getty Museum.
The seemingly effortless touch and impressionistic handling of the woman's dress recalls Claude Monet's technique of small strokes of the paintbrush, which recreates the shimmering effects of the light on a summer afternoon.

they certainly did not provide him with enough money to live on. Renoir recognized the need to cultivate patrons, dealers, and friends who appreciated his art and who could offer necessary connections. His charm and good-natured character helped him in finding such benefactors. Among them was Jules Le Coeur, a wealthy painter nine years older than Renoir. Eventually Renoir befriended the entire Le Coeur family and painted, among other members, Jules's brother Charles Le Coeur in his garden as well as *Jules Le Coeur in Fontainebleau Forest*. Although he could simply have enjoyed the comfortable life of a middle-class man by accepting invitations to outings to the countryside or pleasant dinners, Renoir was hesitant to give in to such an impulse. He often felt that he had to do something productive with himself and he was uneasy and restless without a paintbrush in his hands. Marie Le Coeur, Jules's sister, described such a conflict of Renoir's in a letter of March 29, 1866:

"M. Renoir left today for Marlotte with Jules. That poor boy is like a body without a soul when he is not working on something. At this moment he doesn't know what to start next, since his pictures for the exhibition are finished. The day before yesterday, Jules had already persuaded him to go with him, but he preferred to wait a little and finish Mother's portrait, while his friend Sisley found a place there for the two of them to stay; friend Sisley was pestering him from one side, Jules from

Portrait of [Jean] Frédéric Bazille

1867; oil on canvas; 41 3/4 x 29 1/8 in. (106 x 74 cm.).
Paris, Musée d'Orsay.
This portrait is a spot-glimpse of the camaraderie between Renoir and his friend Frédéric Bazille when they shared the same studio space for some time. Casually dressed in slippers and a loose-fitting jacket, Bazille is painting a still-life with a heron, which is today in the museum of his hometown in Montpellier. The snowy landscape on the wall was a gift to Bazille from Claude Monet.

Frédéric Bazille
Portrait of Pierre-Auguste Renoir

1867; oil on canvas; 48 x 42 1/8 in. (122 x 107 cm.).
Paris, Musée d'Orsay.
The friendship between Renoir and his roommate Frédéric Bazille is documented in portraits the artists painted of each other. Here, Bazille depicts the young Renoir sitting with both legs pulled up on a chair in their studio. The freshness of Bazille's style is evident in the polished painterly quality and the casual pose of the sitter.

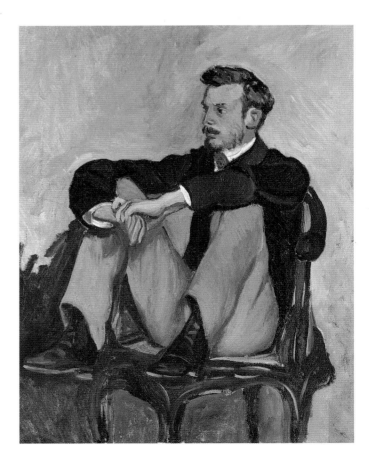

the other; finally yesterday morning he came to work, saying he wasn't leaving at all. This morning he was still resolved to stay, but he went to see Jules off at the railroad station and at the last moment he left."

In July of that year, after Alfred Sisley's marriage, Renoir moved into the studio of his friend Frédéric Bazille at 20 rue Visconti. Later they were joined by the penniless Claude Monet and the three artists worked often together. Renoir and Bazille painted striking portraits of each other. Renoir's canvas showed his friend sitting in front of his easel while working on *Still-life with Heron*, today in the museum of his hometown of Montpellier. Renoir offers a keyhole view of the tall and lanky Bazille, who is almost cramped into the restricted space of the canvas. Casually dressed in slippers and a loose-fitting jacket, he leans over his painting attentively, a brush in his hand, offering the illusion of being completely unaware that he is being observed at his work. Behind his head on the wall hangs a snow scene by Monet. We also know that Sisley painted the same still-life of dead birds that Bazille is working on here. Furthermore, the same sense of a close and utterly informal fraternity is expressed in Bazille's portrait of Renoir, who is depicted with both feet up on a chair. Renoir's face is serious and determined, although his eyes are given a warm and friendly touch. The same fresh and spontaneous atmosphere is contained in Bazille's painting of his own studio, where he offered shelter to both Monet and Renoir. The space is large and luminous, the whitewashed walls filled with his own paintings. He seems to have just received some visitors. From left to right appear Monet, Sisley, Renoir, Manet, Bazille, and the musician Edmond Maître. Such casual gatherings were held regularly in Bazille's studio as well as at cafés, where they would fervently discuss their art.

The Growth of an Artist

On a number of occasions Renoir and Monet painted together out-of-doors, mostly views of Paris. Renoir's *The Pont des Arts* is one of these canvases. A snapshot glance of a typical daily scene in the city is rendered with a light and bright palette, a simple and clear-cut composition with a lot of attention to detail. People are strolling on the quays, children are playing, and two dogs meet each other among the crowd. The sun-filled scene is not yet rendered with the small brushstrokes that both Monet and Renoir would develop only a few years later but, in essence, all the ingredients for the Impressionist style are here already present.

In the summer of 1867 Renoir painted his first life-size figure painting en-plein-air—*Lise with Umbrella*. Fashionably dressed in white attire with a black satin sash, a white hat with red ribbons, red earrings, and a black lace umbrella to protect her delicate complection,

Lise is standing outdoors waiting for her escort during an outing in the Fontainebleau Forest. The painting was accepted at the Salon the following year, together with works by Renoir's friends Monet, Sisley, Pissarro, Degas, Manet, and Berthe Morisot. Although hung close to the ceiling, *Lise* was mentioned by several critics who noticed the influence of Manet—then considered the leader of the avant-garde—as well as the youthful freshness of Renoir's model. While Zacharie Astruc commented: "Now here is 'Lise'. . . the pleasant girl of Paris, at the Bois," other critics were not so positive,

Charles Le Coeur in the Garden

1874; *oil on canvas; 16 1/2 x 11 3/8 in. (42 x 29 cm.).*
Paris, Musée d'Orsay.
Charles Le Coeur was an architect and amateur gardener. Painted in his garden in Fontenay-aux-Roses, the inscription on the top right, "O Galand Jard" ("To the gallant gardener"), is intended as a dedication to the sitter. This is one of Renoir's few full-length portraits. Renoir's friendship with Le Coeur ended when one of his love letters to Le Coeur's sixteen-year-old daughter Marie was discovered.

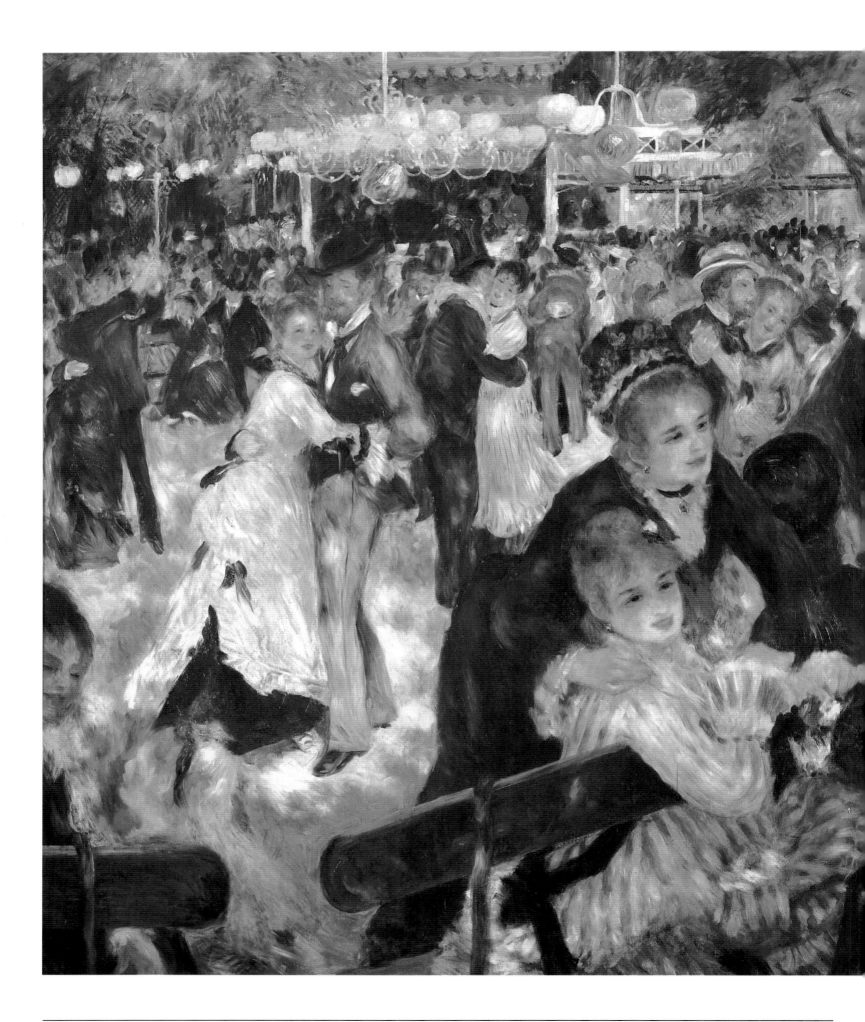

denouncing the figure as that of "a fat woman daubed with white" and not recognizing the extraordinary quality of light and delicate brushwork in the work. In 1901 the painting was purchased by the art dealer Paul Cassirer for his gallery in Berlin.

In 1868 Alfred Sisley asked Renoir to paint a portrait of him and his wife Marie. This large double portrait is set in the urbane environment of a garden or a park. The amorous painter dressed in a black frock coat tenderly approaches his wife, dressed in a lavish, ornamental striped gown of bright orange and white, an example of the latest in Parisian fashion. The intimacy and casualness of their gestures are clearly different from the official portrait style still proclaimed by the academic teaching at the École des Beaux-Arts. The attention and love for detail Renoir always showed toward fashion might very well have been fostered by his family's occupations in the garment trades.

Commissions like this one helped Renoir to survive but he continued to pursue other ways of finding money and recognition. More traditional and realistic works such as the 1864 still-life *Arum and Conservatory Plants*, for example, were painted for the Salon, where—Renoir hoped— they would be accepted and understood more easily by a larger audience. For many years, this dichotomy between a more conservative, official style intended to provide him with a source of income, and the more avant-garde paintings executed for his friends and for connoisseurs, remained a characteristic feature of Renoir's oeuvre.

Being talked about was something Renoir tried to achieve by submitting regularly to the Salon. In 1869 the painting of his model Lise

Ball at the Moulin de la Galette

1876; *oil on canvas*; 51 1/2 x 68 7/8 in. (131 x 175 cm.). Paris, Musée d'Orsay.

The open-air dance hall "Moulin de la Galette," which took its name from a defunct windmill on the top of the Montmartre in Paris, was a highly popular meeting place among young Parisians on Sunday afternoons. Couples sprinkled with sunlight are dancing or talking in a free and relaxed atmosphere. Several eyes are looking out of the picture as if to invite a casual stroller to join them.

Tréhot, *Study: Summer*, was shown. The sketchy execution of the background contrasts with the realistic rendering of the young woman and her thinly veiled eroticism with which Renoir tried to appeal to public taste. However, this work was once again overlooked by critics and potential buyers, and Renoir's financial situation became increasingly bleak. During the summer months, while Bazille spent time with his family in Montpellier, Renoir stayed with his parents in order to save money.

The Early Impressionists

It was in October of 1869 that Monet and Renoir began to paint in a style that would come to be called Impressionism; at the same time, however, Pissarro may have come to this style independently. In a letter to Bazille, Monet explained their goals: "I have a dream, a painting, the baths of Grenouillière, for which I've done a few bad sketches, but it's a dream. Renoir, who

has just spent two months there, also wants to do this painting."

Located on the Seine River at Chatou, Grenouillière (literally, the Frog Pond) was a favorite bathing and boating site for Parisians. A short train ride from the capital, and which cost only twelve sous at the time, the locale offered relaxation during a day's outing. Here, side by side, Renoir and Monet each painted three landscapes with the same view. One might properly call these the first Impressionist images. They depict a casual moment of daily life, created in an atmosphere of freedom and seeming randomness, with vivid colors, small, intense brushstrokes, and a pervasive light. People are seen strolling or dining, while children swim in the river and others are in their boats, and all of this is bathed in the gleaming light reflected by the surface of the rippled water. The overall effect is that of a spontaneous execution, when in fact both Renoir and Monet had carefully studied their

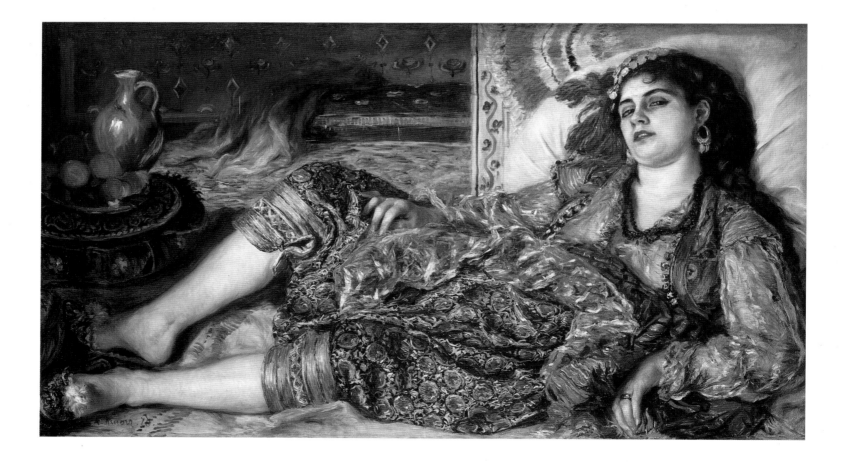

Odalisque

1870; *oil on canvas*; 27 1/4 x 48 1/4 in. (69 x 123 cm.). Washington, D.C., National Gallery of Art, Chester Dale Collection.

Based on Jean-Auguste-Dominque Ingres's Odalisque *and other sources of the exotic harem, Renoir here shows off his technical mastery in rendering the texture of the various fabrics in luminous colors: the precious gold brocade of the knickers; the gauze of the blue-gray blouse; and the multicolored striped sash.*

compositions, painstakingly weighing every one of the tiny details. In order to achieve the high keys of their palettes, the artists used canvases that were not prepared with the traditional warm brown or red ground, but rather with a white or pastel tone to enhance the luminosity of the scenes.

The idea of recording immediate impressions rather than the permanent aspects of a subject was born out of the attempt to reproduce on canvas the actual image as it would (supposedly) appear on the retina of the eye. To that end, both Monet and Renoir used "rainbow" colors and eliminated black shadows and outlines of forms. The depicted objects thus gained lightness and atmosphere. Brushstrokes vary from dry to wet, from thin to impasto, and are broken into hundreds of small spots, each of them having its own hue. Complementary colors are used to model the objects, to give them a tangible feeling in a space no longer defined by lines and perspective. An intense richness and airy, fleeting quality are the results of these efforts.

The eyes cannot focus any longer on details, which appear blurred and without a defining line. Instead the image needs to be seen from a certain distance, where the single spots can be viewed all together, at once, thus recreating the image as the artist saw it during its execution. In an unprecedented manner, the viewer becomes actively involved in the creative process of the artwork. Furthermore, the artists, in their individual fashion, seemed to capture the ever-changing character of the visible world as it appeared in a transient moment. Every artist's perception is unique, and even two painters as close as Renoir and Monet produced works of very different character. Renoir always favored people and their social relationships, while Monet was primarily interested in nature and landscape.

Naturally, in the restrictive milieu of more traditional, academic painting, such everyday-life scenes with their light, bright palette, quick brushstrokes, and seemingly random arrangement were regarded at first as scandalous and disrespectful of the culture of the past. For almost two decades Impressionist artists were forced to fight an uphill battle against such conservative-minded misunderstandings. It was only toward the end of the century when Impressionism found its way into the mainstream.

It might seem surprising at first to find Renoir painting once again traditional images like *Bather with a Dog* or *Woman in Algiers*. He did so, of course, with the jury of the Salon in mind. His strategy proved successful, and both paintings were accepted for the Salon in 1870. The figure of the bather was based on the classical Greek sculpture *Aphrodite of the Cnidians*, while the tradition of an exotic harem in *Woman in Algiers* was derived from

Ingres's *Odalisque* with its long horizontal format. Eugène Delacroix's influence is also visible in the rich surface texture of the multicolored fabrics. It was several years before Renoir himself was able to afford a visit to Algiers.

Among Renoir's earliest large-scale Impressionist figure paintings was *Walk in the Garden* (also known as *The Promenade*), executed in 1870. The subject of romantic

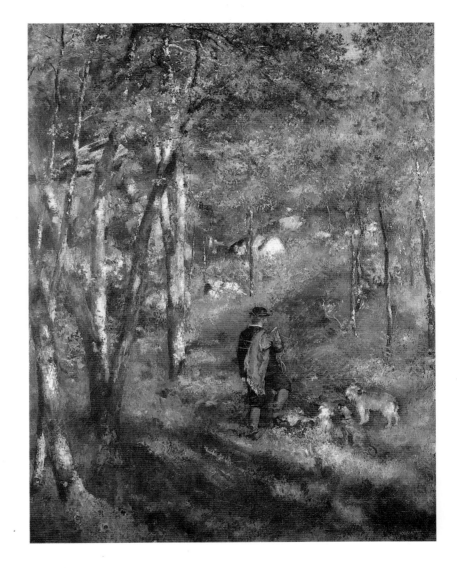

**The Painter Jules Le Coeur
in the Forest of Fontainebleau**

1866; *oil on canvas*; 63 x 31 1/2 in. (106 x 80 cm.).
São Paulo, Museu de Arte, Assis Chateaubrianz.
Painted in the tradition of the Barbizon School, with its predominance of brown and yellow hues, Renoir portrayed here his friend the painter Jules Le Coeur, whom he had befriended the previous year. Renoir became a frequent guest of the Le Coeur family and spent much time at their home in Marlotte in the Forest of Fontainebleau.

love between a fashionable lady and her young bourgeois lover is rendered with an elaborate brushwork which captures the atmosphere in a sun-filled garden. The model was once again Lise Tréhot. In a tender gesture the man invites the somewhat hesitant woman to follow him on a path. Countless small strokes model the forms and shades in an endless variety of hues, which are based mostly in green, white, and black.

Beginning in 1871, Renoir and his friends Monet, Pissarro, and Sisley were aware of painting in a distinct and original avant-garde style. Renoir's bent was to explore the open form of large-scale figures. Seen from close up his people and objects are unclear, without definition, detail, or weight; from a distance, however, the brushstrokes suggest volume, shape, and relief. Yet Renoir's treatment of form never became as summary as Monet's because of his attention to the sensuousness of flesh and clothing. Toward the end of the decade, Renoir's human bodies would again become more defined, tangible, and increasingly idealized. Until then he was among the leaders of the new Impressionist style, without however taking its means to the extreme. His compositions always retain a touch of classicism in the orderly, proportioned disposition of both figures and objects, thus achieving balance, order, and harmony.

Early in 1872, Monet introduced Renoir to the art dealer Paul Durand-Ruel, whom he had met in London during the Franco-Prussian war. In March 1872, Durand-Ruel bought two paintings from Renoir: a still-life for four hundred francs and the 1867 *The Pont des Arts* for two hundred francs. This signaled the beginning of a lifelong relationship between Renoir and Durand-Ruel that went beyond the then customary interest between a gallery owner and his artist. The tradition of the Salon, which awarded prizes to individual canvases, and which exhibited and purchased works for the state, was slowly replaced by a network of influential and taste-making dealers, collectors, and art critics who published and discussed new artistic developments in their journals. Thus the artist's career would be based on the support of a benevolent dealer or critic, who provided exposure, clients, and other forms of financial or moral support. Renoir remained faithful to Durand-Ruel throughout his life, always offering him his works first.

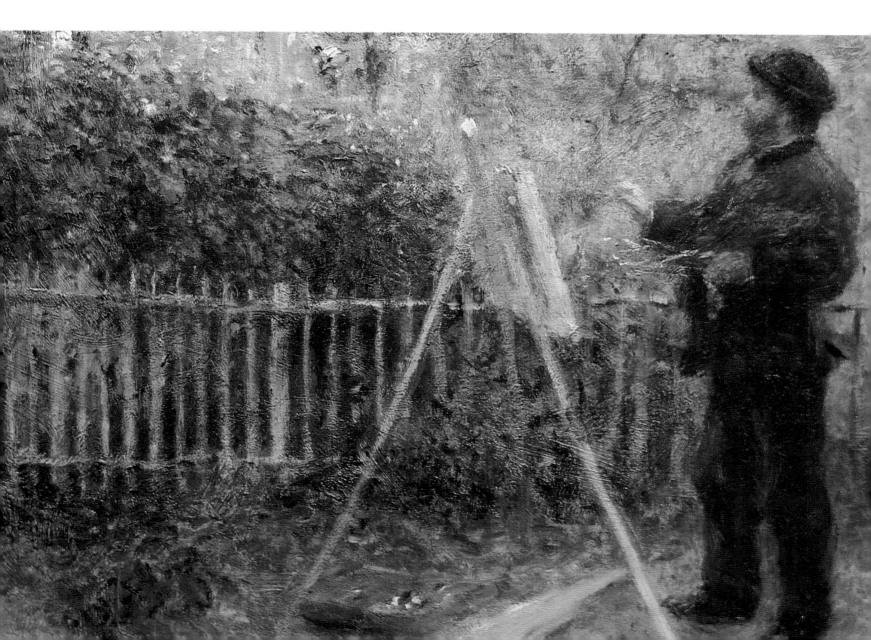

The First Impressionist Exhibition

Renoir painted a portrait of Claude Monet during the summer of 1872 when he visited the Monet family at their house in Argenteuil. He chose the moment when his friend was reading a newspaper and smoking his pipe. A few years later he painted Monet at work in his garden, and still another time inside the house holding a palette. Although both artists pursued disparate paths in their works, they maintained a close friendship for the rest of their lives.

Around the same time, until 1880, a traditional Wednesday dinner for artists was arranged by Hyacinthe-Eugène Meunier, called Murer, who ran a bakery and restaurant together with his sister Marie. Besides Renoir and friends like Monet, Sisley, Pissarro, and Cézanne, others, also supportive to Impressionist art, were invited to attend, such as Père Tanguy, a Montmartre dealer in artist's supplies who was to become a patron of Vincent van Gogh's several years later. Murer offered inexpensive dinners, but if one of his guests was unable to pay for his meal, he would extend credit toward the acquisition of paintings. In this way, Murer assembled a remarkable collection that included at least fifteen Renoirs.

Frequently Renoir received visitors at his studio late in the afternoons. From there they would often go the Café de la Nouvelle-Athènes, where writers joined in their discussions. This circle of friends and acquaintances was vital for Renoir in order to find patrons and obtain commissions. Often—and this was no less important—his friends would serve as models.

From April 15 until May 15, 1874, the first Impressionist exhibition of the newly founded Society of Painters, Draftsmen, Sculptors, and Engravers, of which Renoir was one of its founding members, was held at the studio of the photographer Nadar on the Boulevard des Capucines. A total of thirty-nine artists took part, including Cézanne, Degas, Monet, Pissarro, and Sisley, to name but the most important figures. There was no unified program nor a formal organization or requirement. Over the following years the membership was in constant flux, as was the style of the works. Renoir exhibited several paintings, among them *The Theater Box*

(La Loge). A couple is seated in a theater box attending a performance, from which the viewer, however, is completely excluded. The sensuousness of the woman's presence, her elegant striped dress and beautifully painted face, make this one of the most successful works of Renoir's entire career. Although Impressionist precepts excluded the use of black or brown in the shadows, here Renoir has made black the dominant color. Yet, combined with gold and pink, it has taken on a regal quality of extraordinary refinement. The model for the woman here was named Nini Lopez, known as

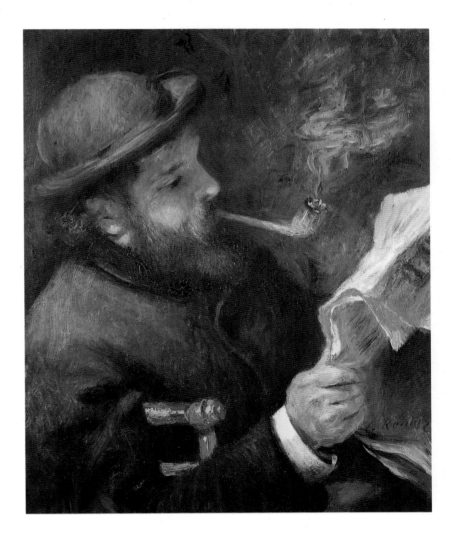

Claude Monet Painting in his Garden at Argenteuil

detail; 1873; Hartford, Connecticut,
Wadsworth Atheneum.
Renoir painted his friend Claude Monet at least three times. Here he is shown at work outdoors in his garden. The descriptive details are evidence of the artist's working practice.

Claude Monet Reading

1872; *oil on canvas;* 24 x 19 5/8 in. (61 x 50 cm.).
Paris, Musée Marmottan.
The artist Claude Monet is shown smoking a pipe while reading a newspaper or a pamphlet. His head slightly inclined, he is leaning over the back of a chair which is visible in the triangle formed by his upper and lower right arm. Renoir's Impressionistic brushwork can be seen as an homage to his friend Monet.

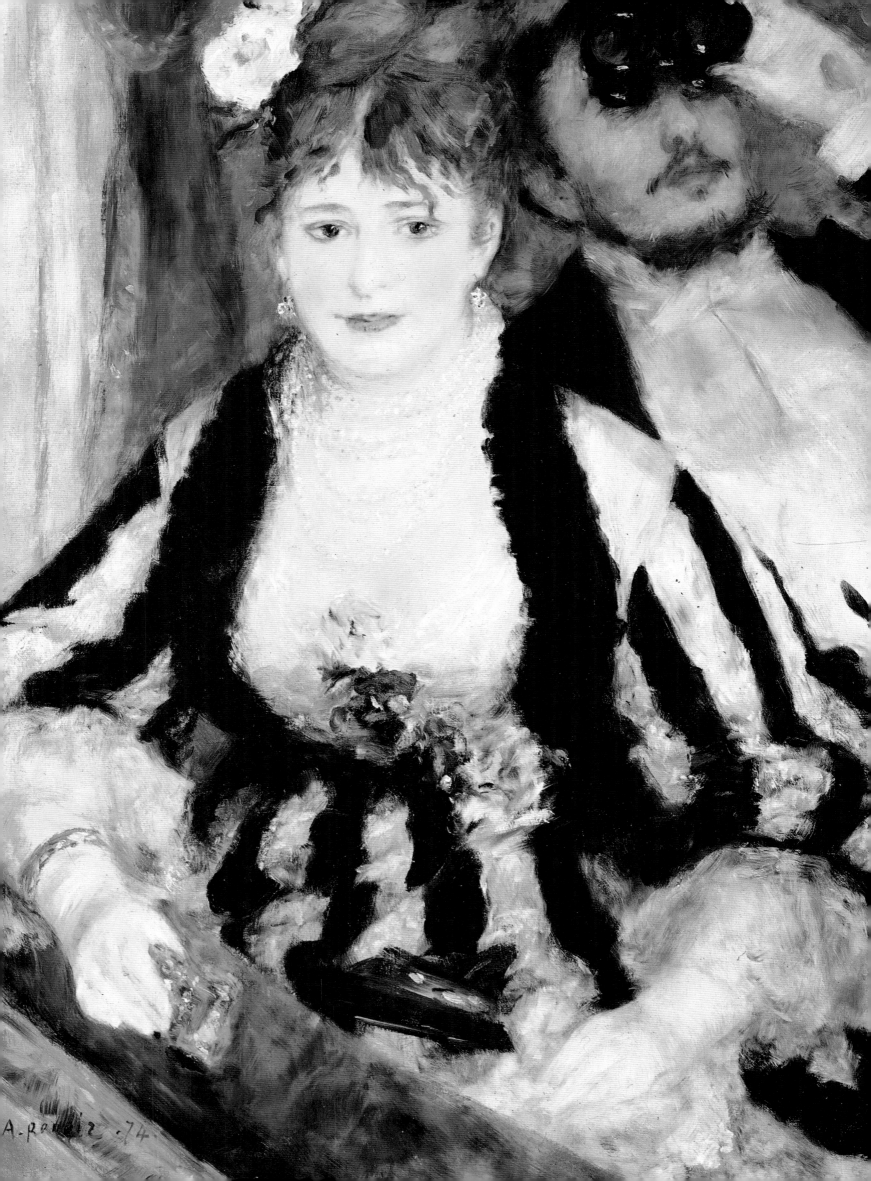

"*Geule de Raie*" (Fish Mouth), who posed together with Renoir's brother Edmond, who had by then become a journalist.

Although the exhibition had strengthened the artists' bonds and made their cause public, the results of the show were meager. Less than 1 percent of the number of visitors to the Salon had come to see the Impressionist works during the same time span, and the show ended with a sizable deficit. What was worse was the worldwide economic crisis starting in 1874, which lasted for the next three years. Renoir was in the direst financial straits of his entire career. Durand-Ruel had to close his gallery in London and drastically limit his purchase of new canvases. Frequently Renoir had to ask his friends to lend him money. In a note to his friend Duret he once wrote: "I am in trouble this morning for 40 francs, which I do not have. Do you have them or a part? I'll make up the rest by asking other people. But I must find 40 francs before noon and I have exactly 3 francs. Greetings. Renoir."

A painting auction was held in order to raise money after the debacle of the Impressionist exhibition. The results were disastrous, especially for Renoir's paintings, which sold for less than those of any other artist. Ten canvases were practically given away for from fifty to ninety francs. One new buyer, however, purchased three of his works and subsequently became one of the most important patron's of Renoir's entire career. His name

was Georges Charpentier. Five years younger than Renoir, Charpentier had inherited a large publishing house in 1871. He lived in a luxurious town house, where his wife Marguerite held a famous salon which was considered an elite literary, artistic, and political gathering place. Renoir soon became a regular guest at their house and was commissioned a number of paintings over the next several years.

The Second Impressionist Exhibition

A second Impressionist show opened in April 1876 at Durand-Ruel's gallery. This time Renoir exhibited more portrait paintings with which he hoped to find more clients willing to invest their money in his works. Despite several positive or neutral reviews in the press, the barrage of negative critiques was overwhelming. Renoir's *Study: Torso, Sunlight Effect*, for example, was described by one critic as a mass of decomposing flesh. Yet others tried to prove that the Impressionists were revolutionaries in politics as well as in art. In the future, Renoir was to be particularly vigilant not be seen as a radical political artist since this would mean the loss of potential clients of the upper classes.

In 1875, Renoir had begun to work on his most ambitious and original genre painting, *Ball at the Moulin de la Galette*. The painting was to be large and the artist made numerous studies and preparatory sketches. In order to catch the atmosphere directly on the spot, Renoir

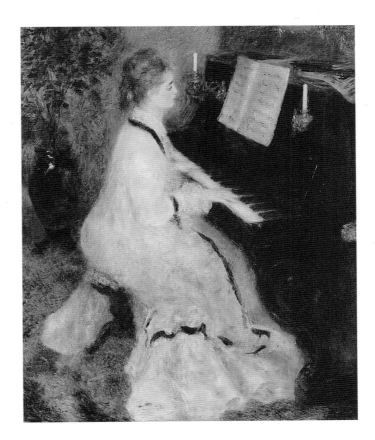

Woman at the Piano

1875; *oil on canvas*; 36 1/2 x 29 in. (93 x 74 cm.).
Chicago, The Art Institute.
This painting represents the first phase of Renoir's mature style and was shown in the second Impressionist exhibition, in 1876. A loose but carefully plotted brushwork is accompanied by Renoir's peculiar technique of allowing the white ground of the primed canvas to show through the paint. Light and joy are the dominant characteristics of this charming work.

The Theater Box (La Loge)

1874; *oil on canvas*; 31 1/2 x 25 1/4 in. (80 x 64 cm.).
London, The Courtauld Institute Galleries.
The theater box was a popular subject among Parisian artists, the theater being an important part of public life at that time. The exquisite rendering of the woman's face, her black-and-white-striped gown, the white gloves, and the precious pearl necklace all contribute in making her a figure from the world of elegant society. The artist's brother Edmond Renoir posed for her male companion.

rented a house near the popular dance hall in Montmartre for a full year and a half. With the help of his friends he carried almost daily smaller preparatory canvases from the studio to the hall. The largest and final version was too unwieldy to move easily so Renoir's friends posed for him in the garden of the studio at the rue Cortot. Georges Rivière recalled later: "Estelle, sister of Jeanne, who is seen in the foreground, is sitting on the garden bench; Lamy, Goenuette [two painters], and myself are sitting at a table on which are glasses of grenadine. There were also Gervex, Cordey, Lestringuez, Lhote [all artists], and others who appear as dancers. Finally, in the center of the picture, wearing 'Merd'Oye' trousers is a Cuban painter called Pedro Vidal de Solares y Càrdenas dancing with Margot [a model]." Rivière published an article about this work, which was probably sanctioned by Renoir himself. He described the painting as a sunlit garden filled with charming young girls of fifteen years in their homemade dresses and young men full of gaiety. The noisy atmosphere of a chatting and laughing crowd has been captured by the artist as a moment of particularly Parisian life.

This painting together with a related work, *The Swing*, was exhibited in 1877 at the third Impressionist show. Both were bought by the wealthy painter and collector Gustave Caillebotte, who became an intimate friend of Renoir's. Caillebotte and Renoir had been instrumental in organizing the show, which was called "Exposition des Impressionistes," adopting the derisive remark from 1874 and acknowledging the common bond among the participating artists. They even put out a newspaper called *L'Impressionisme* in order to promote their cause and to defend themselves from the aggressive attacks of the conservative press. But as in the two prior Impressionist shows, the outcome of their enterprise was less than modest.

At age thirty-six, Renoir found himself deadlocked in nearly every direction. Unable to support himself through sale of his paintings, he decided to look for potential new clients. He even tried, unsuccessfully, to obtain a commission from the state for decorative mural paintings. Soon Renoir would abandon the pure line of Impressionism, turning back toward more classical traditions.

Barges on the Seine River
1869; *oil on canvas;*
18 x 25 1/4 in. (46 x 64 cm.).
Paris, Musée d'Orsay.
Barges are lined up on the Seine, echoing the bend of the river near the horizon. The artist chose an elevated viewpoint for this scene, with grass and shrubs filling the foreground. It is one of Renoir's earliest landscapes without figures.

A Girl with a Watering-Can
detail; 1876; Washington, D.C., National Gallery of Art, Chester Dale Collection.
Renoir frequently painted portraits of little girls with great charm and sympathy. Although he sometimes repeated a certain representational type, he always imbued the sitters' faces with an expression of authentic feeling.

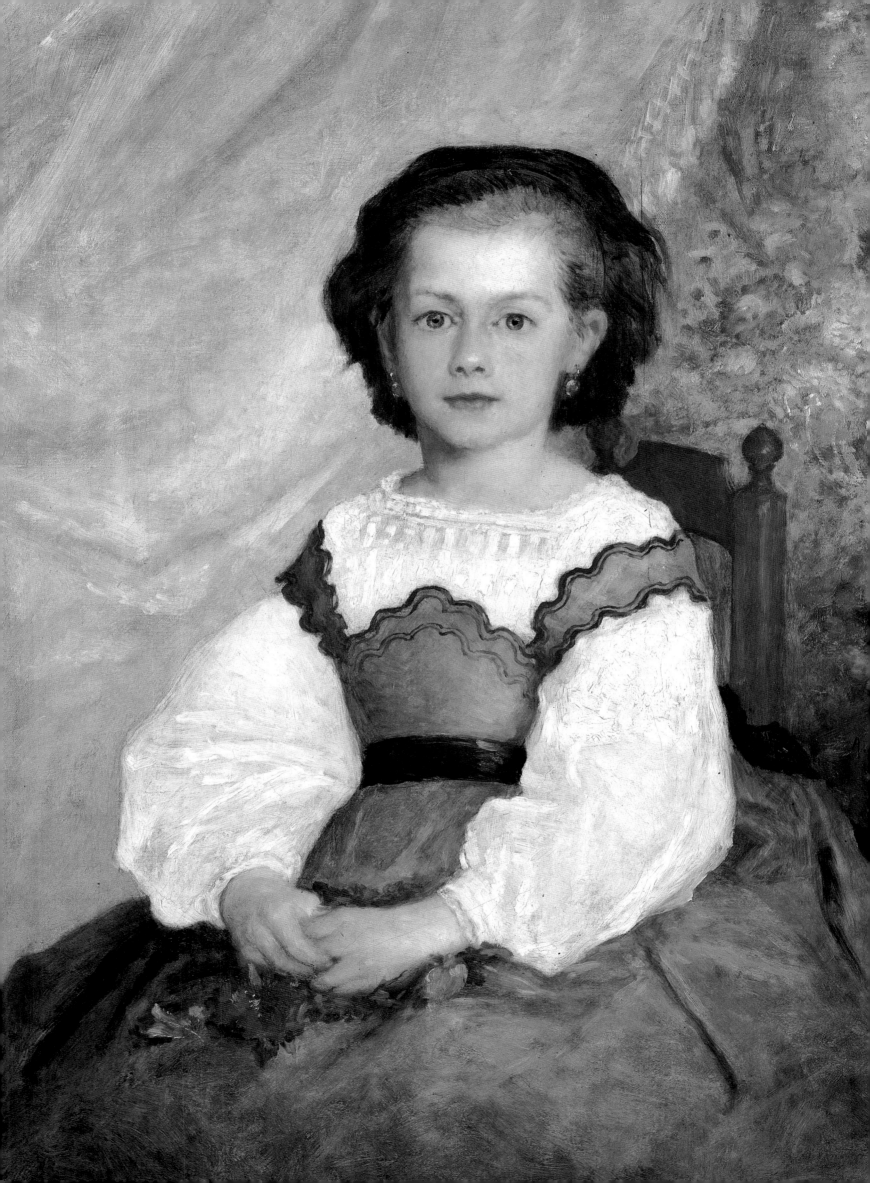

Lise with Umbrella

1867; *oil on canvas;*
72 1/2 x 45 1/4 in.
(184 x 115 cm.).
Essen, Folkwang Museum.
*The life-size figure shows
the model Lise Tréhot,
whom the artist painted
during the summer of
1867 in the forest at
Chailly-en-Biére, near
Paris. The calm pose
and the white dress under-
score the monumental
quality of this work, which
was shown at the Paris
Salon the following year.*

Romaine Lascaux

1864; *oil on canvas;*
31 7/8 x 25 5/8 in.
(81 x 65 cm.).
Cleveland, Ohio,
Museum of Art.
*The colors in this portrait
are as crisp and precious
as enamel. The classical
frontal pose and the joined
hands resting on the
girl's lap were derived
from portraits by Diego
Velázquez and Ingres.
The painting is one of the
artist's earliest commis-
sioned works and one the
many portraits of children
that were to follow.*

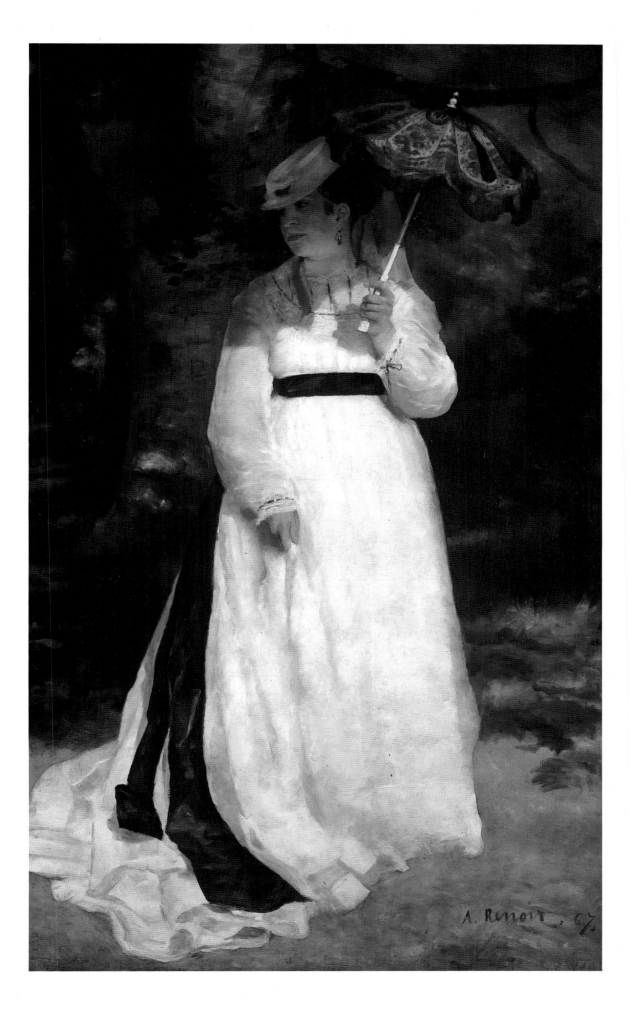

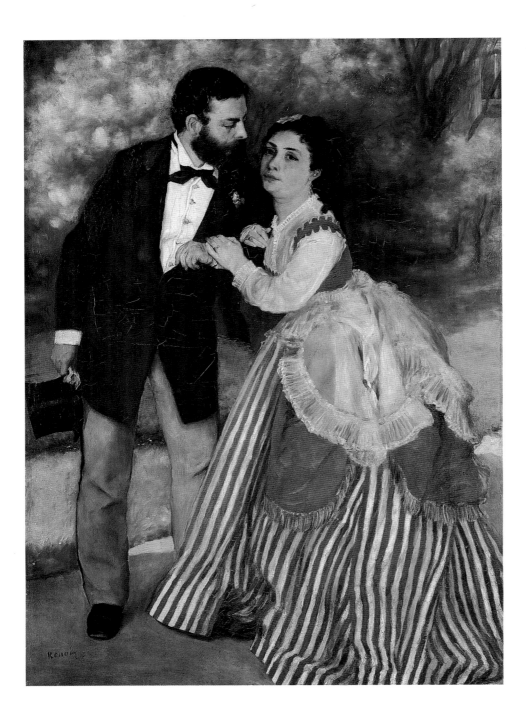

Portrait of Alfred and Marie Sisley

1868; *oil on canvas*; 41 3/8 x 29 1/2 in. (105 x 75 cm.).
Cologne, Wallraf-Richartz Museum.

Renoir portrayed his friend, painter Alfred Sisley
and his wife Marie with an expression of intimate
familiarity. The husband, offering his arm, is facing
his wife as if he is just about to propose something
to her. Marie, dressed in an elegant dress of refreshing
colors, appears to be oblivious to her partner.

Study, Summer

1868; *Oil on canvas*; 33 1/2 x 24 1/2 in. (29 x 22 cm.).
Berlin, Neue Nationalgalerie

Renoir submitted this painting to the Salon of 1869,
but called it cautiously a 'study' as to apologize for
the sketchy execution of the background. Lise Tréhot
sat as the model, whose thinly veiled eroticism and
seductive pose conformed to the dominating taste of the
official art market. The work shows a certain influence
of paintings by Renoir's friend Frederic Bazille.

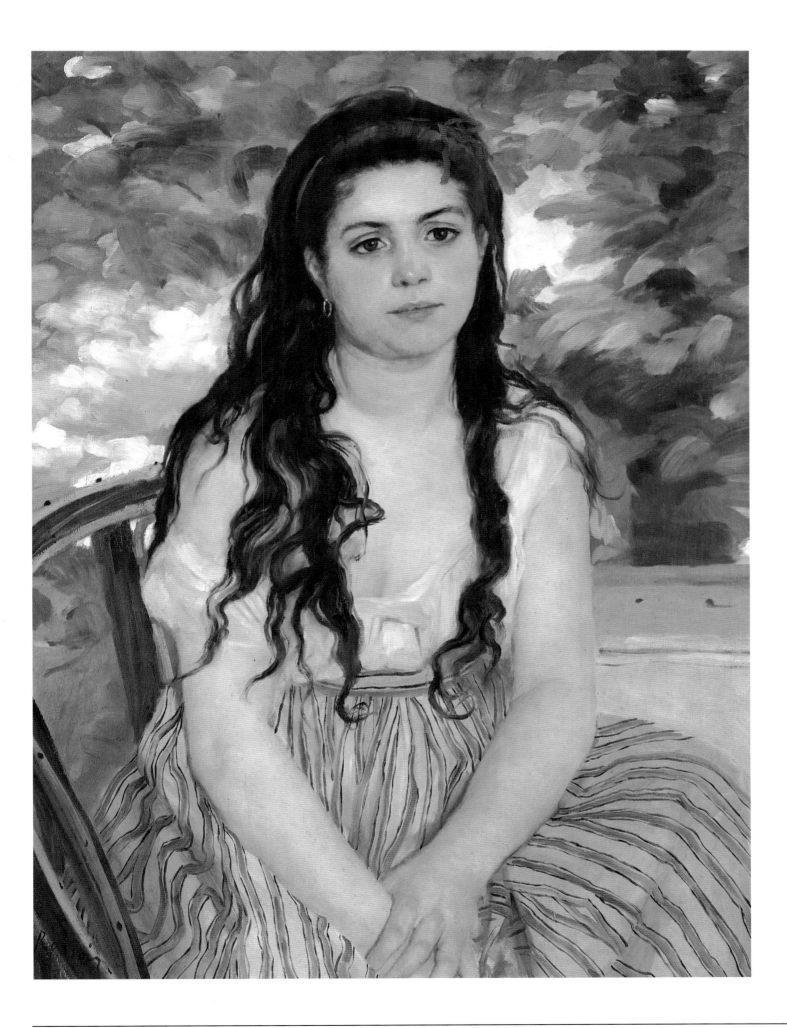

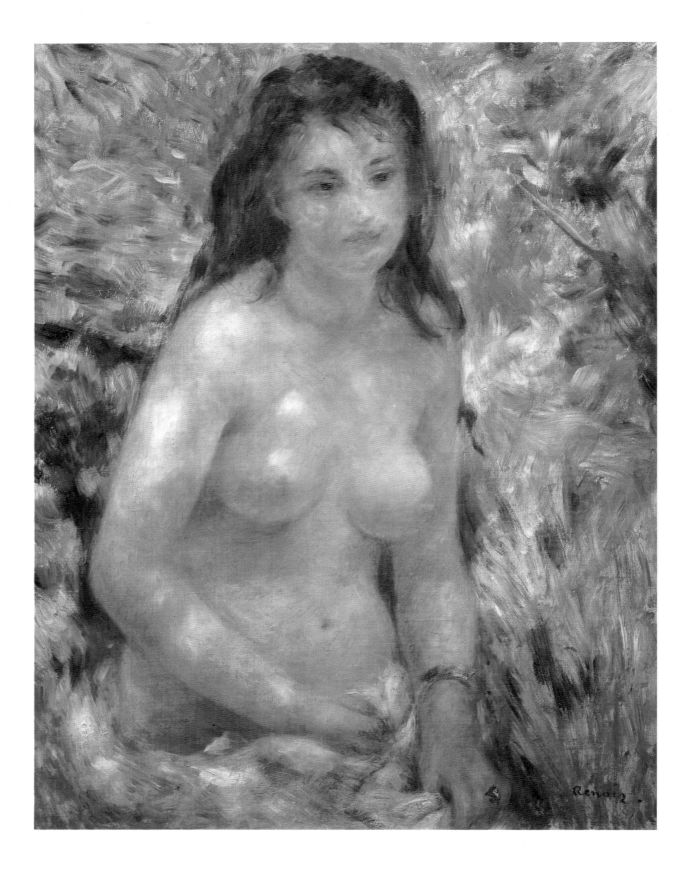

Study: Torso, Sunlight Effect
c. 1876; *oil on canvas*; 31 1/2 x 25 1/4 in. (80 x 64 cm.). Paris, Musée d'Orsay.
A young girl emerges from the sun-struck verdant landscape like a flourishing Venus. Her body is treated with brushstrokes of light and color similar to those in the background, thus melting totally into the surrounding space. The model was Alma Henriette Leboeuf, called Anna, who was nineteen at the time of this painting.

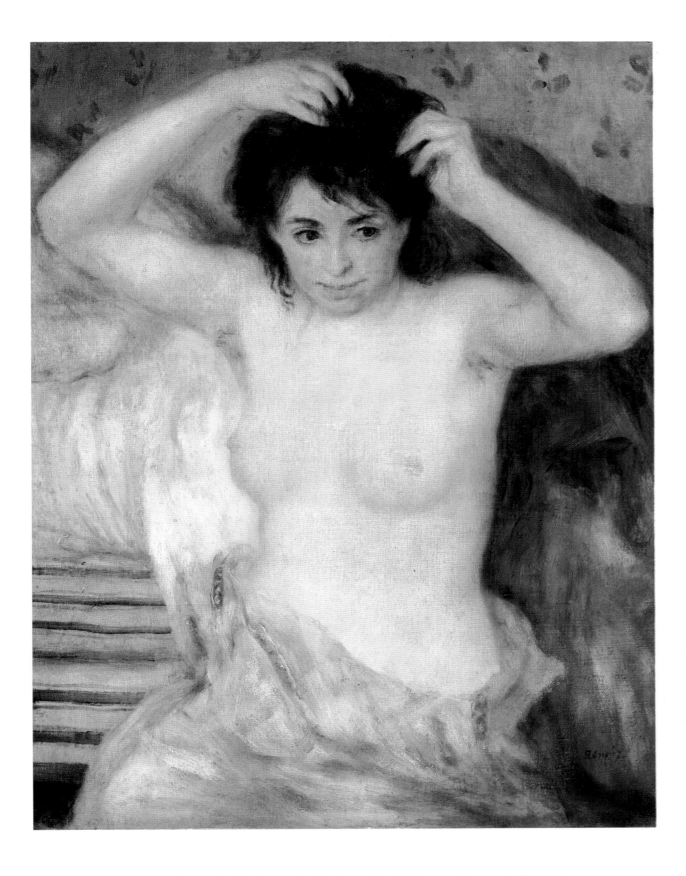

Torso, also called Before the Bath or The Toilette (Buste de femme)

c. 1873-1875; *Oil on canvas*; 32 1/8 x 24 3/4 in. (81.5 x 63 cm.). Merion, Pennsylvania, The Barnes Foundation

Compared to "Study: Torso, Sunlight Effect" of 1876, the present work is more intimate, but marked by a similar direct sensuality. The fine modeling of the flesh and physiognomic detail, executed with a firm yet fluid handling of paint, underline the individuality of the unknown sitter.

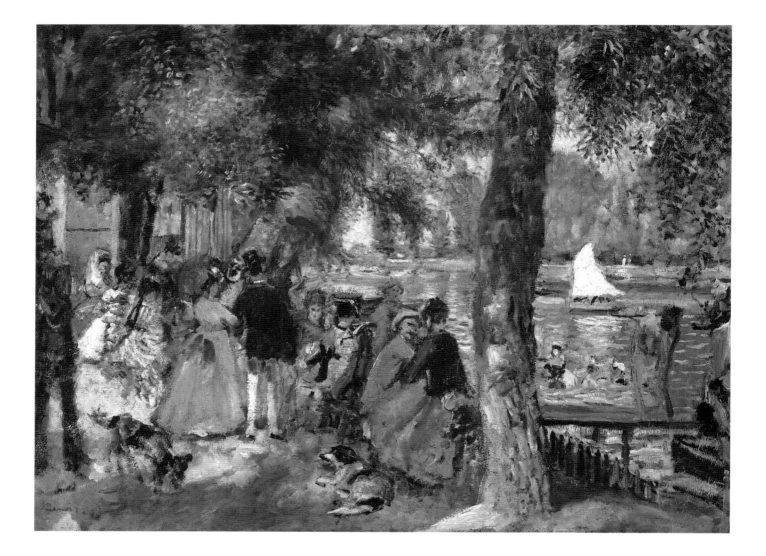

La Grenouillière

1869; *oil on canvas;* 23 1/4 x 31 1/2 in. (59 x 80 cm.).
St. Petersburg, Hermitage.
This work was done side by side with Claude Monet,
who painted the same scene of the island of Croissy in the
Seine River between Bougival and Argenteuil. The location
offered Parisians relaxation during Sunday excursions.
The color dabs seem to recreate the reflections of the water.

La Promenade

1870; *oil on canvas;* 31 7/8 x 25 1/2 in. (81 x 65 cm.).
Malibu, California, The J. Paul Getty Museum.
The attitude of the couple is comparable to that of
the Sisleys, although the result is a more compressed
composition. Bowing slightly forward, the man offers
his arm to the woman to help her climb the slope. Her
figure in a superb white dress appears in full sunlight
while the man's face is overshadowed by the tree and a hat.

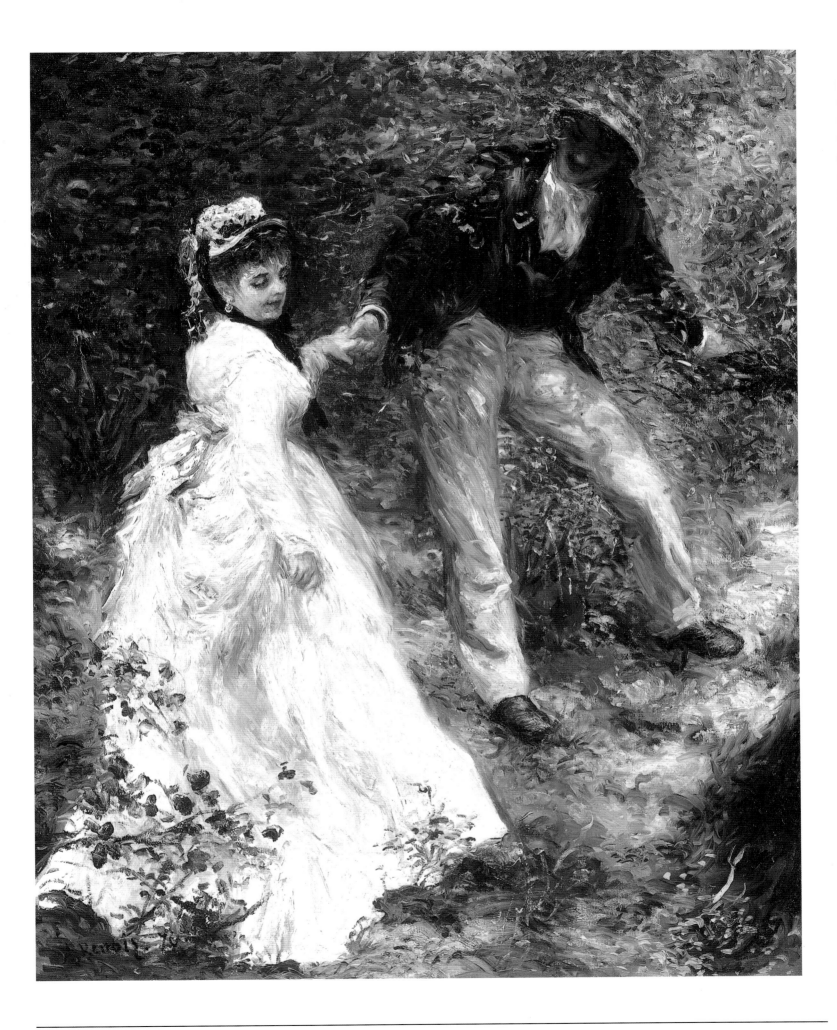

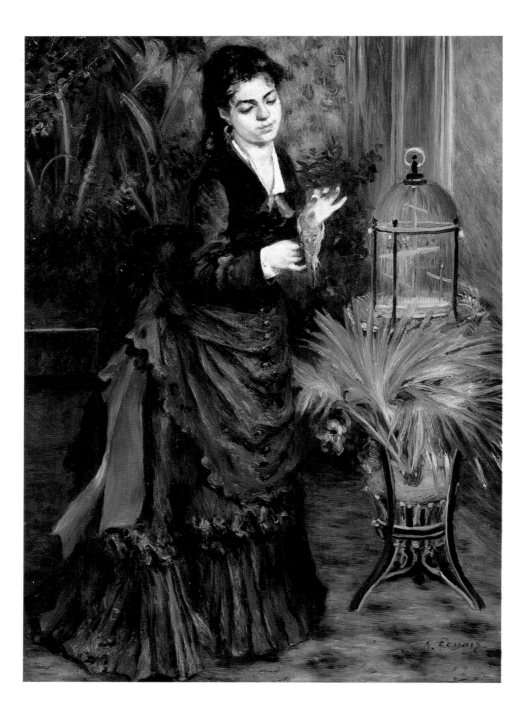

Woman with Parrot

1871; *oil on canvas;* 35 7/8 x 25 1/2 in. (91 x 65 cm.).
New York, Solomon R. Guggenheim Museum.
Renoir presents a very personal relationship
between the woman and her pet bird. We might
assume that she is talking to it while trying to feed it.
The opulent setting is reflected in the choice of the
woman's rich satin dress accentuated by a red sash.

A Girl with a Watering-Can

1876; *oil on canvas;* 39 1/2 x 28 3/4 in. (100 x 73 cm.).
Washington, D.C., National Gallery of Art, Chester Dale Collection.
The bright blue dress with white laces and the red ribbon
on the girl's head contrast effectively with the surrounding
garden of flowers. The scene is depicted from a low per-
spective, thus allowing the viewer to share the same
outlook on nature as the young protagonist. In its spon-
taneity and gaiety, this scene evokes memories of childhood.

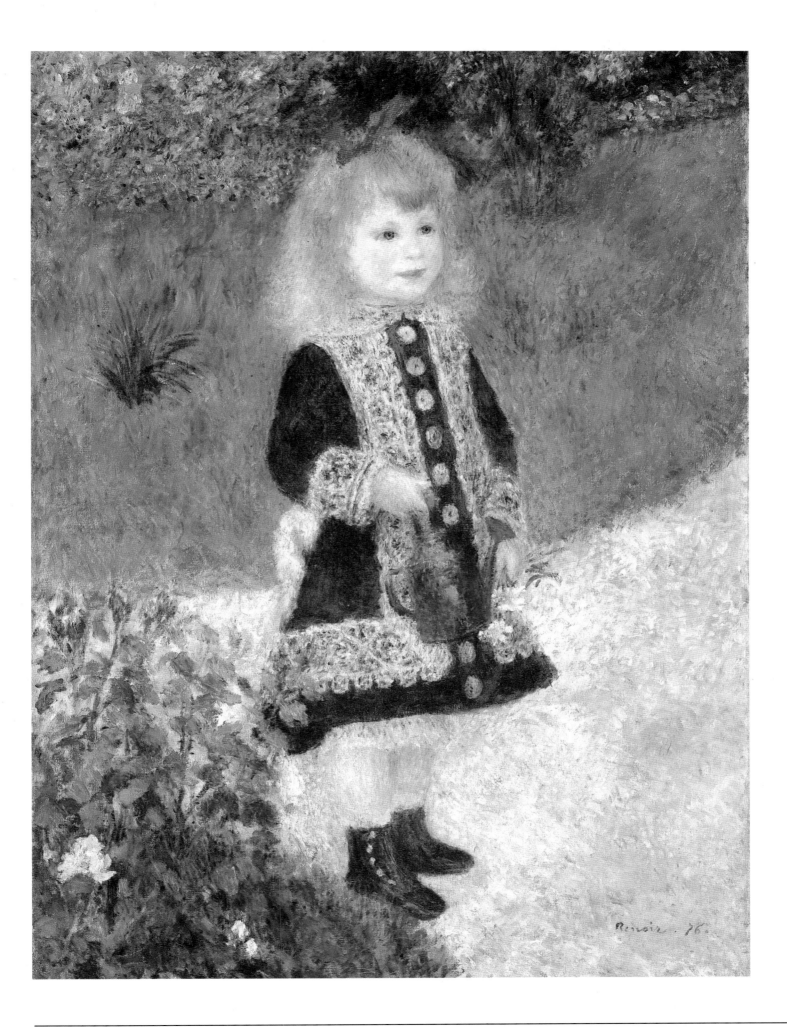

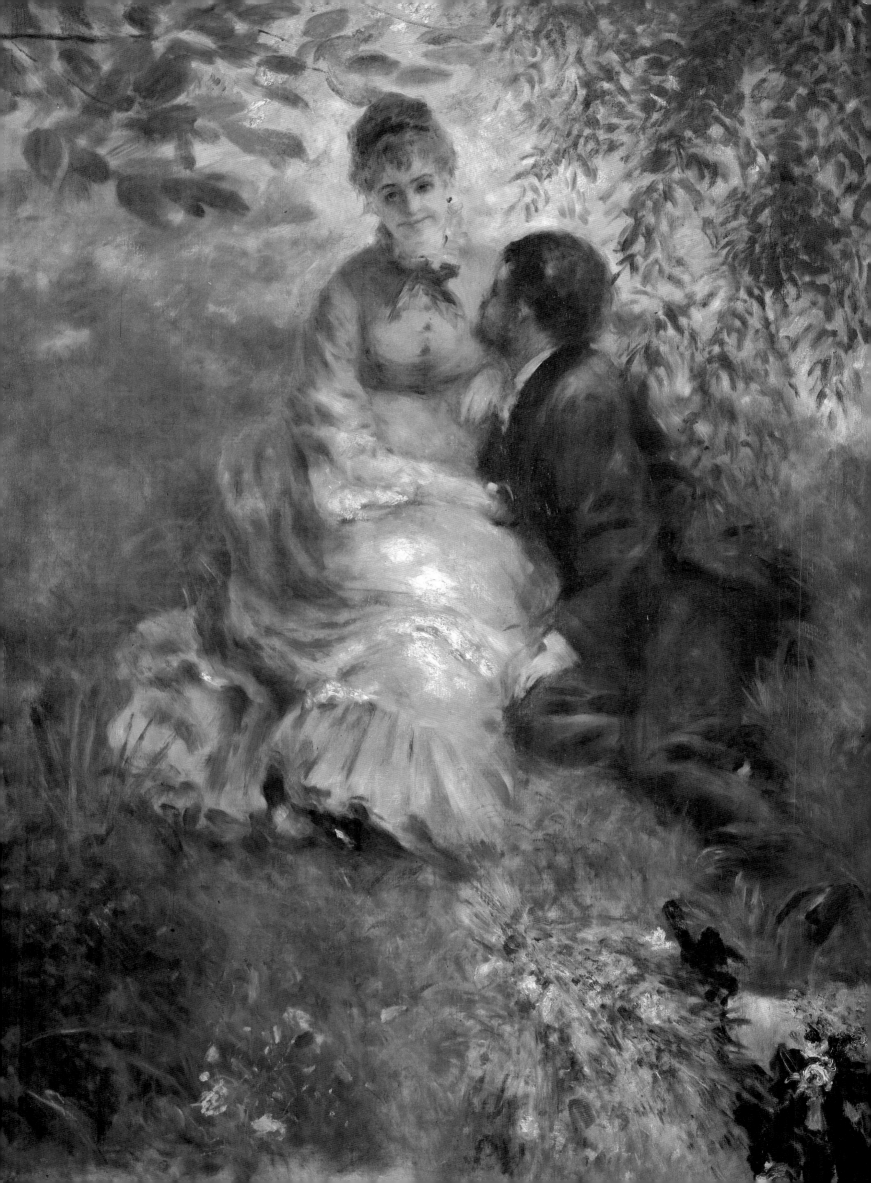

CHAPTER 2

OUTDOOR PAINTING AND STILL-LIFES

Throughout his career Renoir painted portraits of friends, patrons, his wife and children, and also of models. In particular during his earlier years he saw portraiture as a source of income. Indeed, commissions for portraits of members of the upper bourgeoisie helped Renoir to make his living since selling his impressionistic landscapes or genre scenes proved to be very difficult. Conforming to the more conservative taste of most of his patrons, Renoir usually chose a more academic and restrained style for his portraits. This was true even moreso when he painted a work he intended to submit to the Salon, anticipating strong resistance toward avantgarde work.

In the fall of 1871, Jules Le Coeur introduced Renoir to Captain Paul Darras, who asked him to paint portraits of himself and his wife Henriette. With the money from this commission, Renoir was able to rent his first studio, on the Right Bank near the Louvre and south of the Café Guerbois. His friend Monet took a studio shortly thereafter not far away near the Gare St.-Lazare. Thus the death of Frédéric Bazille, which had left Renoir literally homeless besides losing his closest friend, was now at least partially compensated. Slowly, following the war, the artistic and intellectual life of Paris began once again to resume.

For the Salon of 1873, Renoir prepared a large canvas in a more conservative style. *Riders in the Bois de Boulogne* features Henriette Darras on horseback accompanied by a young boy, Joseph Le Coeur, the son of Charles. Dressed in a black costume with a kind of top-hat and a veil, Henriette keeps her body straight while offering the viewer a cool and aloof glance. Her gloved hand holds a whip. Her entire persona demands respect and even the

horse expresses majesty and noblesse in its controlled movements. The only sign of distraction is a red rose placed on Henriette's chest. She seems to be unaware of the young boy at her side, who is looking in admiration at her horse. He has pink cheeks and red lips, wears an ochre jacket with a neck-tie, called *"Lavallière,"* and a small black hat.

Both figures and the horses are rendered with a smooth, finished surface, while the landscape of the Bois de Boulogne (in the outskirts of Paris) is rather sketched in as not to distract from the sitters. The predominance of brown, ocher, and black gives a very

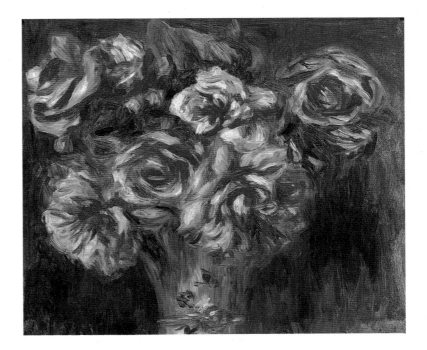

The Lovers

1875; *oil on canvas*; 68 7/8 x 51 1/4 in. (175 x 130 cm.).
Prague, Narodni Gallery.
Shielded from the bright sunlight, a couple is sitting in the shadow under a tree. The man's amorous advances are indicated by his kneeling position and the two bouquets of flowers—one a freshly picked bunch of wild poppies and wild herbs and the other a group of cultivated flowers wrapped in paper.

Moss Roses

c. 1890, *Oil on canvas*; 14 x 10 5/8 in. (35.5 x 27 cm.).
Paris, Musée d'Orsay
Pure still Lifes are relatively rare in Renoir's oeuvre, but when he painted them, he dedicated the same diligence and attention to such works as he did to his figure paintings. The fragile texture of the moss roses has been rendered with a soft brushwork, modelling each flower individually, and imbuing them with a life of their own.

different result from the bright impressionistic outdoor scenes painted at Grenouillière three years earlier. Only the blue of the pond in the background, where some figures seem to be playing with dogs, reveals Renoir as an Impressionist. The horses, figures, and the background were painted at various times, but not outdoors in natural light. Indeed, Renoir made studies of horses in a riding school, perhaps in order to achieve a more academic touch. His hopes, however, were not fulfilled. The jury of the Salon rejected the painting, which was then hung at the Salon des Refusés that year. Despite some negative criticism ("improbable horsewoman, impossible horses"), the work was soon purchased by Henri Rouart, an industrialist and collector, who was a friend of Degas's.

Renoir's landscapes and outdoor scenes are rarely without figures, very much unlike the paintings of his Impressionist friends, in particular of Monet. In *The Lovers* (1875), Renoir depicts a couple sitting under a tree on the grass. The foliage filters out the harsher sunlight. Two bouquets of flowers, one of freshly picked country wildflowers, the other brought from the city and still wrapped in paper, serve to stress the juxtaposition of

the sexes. The focus of attention is the amorous proposal of the young man, while his mistress listens smiling to his words. The woman was Margot (Marguerite) Legrand, who became one of Renoir's favorite models over the next years. His strong reaction at her untimely death in 1879 suggests that they might have been lovers. It is quite possible that the artist depicted here his own amorous life, since the subject of couples appears more frequently during these years.

Path in the High Grass (1874) is a quintessential summer landscape. In the flickering atmosphere of a hot afternoon, women carry their parasols through an almost invisible path among yellow, dry grass. The setting is reminiscent of Claude Monet's poppy field. In September 1876, Renoir was invited to paint the portrait of the writer Alphonse Daudet's wife in Champrosay, where they spent several weeks at their house. There, Renoir took the occasion to paint a light- and windswept view of the Seine in blue and gold tones. The quick brushwork and the sketchy quality of the work reveal its rapid execution out-of-doors.

Two smaller paintings, executed the same year, are closely linked to his masterpiece, *Ball at the Moulin de la Galette. The Pergola* shows the same location, featuring some of Renoir's friends sitting under a tree with a glass of wine. A similarly informal gathering is seen in *The Swing*, which was painted in the garden of Renoir's

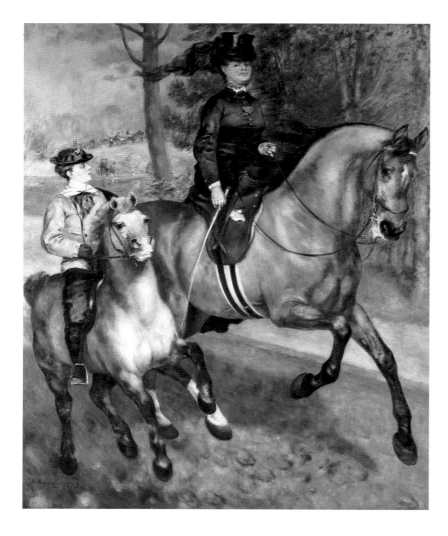

Riders in the Bois de Boulogne
1872-1873; *oil on canvas*; 102 3/4 x 89 in. (261 x 226 cm.).
Hamburg, Kunsthalle.
A proud woman—in the French tradition also called an amazon—is riding on horseback in the Bois de Boulogne, in the outskirts of Paris, accompanied by an adolescent boy. The painting expresses a cool nobility underscored by the woman's aloof gaze, her black dress, and by pale-green and bluish colors.

The Pergola
1876; *oil on canvas*; 31 3/4 x 25 1/2 in. (81 x 65 cm.).
Moscow, Pushkin Museum of Fine Arts.
The human figures here are nearly fused into the natural scene surrounding them. The woman, seen from the back, introduces the viewer to the group sitting at a table covered with glasses and drinks. The scene takes place at the garden café called Moulin de la Galette, and is a prelude to Renoir's more ambitious painting known by that title.

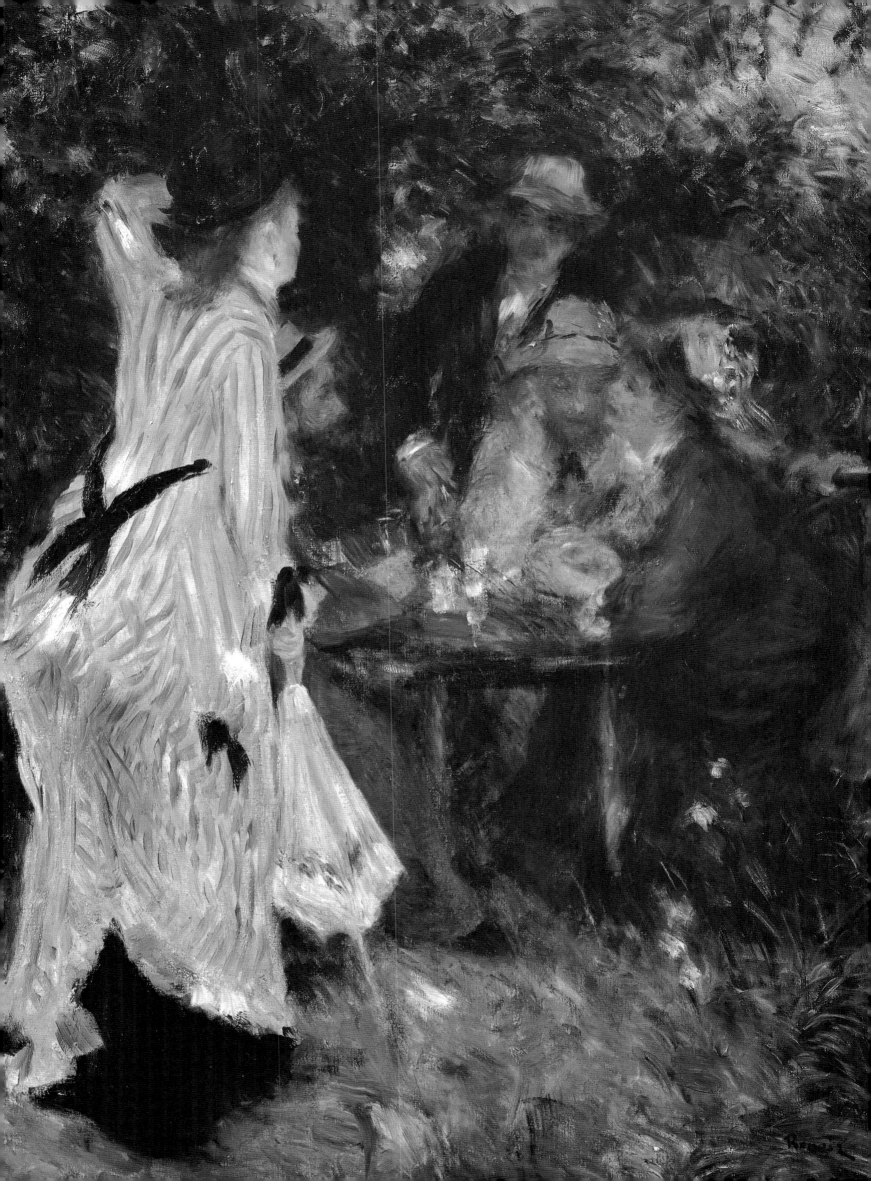

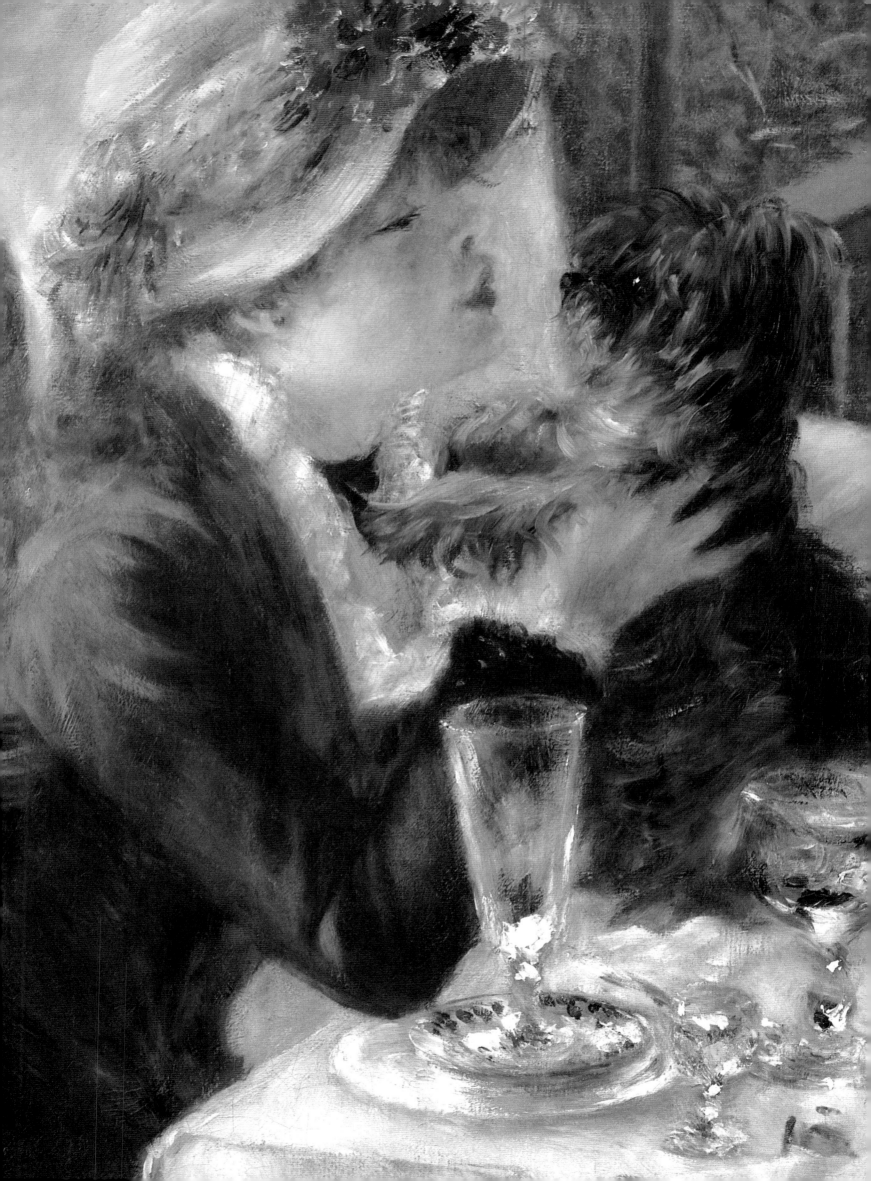

studio at Montmartre. The predominance of the blue color and the flickering sunlight penetrating the foliage are of the same quality as in *Moulin de la Galette*. Renoir made an engraving after a pen-and-ink drawing of *The Swing* for the cover of the newspaper *L'Impressioniste*, which was published during the third Impressionist exhibition in 1877. His friend Rivière wrote an article for the paper in which he referred to Renoir's paintings in the show. Encouraging young women to commission portraits of themselves he wrote: "You attended, Madame, the exhibition of the Impressionists, you saw there paintings full of sunlight and gaiety, and since you are young and pretty, you found the paintings to your taste, you saw these portraits of women, I am too gallant to insinuate that they are flattering, but after all they are very pretty, at least in your opinion, and you would like to have in your own home a ravishing portrait in which the charm that floods your dear person would be found."

Impressionism *En-Plein-Air*

In 1879 Renoir began to focus on outdoor scenes of outings, luncheons, and depictions of people relaxing. In *The End of Lunch* he showed a group of people seated around a table at the end of their meal. Coffee cups and dessert plates have been placed on top of each other, the man on the right lighting a cigarette and the woman on the left holding a glass of liqueur. None of the three is looking straight out of the picture and they seem to have interrupted their conversation only momentarily. The still-life of glasses, cups, and carafes displayed upon the table is a masterpiece. The arabesque motif of flowers on the chinaware brings to mind Renoir's early beginnings in the Lévy brothers' porcelain factory. The woman wearing a beautifully painted white gown, a white hat with purple flowers, earrings, and jewelry is the actress Ellen Andrée; the man was modeled after Renoir's brother Edmond; the woman in black has not been identified. Rather than being portraits of specific people, however, the figures represent a certain type of fashionable Parisian observed during an outdoor lunch in the outskirts of the city. The close-up view of the scene does not allow the viewer to identify the locale, and one can only assume that it takes place on a terrace, possibly overlooking a river.

Luncheon of a Boating Party

detail; 1881; Washington, D.C., The Phillips Collection.
In this group portrait of his friends "Luncheon of a Boating Party", Renoir included his mistress and future wife Aline Charigot, seen here playing with a dog.

The Rowers' Lunch

1880; *oil on canvas*; 21 1/4 x 25 1/2 in. (55.1 x 65.9 cm.).
Chicago, The Art Institute.
The island of Chatou on the Seine offered Renoir many motifs of Parisians relaxing and dining during their weekend outings. Here rowers are sitting on the terrace of a restaurant overlooking the river. The subject was epitomized in the large canvas Luncheon of a Boating Party, *but here the colors—in particular the yellow and the white—are almost ethereal.*

When Renoir and Monet painted their views of Grenouillière about ten years earlier, the artists might not have imagined that this spot and its surroundings would assume such a prominence in their works. Between 1879 and 1881, Renoir painted the Seine near the island of Chatou numerous times, celebrating the sun-drenched landscape but focusing even moreso on the people and their various activities. In *Oarsmen at Chatou* the artist included for the first time his model and future wife Aline Charigot, who is about to embark on a rowboat in which a young man in a white shirt is waiting. Standing next to her with a straw hat and a white jacket is Edmond Renoir. The largest part of the canvas, however, is dominated by the Seine. Countless ripples on its surface reflect the bright sunlight rendered with small brushstrokes of white, blue, orange, and green. The oblique direction of the composition is balanced by the almost horizontal arrangement of the rowing boats. Details can barely be

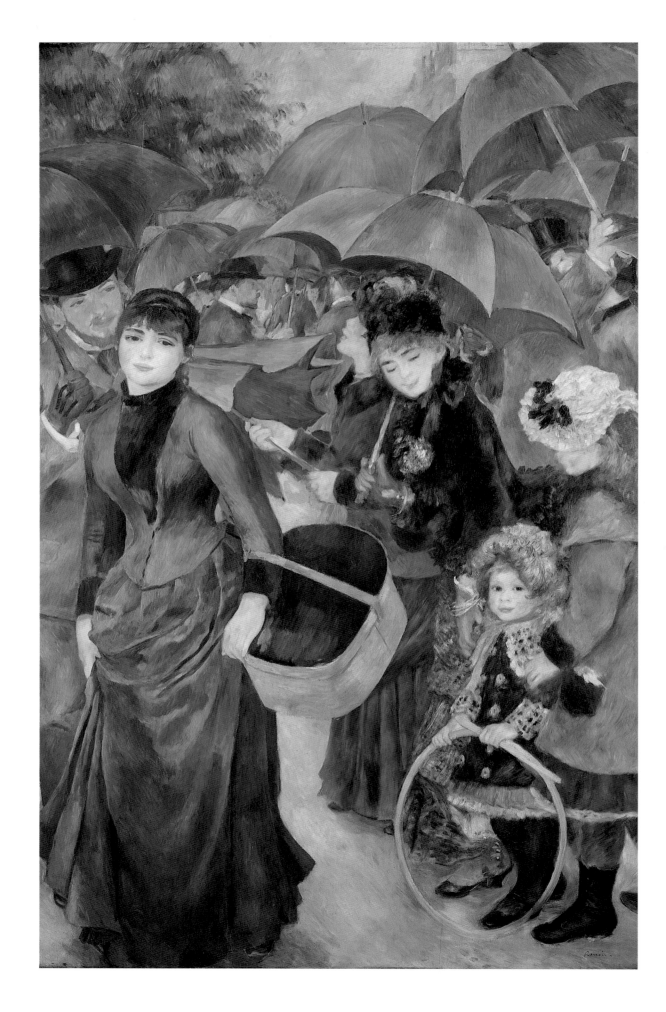

The Umbrellas
1883; *oil on canvas;*
70 7/8 x 45 1/4 in.
(180 x 115 cm.).
London, National Gallery.
*In a number of paintings
Renoir experimented
with the problematic
use of black paint, but
nowhere else is this
color more pervasive.
Admittedly, he mixed
some blue into the paint
so that it appears lively
and reflects light in
various degrees. This
tour de force is a brilliant
demonstration of the
artist as master colorist.*

made out, and even the faces of the sitters are hardly recognizable. But it is the overall atmosphere which Renoir has captured magnificently and with a truly "impressionistic" technique.

The inn of Père Alphonse Fournaise on the island of Chatou in the Seine was to become a major motif for several works. *The Rowers' Lunch* and *The Sisters* represent the terrace, from which guests would overlook the river. Protected by the green leaves of a bower from the bright sunlight, a group of rowers, recognizable by their short-sleeved cotton shirts, are gathered after their tiring activities. It is remarkable that Renoir always focused on the aftermath of an event, the moment when people relax and talk about their previous adventures while drinking a glass of wine and smoking a cigarette or pipe. Perhaps his classical training under Gleyre and his adherence to the principles of solidly arranged compositions in the academic tradition coerced Renoir to avoid the instability of fleeting moments of action.

In *The Sisters* the view over the water is open, and a few brushstrokes indicate rowers in their boats between the trees. There are even some whitewashed houses with red roofs on the other side of the bank. The older girl in a dark blue dress and a red hat is seated on the terrace in a garden chair in front of a basket of colorful fruit and vegetables. Her little sister wears a white blouse and a dark blue hat with various flowers. Except for their more refined faces, the painting has been executed with many quickly dotted spots of color. The intense colors and subtle distortions of space and scale are also evident in other works from this period.

Between mid-April and mid-July of 1881 Renoir worked on the large canvas of the *Luncheon of a Boating Party*, today housed at the Phillips Collection in Washington, D.C. It is a monumental work and one of the most successful paintings of his entire career. He had already begun it at the end of the previous summer, as he explained to his friend Paul Bérard: "I'm at Chatou . . . I'm doing a picture of boaters which I've been itching to do for a long time. I'm getting a little old. I didn't want to postpone this little party for which I wouldn't be able to meet the expenses later on, it's already very hard. I don't know if I will finish it, but I told my misfortunes to [Charles] Deudon, who agreed with me [that] even if the enormous expenses wouldn't let me finish my painting, it's still progress; one must from time to time try things beyond one's strength."

Luncheon of a Boating Party is set on the terrace of the inn of Père Fournaise, where many of Renoir's friends and models have gathered around a table after a meal. The atmosphere is gay, people are talking to each other or enjoying themselves. Seated at the table on the left is

Aline playing with a little lap dog. Standing behind her with the short-sleeved shirt of a rower and a bearded face is the owner of the restaurant, Alphonse Fournaise, who is looking over to his two children. Alphonsine Fournaise leans over the balcony listening to Baron Raoul Barbier, who is seated with his back to the viewer. Her brother Alphonse Jr. is talking to the top-hatted banker and collector Charles Ephrussi. Straddled on a chair in the front with a cigarette in his right hand is the painter Gustave Caillebotte. Ellen Andrée, who had modeled for *The Lunch* two years earlier, sits to his right, while the Italian journalist Maggiolo leans over her. The group behind them features Paul Lhote with a pince-nez, Eugène-Pierre Lestringuez, and the actress Jeanne Samary, whom Renoir also portrayed individually. The girl at the center, the model Angèle, is drinking wine with a man seen only in profile. The exquisite rendering of the still-life on the table is equally important to the rendering of the sitters's dresses. The colors blue, red, and yellow complement each other in a variety of shades. Beyond the terrace are reeds and willows

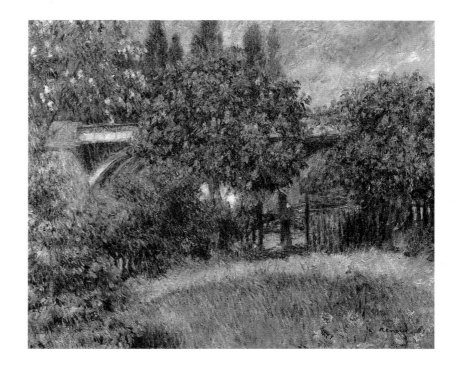

The Railway Bridge at Chatou
1881; *oil on canvas;* 21 1/4 x 25 1/2 in. (54 x 65 cm.).
Paris, Musée d'Orsay.
Modern industry appears only rarely in Renoir's oeuvre. Here he masked the presence of the railway line at Chatou, which linked the resort town with nearby Paris, by hiding the bridge behind trees. This device merges it almost completely with the surrounding environs.

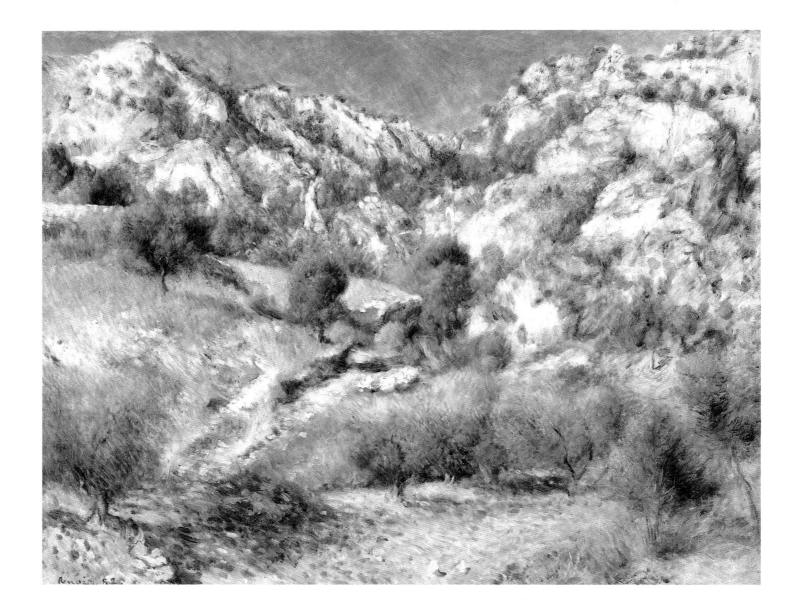

Mountains at L'Estaque

1882; *oil on canvas;*
26 1/8 x 37 7/8 in.
(66.5 x 81 cm.).
Boston, Museum of Fine Arts.
The bare, craggy mountains
set off against the spare
Mediterranean vegetation
of olive trees and shrubs were
captured at L'Estaque near
Marseilles where, on his way
back from Italy, the artist
had joined Paul Cézanne.
The paths at the center seem
to disappear in the thicket
of untouched wild nature.

along the river with rowing and sailing boats.

Like *Ball at the Moulin de la Galette, Luncheon of a Boating Party* represents a slice of contemporary everyday life. People of the urban society mingle with people from the country. Members of the upper bourgeoisie socialize democratically with people from the lower classes. But unlike in the earlier work, *Luncheon* has fewer and more individualized figures, which are larger in scale. Additionally, their bodies are more tangible. The color scheme of the painting is no longer dominated by a single hue but is varied, even with certain high keys that Renoir would explore further in later years. Areas of white and yellow are set off against blue and red zones, thus clarifying individual structures. This is a happy, untroubled gathering of friends, which belies Renoir's difficult economic situation at the time.

At 'Grenouillère' (Woman Outdoors) is a variation of the same subject. Here a young woman, possibly the same Alphonsine Fournaise as in the boating party, is sitting by herself in front of a table on the terrace, happily smiling beneath her little red hat. *The Railway Bridge at Chatou* is a rare example wherein Renoir included an element of modern industry. The bridge, almost completely hidden by the trees, is a symbol for the accessibility of this location, which could be easily reached with a short train ride from Paris. Unlike other Impressionists, Renoir avoided depicting the discrepancy

between natural and man-made, industrial objects, be it a train or a factory. He strongly opposed, therefore, the Neo-Impressionist movement under Paul Signac's leadership.

In a late work of 1895, *Road to Louveciennes*, Renoir summed up his own view of a peaceful nature. On the sandy road a lonely horse-drawn cart proceeds slowly toward the viewer. An intense green pervades the painting, symbolizing the fertile power of nature. The road toward Louveciennes had a highly personal meaning for the artist, since his mother was still living in that town, not far from the capital.

The Artist Abroad

With the end of the 1870s a certain success and wealth allowed Renoir to make several trips to foreign countries. His first journey was to Algeria, which was a fashionable place to visit, especially for Salon artists such as Bonnat, who followed the path of Delacroix to North Africa in search of exotic subjects. Renoir hoped to explore the effects of light even further. He sought to transform his figure style by adopting stronger effects of sunlight, atmosphere, and reflection in order to express more clearly the internal feelings of his figures. Another motivation for his travel related to his age and his position in society. When he left for Algeria

Seaside at Guernsey
1883; *oil on canvas;*
20 1/4 x 24 1/4 in. (50.5 x 61.5 cm.).
Zurich, Kunsthaus.
The vastness and barrenness of the space here are unique in Renoir's oeuvre. The dark blue sea and the lighter blue of the sky are counterbalanced by the yellow sand in the foreground. Executed during a month-long stay on the Channel islands of Jersey and Guernsey in September of 1883, the artist has chosen a high vantage point on the dunes.

Chrysanthemums

1882; *oil on canvas;*
21 1/2 x 26 in. (54.7 x 65.9 cm.).
Chicago, The Art Institute.
*This autumn flower was chosen
several times by Renoir as a
painting subject. The slightly
irregular composition is fairly
complex, with the bouquet filling
the rectangular space of the canvas
almost completely. The white and
purple petals are of an astonishing
richness and subtlety, placed as
they are in a vase on a round table
covered with a white tablecloth.*

in February 1881, he was already forty years old and longed to finally be recognized as a successful artist among his friends and patrons of the upper bourgeoisie—people such as Gustave Caillebotte, the Bérards, and Charpentiers.

The first letters Renoir wrote back to Paris are reports of problems and failures. He complained of the presence of too many (and mediocre) artists in the French colony. Furthermore, he realized that the women he needed as models were difficult to meet. To Paul Bérard he confided: "Women so far are unapproachable, I don't understand their jabber and they are very fickle. I'm scared to death of starting something again and not finishing it. It's too bad, there are some pretty ones, but they don't want to pose."

Although in the end he found some models, Renoir's main achievements in Algeria were several North African landscapes. *Banana Plantations* is a celebration of the lush tropical plant. Its intense green paired with yellow and red hues is set off against the white of the city and the blue of the Mediterranean Sea in the background. About the Algerian landscape Renoir wrote to Mme. Charpentier: "One ought to see this Mitidja Plain at the gates of Algiers. I have never seen anything more sumptuous and more fertile. Normandy is poor by comparison. Incidentally, there are parts that look very much like it, a

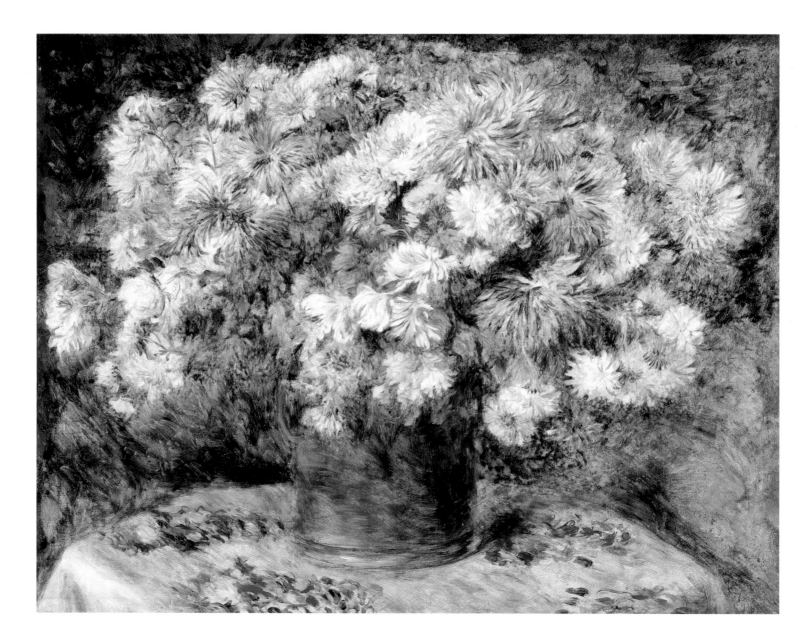

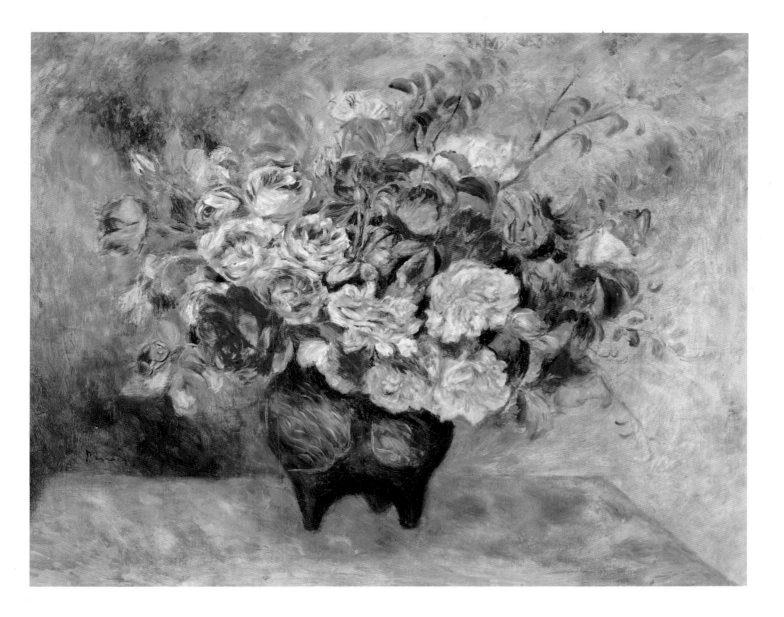

marvelous green with the mixture of prickly pear and aloes in hedges . . . and on the other side the sea, eternally cheerful and almost always blue, a sea into which one feels like diving."

Since models were hard to come by, Renoir painted a festival scene outside the city of Algiers. The precise subject of the event taking place in *The Mosque (Arab Holiday)* is not clear, and the impressionistic brushwork does not make the reading of the work any easier. However, Renoir's fascination with the swirling movements of the dancers and the people in their white and red clothes is obvious. While the dominant color in *Banana Plantations* is green, here it is brown-red and white that permeate the entire canvas.

The following year Renoir made a trip to Italy where he visited Rome, Naples, Venice, and Palermo. In Rome he was deeply impressed by Raphael's fresco cycles, and in Naples by the Roman frescoes in the Archaeological Museum. "Go see the museum in Naples," he wrote to Charles Deudon in Paris. "Not the oil paintings, but the frescoes. Spend your life there."

On his way home, he made a seemingly unprepared stop at Marseilles where he sought out Paul Cézanne, who often worked at nearby L'Estaque. Renoir had a great admiration for his older colleague, whom he considered the greatest living artist. Together the two men painted at the coast. Interestingly,

A Bouquet of Flowers

c. 1880-1882; *oil on canvas;*
21 2/4 x 26 in. (58.5 x 73.5 cm.).
Jerusalem, Israel Museum,
Renoir, who was more intrigued by the human figure or scenes from everyday life, painted only a small number of still-lifes. Most of them are of flowers in a vase. Here the petals display all their richness and subtlety in front of a neutral wall. Less vibrant than the works by Claude Monet, this still-life nevertheless bears witness to the influence of this colleague.

Near the Lake
c. 1880; *oil on canvas;*
18 x 21 2/3 in. (47.5 x 56.3 cm.).
Chicago, The Art Institute.
A couple is seated under a bower
on a terrace overlooking a river.
The location is most likely the
island of Chatou, which Renoir
painted so frequently during the
1880s. The bend of the river
might be same as in his Chestnut
Tree Blooming; *here, however,*
it is seen from its opposite end.

Fruits from the Midi
detail; 1881; Chicago,
The Art Institute.
*The artist's keen eye
caught the differences of
color and texture of various
Mediterranean fruit,
translating his observations
ably with the paintbrush
onto the canvas. The result is
a demonstration of nature's
lush and diverse products.*

Garden Scene in Brittany

c. 1886; *Oil on canvas*; 21 1/4 x 22 1/8 in. (54 x 56.2 cm.).
Merion PA, The Barnes Foundation
*In the summer of 1886 Renoir vacationed with his family
in Brittany at La-Chapelle-Saint-Briac. On the bench
sits his wife Aline knitting while the eighteen-month-old
son Pierre has turned around to a woman, who exchanges
pleasantries as she passes by. The painting conveys the
refreshing atmosphere of a life in the countryside.*

however, Renoir did not choose the same motifs of the
blue Mediterranean Sea as did Cézanne. Rather he depict-
ed the rocky crags with their spare vegetation. The color
scheme of *Mountains at L'Estaque* is decidedly toned down
compared to his Algerian experience, but the vigorous
brushstrokes imbue the scene with liveliness.

From early September until October 8, 1883, Renoir
went to the Channel islands of Jersey and Guernsey
along with Aline and his friend Paul Lhote. There he
made at least eighteen paintings, often showing children
bathing or playing on the beach. In *Seaside at Guernsey*
the scene shows an empty beach, rough water, and a
bluish-gray sky, all of an unusual barrenness and rigor.

Besides figure— and landscape painting, Renoir pro-
duced a smaller number of still-lifes, mostly of flowers or
fruit. His loose brush renders the delicate color range of
Moss Roses with great virtuosity. *Mediterranean Fruit*
(1881), with its bright colors, reflects his trip to Algeria.

The same year, Renoir painted a more muted still-life of
peaches, indulging in the velvety texture of the yellow
surface. Virtually all these still-lifes were painted with
their immediate sale in mind although, interestingly
enough, almost all of them were painted when Renoir's
career was already fairly well established. Still-lifes
clearly remained a side line in the artist's oeuvre, and he
does not seem to have mentioned them very often.

Renoir's Black Period

One peculiar work stands out among all the other
paintings in the artist's career: *The Umbrellas* (1883).
Neither a portrait nor a genre scene, this work is an
homage to the most difficult color for any painter: black.
The painting was first exhibited in New York in April
1886 and is a transitional work in which Renoir
seems to vacillate between a quick execution in the
Impressionistic manner and a more sedate linearity,
something he pursued increasingly from the mid-1880s
on. Aline modeled for the peasant woman carrying a
large, empty basket, and Lhote modeled for her admirer.
The monumentality of the solid yet luminous figures
and the simplicity of the forms are perhaps the result of
Renoir's experience with Raphael and the Pompeiian
frescoes. The most surprising element, however, is the
pervasive presence of black, albeit toned down into vari-
ous gradations of dark blues. This is the only time that
Renoir depicted a street scene, but as a slice of life it
adheres to the Impressionistic credo to show directly and
immediately what is presented to the painter's eyes.

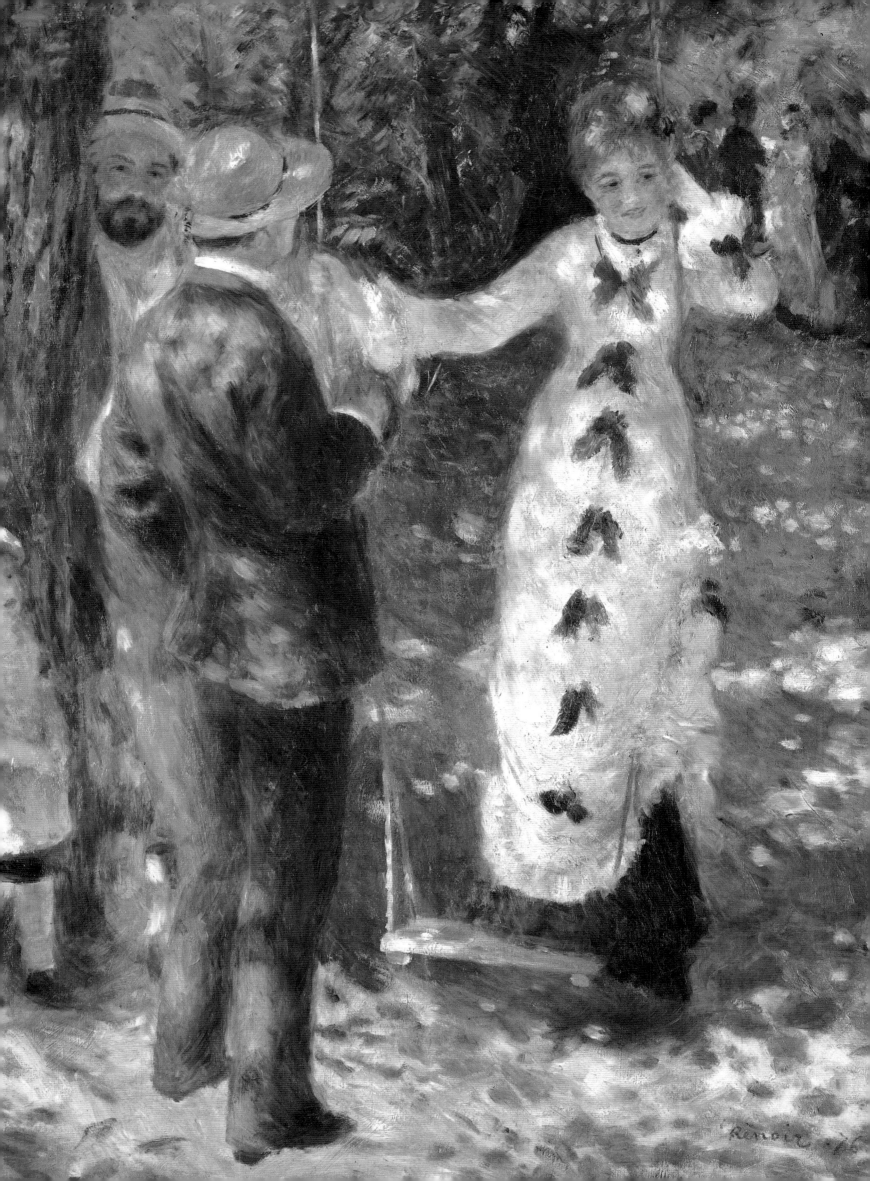

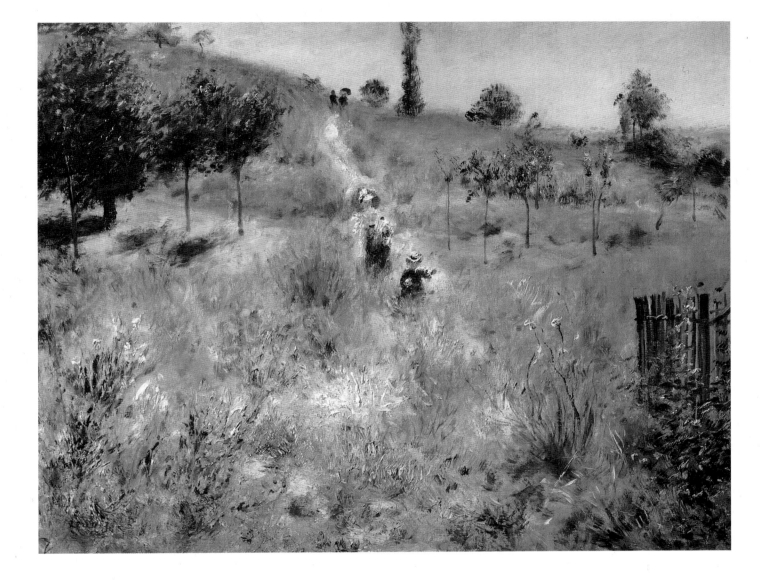

Path in the High Grass
1874; *oil on canvas;* 23 1/4 x 29 1/8 in. (59 x 74 cm.).
Paris, Musée d'Orsay.
The subjects of this painting are the scents of herbs and flowers and the summer heat rising from the ground, with its grass turned yellow. Two figure groups blend completely into nature as accessories. They seem to follow a "path" marked by a thin veil of white color.

The Swing
1876; *oil on canvas;* 35 1/4 x 28 3/4 in. (92 x 73 cm.).
Paris, Musée d'Orsay.
The woman standing on the swing is a model named Jeanne Samary, who posed in the garden of the artist's studio in Montmartre. Effects of shimmering light on her dress emphasize the grace of a sunny day. Like many other Impressionist paintings, this work entered the Musée d'Orsay as part of the bequest of the painter Gustave Caillebotte, who was one of Renoir's close friends and supporters.

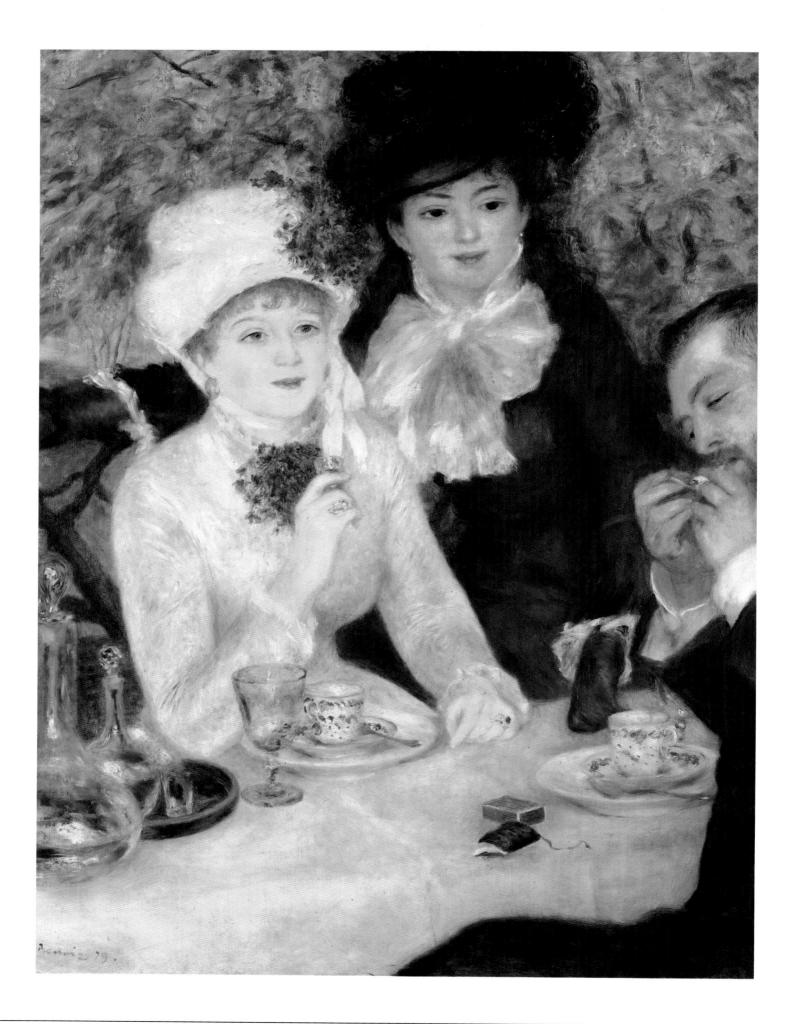

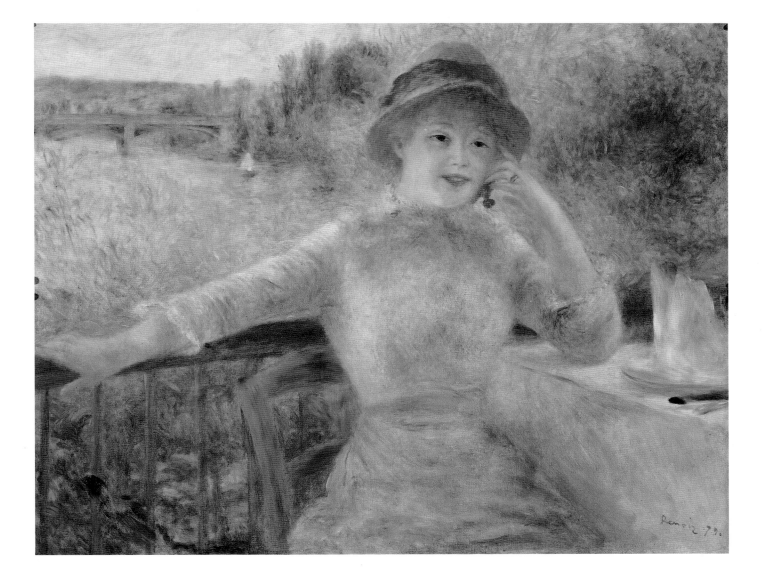

At 'La Grenouillière' (Woman Outdoors)
1879; *oil on canvas;* 28 3/8 x 36 1/4 in. (72 x 92 cm.).
Paris, Musée d'Orsay.
Located on the island of Chatou on the Seine,
this site offered tourists and visitors on excursions
numerous restaurants and other amenities. Renoir
had a particular preference for the restaurant of
Alphonse Fournaise, whose daughter Alphonsine
might have been the model for this painting.

The End of Lunch
1879; *oil on canvas;* 39 1/6 x 32 1/4 in. (99.5 x 82 cm.).
Frankfurt, Staedelsches Kunstinstitut.
After having finished an outdoor lunch, the group is relaxing
with coffee and liqueur. The still-life on the table cloth is
painted with utmost delicacy and tenderness. The woman
in white is the actress Ellen Andrée, and the man lighting
a cigarette is the artist's brother Edmond. His figure is cut
off by the picture frame, a device utilized to increase a sense
of spontaneity. The woman in black has not been identified.

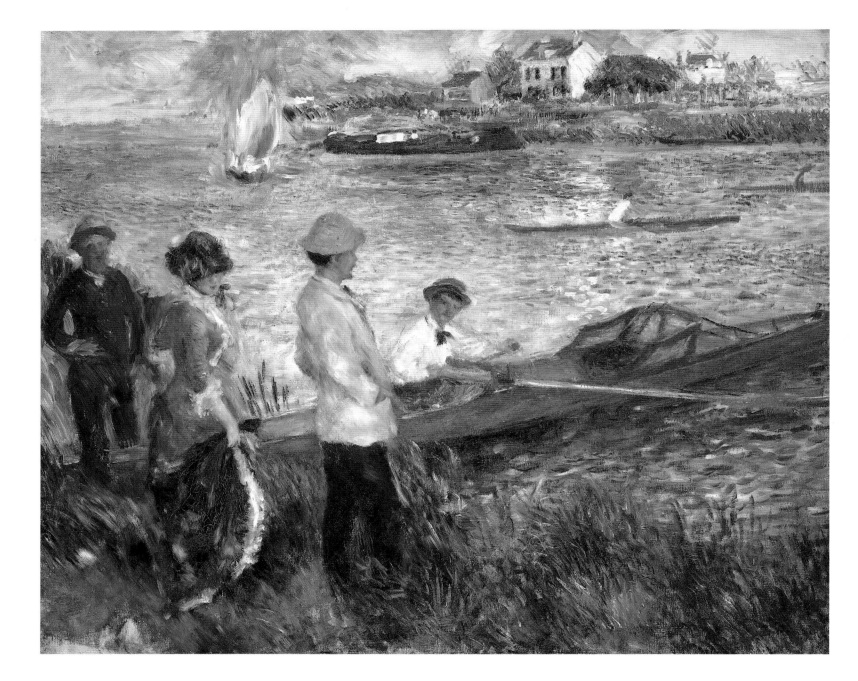

Oarsmen at Chatou
1879; *oil on linen;* 32 x 39 1/2 in. (81 x 100 cm.).
Washington, D.C., National Gallery of Art, Gift of Susan A. Lewisohn.
Aline Charigot, who would become the artist's wife, appears here for the first
time in a painting. She is about to embark on a boat together with a man
dressed in white (Renoir's brother Edmond posed for the man). Such outings
to the island of Chatou were a regular pastime for the artist and his friends.

Road to Louveciennes
1895; *oil on canvas*; 12 1/2 x 16 1/8 in. (32 x 41 cm.).
Lille, Musée des Beaux-Arts.
*This somewhat melancholy picture, perhaps influenced by Camille
Corot's paintings, is unusual in Renoir's oeuvre. A horse-drawn cart is
arriving on a sand-colored road framed on each side by thin poplar trees.
Louveciennes is the town where Renoir's parents lived for many years.*

Still-life with Peaches

1881; *oil on canvas;* 21 x 25 1/2 in. (53.3 x 64.7 cm.).

New York, The Metropolitan Museum of Art.

The bowl of peaches is oddly set toward the background of decorative wallpaper with a baroque motif of arabesques. Renoir clearly preferred the velvet texture of the peaches and their yellow-pink color over the more mundane pears and apples on the tablecloth, which serve to fill the empty space.

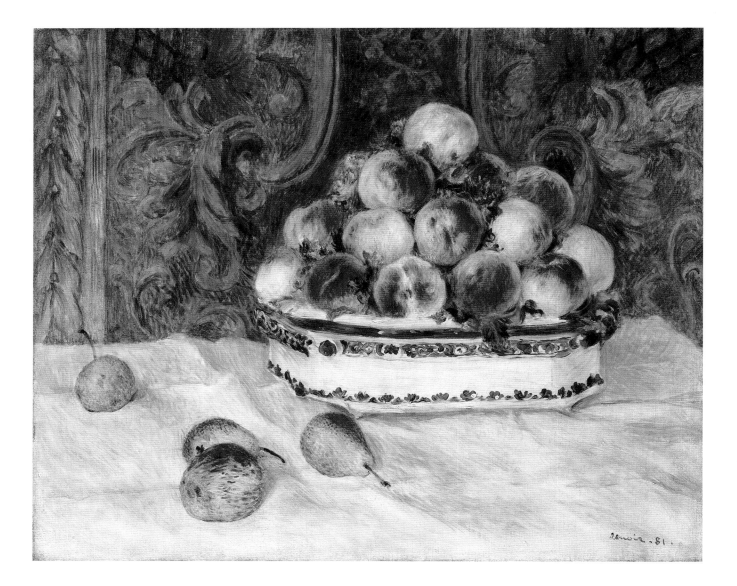

Fruits from the Midi
1881; *oil on canvas;* 20 x 25 3/4 in. (50.7 x 65.3 cm.).
Chicago, The Art Institute.
In this still-life Renoir's brush is as unrestricted from artistic
convention as are his works in portrait painting. Here he indulges
in the richness of vivid colors and the differences in surface of
Mediterranean fruit, including bell pepper, pomegranate, and eggplant.
The white tablecloth is the perfect backdrop for this coloristic feast.

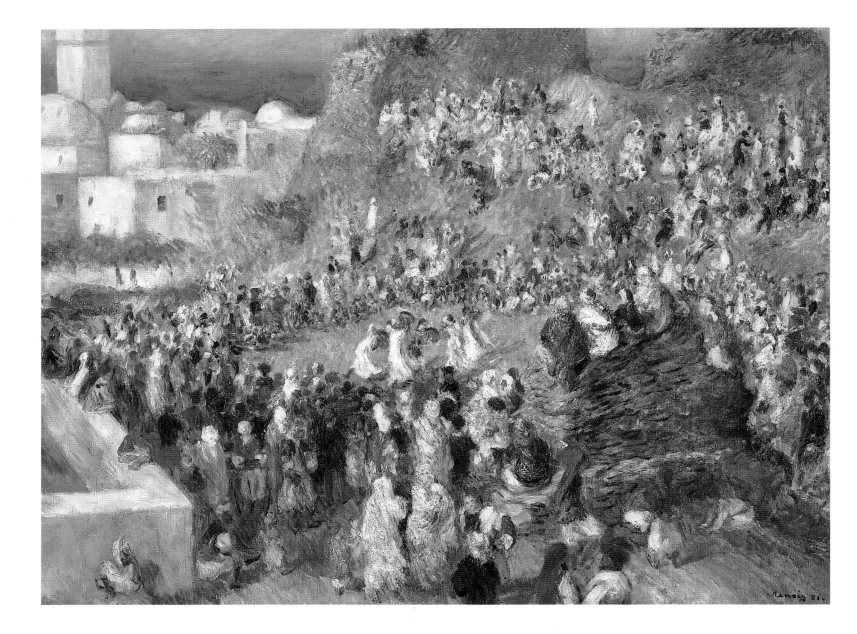

The Mosque (Arab Holiday)

1881; *oil on canvas*; 28 3/4 x 36 1/4 in. (73.5 x 92 cm.).

Paris, Musée d'Orsay.

After Renoir had gained a certain reputation and economic independence, he set
off for several journeys outside France. In 1881 he visited Algeria and was imme-
diately fascinated by the quality of light and rich scenery there. Reinterpreting
the hackneyed path of Orientalist painters, he imbued the subject with a flickering
light and animated brushwork, focusing on the rendering of white color.

Landscape with Snow

c. 1875; *oil on canvas;* 20 x 26 in. (51 x 55 cm.).

Paris, Musée de l'Orangerie.

Renoir was apparently not interested in a pure winter landscape
covered with powdery snow, unlike his colleague Monet. Branches
of trees and some green herbs animate this winter scene with
some orange and brown colors. This is one of the few pure
landscape scenes without any figures executed by Renoir.

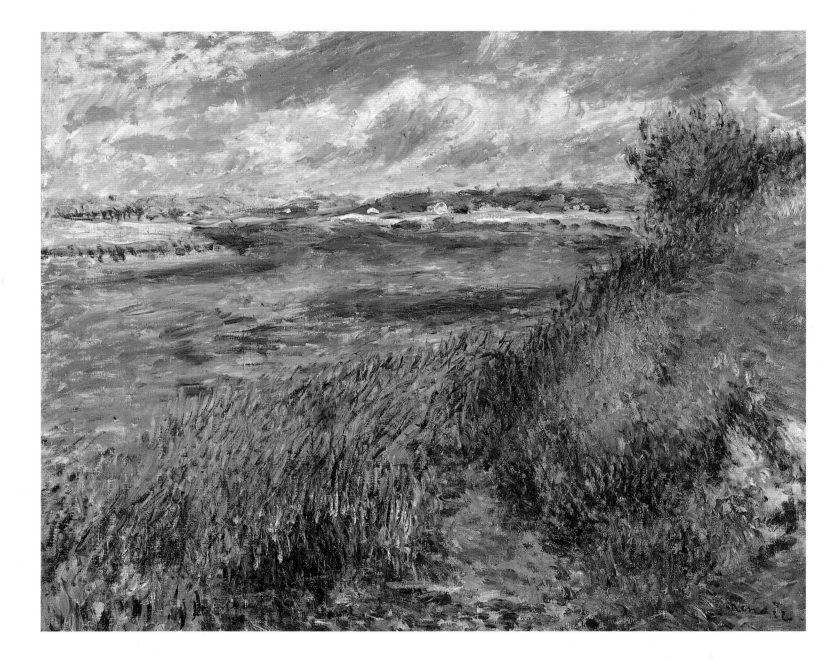

The Seine at Champrosay
1876; *oil on canvas;* 21 1/2 x 26 in. (55 x 66 cm.).
Paris, Musée d'Orsay.
This view of the Seine was painted during a three-week stay
at Champrosay, where Renoir painted the portrait of the wife of
the writer Alphonse Daudet. The windswept sky and the brisk
autumn weather can be sensed in the clear blue and golden light.

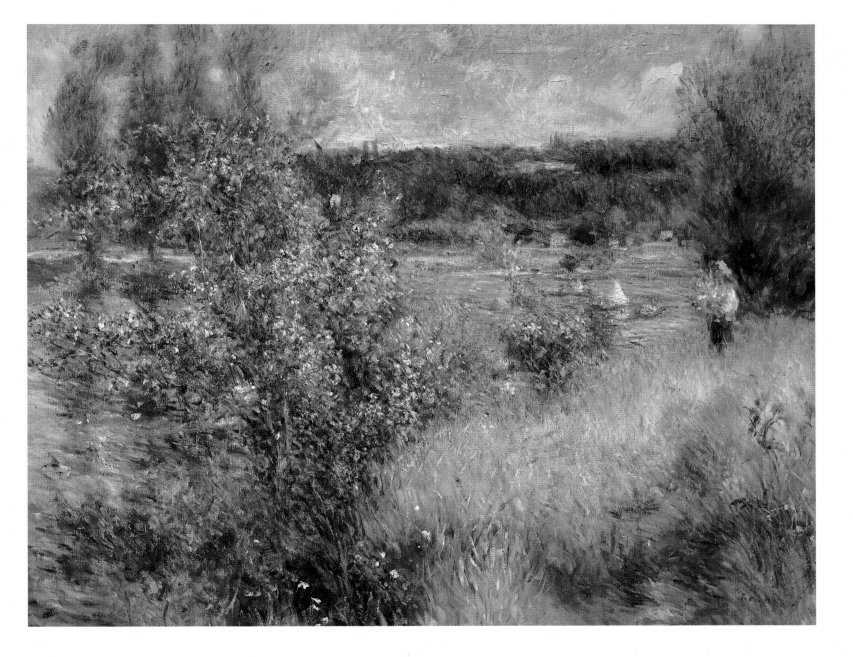

The Seine at Chatou

1880; *oil on canvas;* 29 x 36 1/4 in. (74 x 92 cm.).

Boston, Museum of Fine Arts.

Influenced by Monet's landscape paintings, Renoir occasionally emulated his friend's style. The small figure is just an addition to the untamed landscape of the embankment, which is clearly the main subject. The vibrant green, blue, yellow, and pink colors are applied with quick brushstrokes and thick impasto.

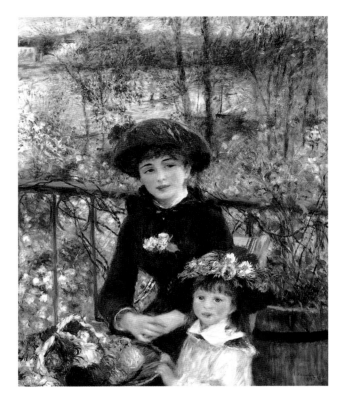

Two Sisters (On the Terrace)
1881; *oil on canvas*; 39 3/8 x 31 1/2 in. (100.5 x 81 cm.).
Chicago, The Art Institute.
The two girls here are generally considered to be, in fact, sisters. Renoir painted them with a loose brush and a range of bright hues. The location appears to be Grenouillière, at Chatou on the Seine, where the artist frequently visited the restaurant of Alphonse Fournaise.

Luncheon of a Boating Party
1881; *oil on canvas*; 51 x 68 in. (129.5 x 172.5 cm.).
Washington, D.C., The Phillips Collection.
Perhaps Renoir's best-known painting, this scene depicts an outing of the artist's friends on an island near Chatou on the Seine. The woman on the lower left is Aline Charigot, Renoir's future wife. On the right wearing a T-shirt and a straw hat is the painter Gustave Caillebotte. The fresh colors and the still-life of a finished luncheon make this conversation piece one of the most successful and charming works by the artist.

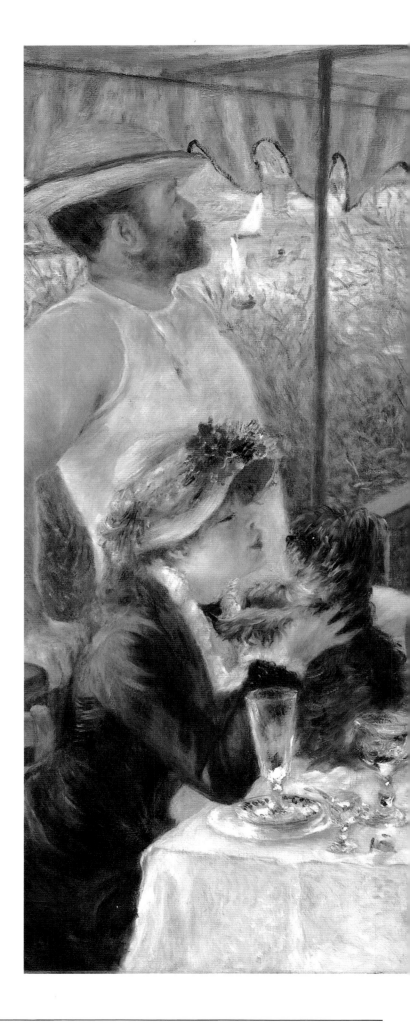

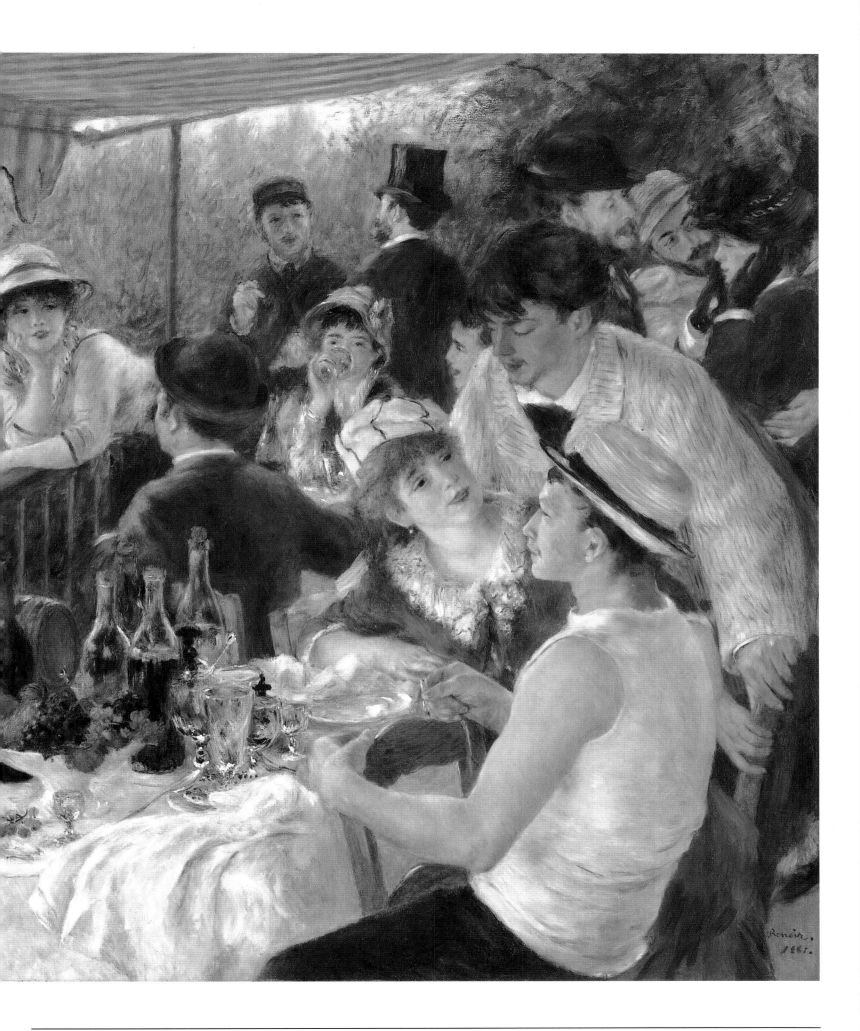

The Luncheon
c. 1879; *Oil on canvas*; 31 3/4 x 35 5/8 in. (80.5 x 90.5 cm.).
Merion, Pennsylvania, The Barnes Foundation.
*The plain composition of this charming, intimate encounter
is rendered with a heightened awareness for realistic details
and atmosphere. The still-life on the table, bread, wine
and glasses, as well as the couple's casual attire are painted
with great delicacy. The male sitter is a certain M. de
Laurador, who appears also in "The Rower's Lunch."*

Leaving the Conservatoire
1877; *Oil on canvas*; 73 3/4 x 46 1/4in. (187.3 x 117.5 cm.).
Merion, Pennsylvania, The Barnes Foundation.
*According to Georges Riviere, a friend and biographer of
Renoir's this large canvas was begun outdoors in front of
the artist's studio. A group of young women—aspiring
singers or actors leaving the school of performing arts—are
greeted by young men in top hats. This work relates in spirit
to the famous "Ball at the Moulin de la Galette" of 1876.*

Chestnut Tree Blooming
1881; *oil on canvas;* 28 x 35 in. (71 x 89 cm.).
Berlin, Neue Nationalgalerie, Staatliche Museen Preussischer Kulturbesitz.
*Located at an idyllic spot on a river, the blooming chestnut tree seems
to embody the delicacy of the scent of spring flowers. The bend of the
water conveys energy and the light-pink color of the petals rendered
with quick dappled brushstrokes give this painting its airy feeling.*

Looking Out at the Sacre-Coeur

1896; *oil on canvas;* 12 3/4 x 16 1/8 in. (32.6 x 41.2 cm.). Munich, Neue Pinakothek.
*Looking from a green hilltop one can clearly see the church of Sacre-Coeur, an
ever-popular tourist attraction in Paris. In Renoir's time, the Montmartre region
was still somewhat rural, with small gardens. This work was painted at a time in the
artist's life when he spent the winters in the south of France because of his ailment.*

CHAPTER 3

PORTRAITS

*B*y far the most numerous single type of painting in Renoir's oeuvre are portraits, which were something like his daily bread and butter. They earned the artist recognition and often desperately needed financial remuneration. His earliest portraits were influenced by the classical examples of Ingres, often showing a frozen pose and a serious demeanor. Soon, however, his sitters began to appear in more relaxed and natural poses, thereby achieving the ideal of Impressionism.

At first Renoir's friends, like Bazille and Monet, would frequently pose for him. But already by his rendering of James Bollinger Mazutreek in *Pagliaccio (The Clown)* in 1868 he had overcome the traditional restraints of portraiture painting. Caught at an arrested moment,

the clown is seen in full outfit and make-up during a performance at a circus. The perspective is high, and there is a clear distinction between near and far. The isolated position of the figure in the arena and the pose of the raised arm is very similar to that in Manet's *Mlle. Victorine in the Costume of an Espada* (1863), which was certainly influential for Renoir's concept. The painting was commissioned as a wall decoration for the café

Pagliaccio (The Clown)
1868; *oil on canvas;* 76 x 51 1/4 in. (192 x 128 cm.).
Otterlo, Rijksmuseum Kroeller-Mueller.
Renoir was commissioned to paint a portrait of the clown-violinist James Bollinger Mazutreek as a wall decoration for the Cirque d'Hiver, a café in Paris. The owner of the café went bankrupt and Renoir, who was already living on a small budget, had to keep the painting. The pose of the clown is inspired by Édouard Manet's Mlle. Victorine in the Costume of an Espada *(1863), today in the Metropolitan Museum in New York.*

Madame Charpentier with her Children
detail; 1878; New York, Metropolitan Museum of Art.
Her head turned toward her younger brother and her mother, Georgette Charpentier is sitting on the back of a black-and-white Newfoundland dog, who is guarding her with a watchful eye. This narrative and amusing detail is typical of Renoir's lighthearted character.

Cirque d'Hiver in Paris, but its owner went bankrupt and Renoir had to keep the painting for himself. Luckily for the artist this remained a rare case in his career.

Portraits of Patrons and Models
Beginning in 1865, and until 1874, Renoir was frequently the guest of Jules Le Coeur, a wealthy painter who owned several homes in different parts of the country. Eventually Renoir painted portraits of numerous members of the family, among them Jules's brother Charles, outside the house among his garden flowers.

Mother Strolling with her Two Children
1875; *oil on canvas;* 66 x 41 in. (168 x 104 cm.).
New York, The Frick Collection.
Shown at the second Impressionist exhibition in Paris,
in 1876, the porcelain-like faces and black eyes of the
mother and her girls were to become typical of Renoir's later
portrait paintings. The high key tones of the dresses are
balanced by a more neutral background and the white color.
Obviously the setting is that of a public garden, where
children accompanied by adults play together. The poses of
the two sisters, however, appear to be frozen for the portrait.

Charles was an architect, but also an amateur gardener. Dressed in a light, white summer suit with a straw hat, he has the elegant nonchalance of a well-to-do bourgeois.

In 1874, Renoir acquired several new models. One of them was Nini Lopez, who posed for the large *Mother Strolling with her Two Children.* This was the first painting of a subject that was going to occupy the artist many times in his later years. Two little girls dressed as sisters with the same green outfits are taken for a walk in the park by their mother. The older girl is holding a little doll. The details of the surrounding park are blurred and in the background one can only barely recognize the figures of other visitors and their children.

Ballerina, done the same year and shown at the first Impressionist exhibition together with the previous painting, represents Ninette Legrand, the daughter of Renoir's friend Alphonse. She is shown in the typical pose of a dancer with her legs crossed. Her body, twisted, is turned toward the viewer, thereby pushing up her tutu. Her face, reddish hair, and red lips are remarkably refined, while the dress as well as the neutral background are rendered with light brushwork.

A new model entered Renoir's life in 1875. Margot (Marguerite) Legrand (no relation to Ninette) became the artist's favorite model for the next four years. She posed with a charming gesture in *Young Woman with a Cat.* In 1879, Margot contracted smallpox. Renoir, who feared contracting the illness himself, remained in touch with her by mail. The attempts of her doctors—first Paul Gachet, later another homeopathic physician—failed to save her. Renoir's grief at her death seems to indicate that his relationship with her had been more intimate.

Renoir's friendship with Monet continued even after Monet had moved to Argenteuil, where the cost of living was lower and where he could set up for himself a garden with flowers. During one of his visits to the Monets, Renoir painted his friend in *Claude Monet Painting in a Garden.* The canvas placed on a light folding easel is set down on the grass. Underneath is an open box of paint and an umbrella to protect the canvas, if necessary, from too much sunlight or rain. As in the slightly later portrait, *Claude Monet with Palette,* the artist is shown in the casual, relaxed atmosphere as exists between two people who have come to know each other very well. The painting also provides insight into the working habits of the artist Monet, who apparently always wore his brown loose-fitted jacket and a hat while painting.

About *Claude Monet with Palette,* which was exhibited at the second Impressionist show in April 1876 at Durand-Ruel's gallery, the renowned author Émile Zola wrote for

Le Messager de l'Europe, a St. Petersburg newspaper: "The portrait of Monet that he [Renoir] exhibited is very successful," and another critic in *La Presse* called it daring and vigorous.

In an unfinished self-portrait of 1876, Renoir depicts himself as a sensitive, charming man. Large questioning eyes are looking out of a face that is squared by a thin beard. As in his portraits of Monet, the artist wears a hat and a light jacket. The neutral background is unfinished and he might have intended to include a palette in his left hand.

A major success—and the perfect opportunity to present himself in the limelight of Parisian society—was the moment when Mme. Charpentier asked Renoir to paint a portrait of her and her two children. Renoir hoped that Mme. Charpentier, who was acquainted with the new director of fine arts of the Salon jury, could be of invaluable help in having his painting accepted at the next Salon, and even in having it placed in a good position where critics and visitors would inevitably see it. Renoir decided to use a large format for this painting so that it could not easily be hidden away.

For *Madame Charpentier with Her Children* Renoir chose the Japanese salon in the Charpentier's town house in Paris. Japanese art was very much in vogue in those days, and Japanese prints and art objects could be found in every distinguished household in Paris. Artists like Manet, for example, used Japanese woodblock prints in his works and Theo and Vincent van Gogh were avid collectors of these images.

Dressed in a sumptuous black gown, Mme. Charpentier dominates the picture. Next to her on the sofa sits her three-year-old son Paul, dressed as a girl, as was then customary. His older sister Georgette is sitting atop a black-and-white Newfoundland dog, who is patiently guarding her. The diagonal arrangement of the sitters leaves a larger space between them and the viewer. Renoir took pains to work out every detail of this seemingly casual setting. At least forty sittings were necessary between September until mid-October of 1878. Edmond Renoir recorded that this painting was done at Charpentier's home "without any of her furniture having been moved from where it stood every day, without anything having been prepared to improve one part of the painting or another. . . . Is he doing a portrait? He will ask his model to maintain her customary manner, to sit the way she sits, to dress the way she dresses, so that nothing smacks of discomfort and preparation. This is why, in addition to its artistic value, his work has all the 'sui generis' charm of a painting faithful to modern life."

While painting the portrait of Mme. Charpentier, Renoir attempted to counter attacks voiced earlier against his figure painting. He decided to make the surfaces smoother and clearer instead of leaving violent, visible brushstrokes. He reduced reflected colors in order to allow for sensuous details and rich textures. Instead of dissolving his figures in loose streaks of paint he built more tangible, solid bodies, firmly placed into a pyramidal structure. However, Renoir did not entirely give up Impressionist methods, such as the high-key shades, true-to-life setting, and the informal postures of his sitters. Spatial incongruities, like the disproportion between Mme. Charpentier and the chair behind her, or the angle of the carpet and the Japanese wall hangings

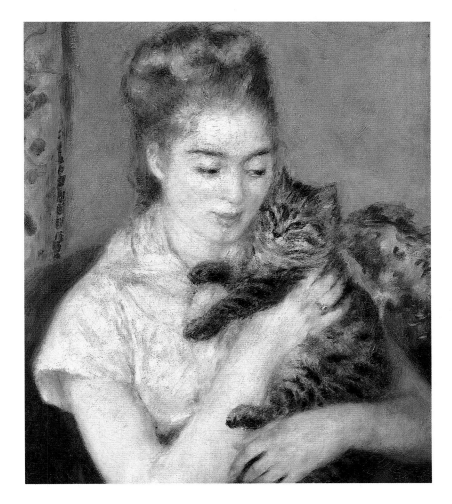

Woman with a Cat
c. 1875; *oil on canvas; 22 x 18 1/4 in. (56 x 46 cm.).*
Washington, D.C., National Gallery of Art,
Gift of Mr. and Mrs. Benjamin E. Levy.
In 1875 Marguerite Legrand became the artist's favorite model, and would continue to be so for the next four years. Renoir's strong reaction following her illness and untimely death in 1879 indicates that they might actually have been lovers. Here, Marguerite is holding a cat in her arms.

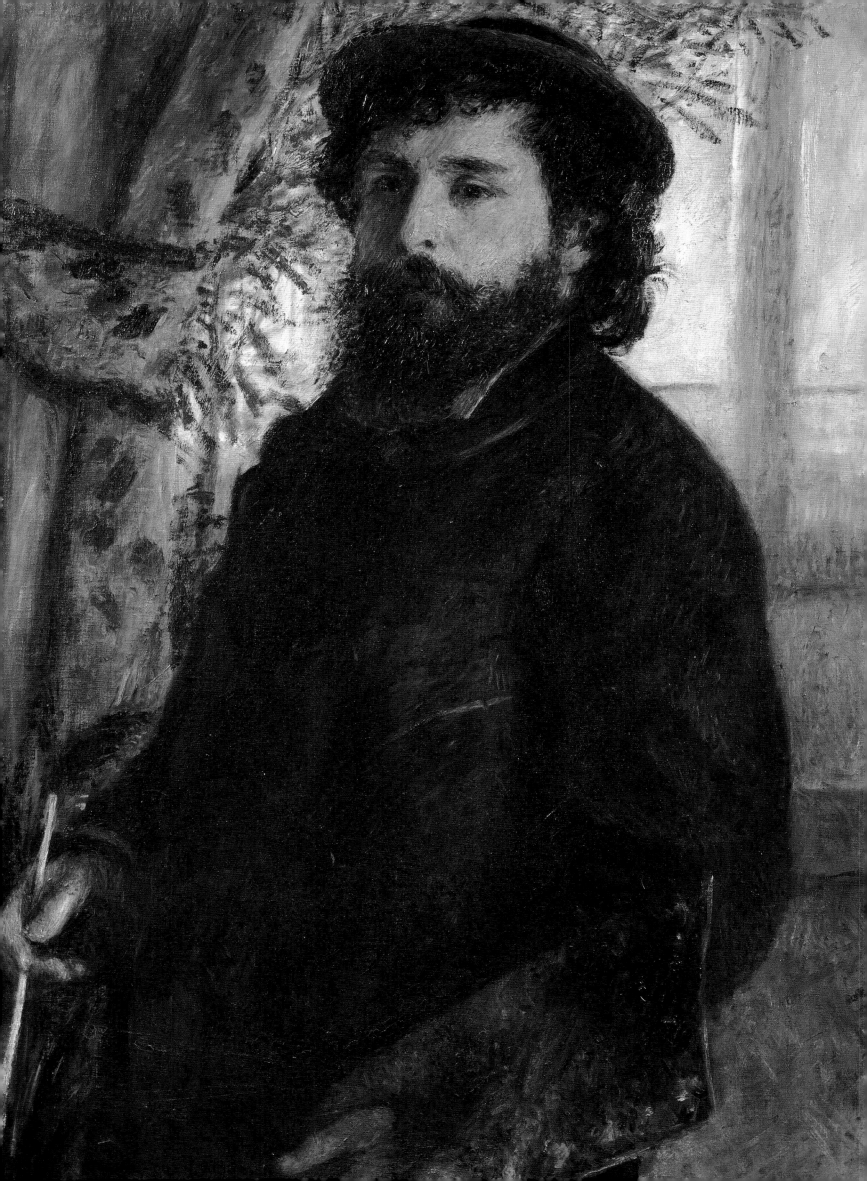

with peacock decorations, are the result of the contemporaneous emphasis of two-dimensional patterns set into a three-dimensional place.

Finally, on October 15, Renoir wrote to Duret: "The time that portraits make you waste is incalculable. The portrait of Mme. Charpentier is entirely finished but I can't say what I think of it. I don't know at all. In a year I'll be able to judge it but not before." Renoir still had six months to show the portrait to as many people as he possibly could until the Salon of 1879. Again and again he asked his patron to allow him and his visitors to look at the painting. On November 30, 1878, Renoir wrote to Mme. Charpentier one of his typically charming and flattering notes: "Next Monday I'm having lunch with some close friends of Bonnat, Mrs. Charles Ephrussi and Mr. Deudon. They have asked me to get your permission to see your portrait. So if you give it to me, as your boundless kindness to me leads me to suppose, we will be at your place in Monday about 1:30. I'm not saying that I will be grateful for it, because my debt to you is already too heavy to be increased any more. Your resident painter, A. Renoir."

The painting was successfully exhibited at the Salon of 1879. As Renoir explained later, it was due to Mme. Charpentier's vigorous lobbying of the members of the jury, whom she knew, that her portrait was placed so prominently among the 3,040 works in the show. Philippe Burty, a critic who had supported Renoir as early as 1869, remarked about the work: "Everything obeys a general impression of modern harmony. The poses are of a striking accuracy, and the flesh tones that the children innocently offer to the kisses of the light are as firm as ripening cherries. One thinks one has before one's eyes the velvetiness of a huge pastel."

At the same Salon, Renoir also exhibited a life-size portrait, *Jeanne Samary Standing*, of an actress whom he had encountered in the house of Mme. Charpentier. He showed her in an alluringly elegant evening dress standing in the lobby of the Comédie Française, where she played. The year before, he had depicted the actress, in *Jeanne Samary in a Low-Necked Dress*, in a vaporous bust-length portrait. The intimacy and immediacy of the earlier work had been transformed into the more distanced elegance of an official portrait.

Both *Jeanne Samary Standing* and, even moreso, *Mme. Charpentier with her Children* were enormous successes for Renoir. The portrait of the actress was purchased by Durand-Ruel for 1,500 francs, while the other work sig-

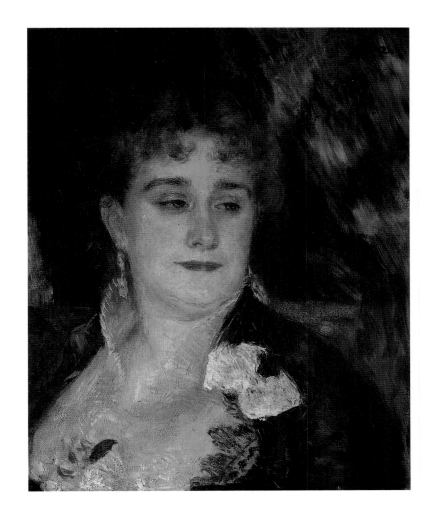

Madame Charpentier
1876-1877; *oil on canvas;* 18 x 15 in. (46 x 38 cm.).
Paris, Musée d'Orsay.
Two years before he painted the ambitious and successful canvas of Madame Charpentier and her children, Renoir made this smaller portrait of the mother alone. Married to a distinguished publisher, Marguerite Charpentier led a fashionable salon in Paris which attracted writers like Émile Zola, Gustave Flaubert, and Guy de Maupassant, as well as Édouard Manet.

Claude Monet with Palette
1875; *oil on canvas;* 33 1/2 x 23 1/2 in. (85 x 60 cm.).
Paris, Musée d'Orsay.
Standing before a window with his palette and a brush in his hands, Monet is portrayed with his characteristic beard and black hat. A curtain to the right is a decorative element frequently used in Renaissance portraits. This painting was shown at the second Impressionist exhibition, in 1876, as Portrait of Monsieur M.

naled an upswing in Renoir's career for the next three years. Pissarro wrote to Murer: "Renoir is having a great success at the Salon. I think he is launched, so much the better, poverty is so hard!"

More Portrait Successes

In the following years Renoir received numerous commissions for portraits in oil as well as in pastel, and his new wealth enabled him to travel extensively during the early 1880s. Occasionally he was so busy painting that he had to decline dinner invitations even from Mme. Charpentier, who had been so instrumental in the launching of his career.

Taking advantage of his current notoriety, Renoir arranged to have a one-man exhibition at the editorial offices of *La Vie Moderne*, a weekly illustrated newspaper of art, literature, and social life, which was published by M. Charpentier. Renoir timed the opening carefully—right after the Salon closed down in mid-June. Most works in this exhibition were portraits, among them *Jugglers at the Circus Fernando*, a large double portrait of Francisca and Angelina Wartenberg, jugglers and gymnasts at their father's circus in Montmartre. Seen from a high vantage point, the two sisters are virtually alone in the arena. One of them is holding brightly colored oranges, which she has just juggled. The spectators of the first rows are cut off at their heads, which heightens the immediacy of the scene.

Jeanne Samary in a Low-Necked Dress

1877; *oil on canvas;* 22 x 18 1/8 in. (56 x 46 cm.). Moscow, Pushkin Museum of Fine Arts. *The actress Jeanne Samary (1857-1890), who lived in Renoir's neighborhood, posed several times for the artist. The slightly melancholic expression of her eyes and the thoughtful pose of her hand touching her cheek balance the vibrancy and brilliance of the painted surface, thus heightening the intensity of her character.*

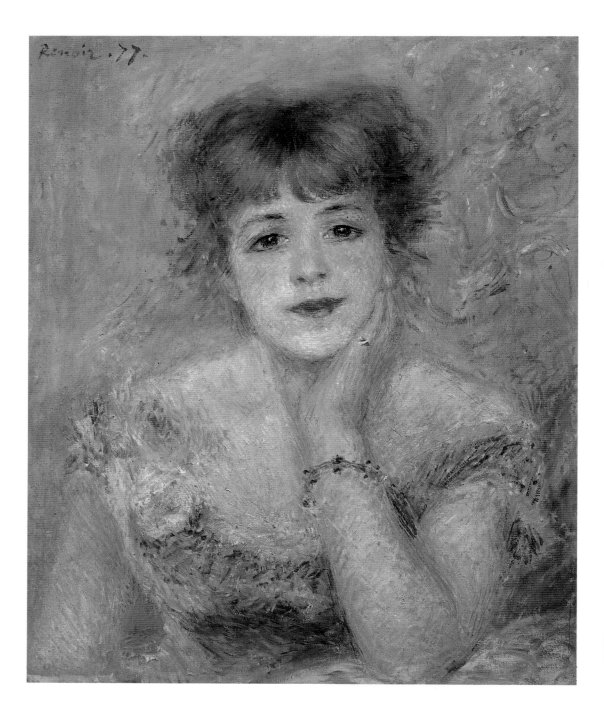

Renoir might have learned this device from paintings by Degas. The almost monochromatic handling of this canvas is an astonishing tour de force.

In March 1879, Renoir was introduced by Charles Deudon, who owned *The Dancer*, to a new patron named Paul Bérard. About eight years older than the artist, Bérard was a retired banker and diplomat who enjoyed hunting and gardening. In spite of their different backgrounds, he and Renoir developed a close friendship which lasted until Bérard's death in 1905. His first commission for Renoir was a portrait of his eldest daughter, the nine-year-old Marthe. Wearing a dark blue dress with white laces, a double row of buttons, and a light blue sash, Marthe is standing with her hands folded. Renoir obviously paid as much attention to her dress as to her soft features.

In the following years, numerous portraits of other family members were painted. Renoir became an "habitué" at Bérard's house and was also frequently invited to their spacious château at Wargemont in Normandy. During his first visit there, Renoir painted the rose garden and decorative wall panels for the library and the drawing room. Between 1879 and 1885, Renoir executed a total of about forty paintings for the Bérards at Wargemont. The sharp contours of the figures, the firmly modeled faces, and the definition of the sitters' individuality are often striking to a point that one might wonder if Renoir used photographs as a supplement to painting from life. The large 1884 painting, *The Children's Afternoon at Wargemont*, reveals a certain stiffness and preciousness despite the strong, vivid colors of the fabrics. Nevertheless, the three Bérard daughters are rendered with a distinct characterization.

While at Wargemont, Renoir visited friends of the Bérards, Mme. Blanche and her eighteen-year-old son Jacques-Emile, at their summer house in Dieppe. The young man was an aspiring artist and Renoir, who was very much impressed with his talented paintings, encouraged Jacques-Emile in his vocation. Back in Paris, Renoir gave him painting lessons for the next two years. Eventually, Blanche became an eminent portrait painter of Parisian society and the artistic intelligentsia, whose sitters included Marcel Proust and Igor Stravinsky.

Another important patron was the Cahen d'Anvers family. In 1880 Renoir painted the exquisite portrait of their daughter Irène, whose gorgeous reddish hair beautifully contrasts with the white dress and the green background of the garden. The following year, he was commissioned to paint a portrait of the two younger daughters, Alice and Elisabeth, one wearing a pink and the other a blue sash, hence the title of the painting, *Pink and Blue*.

By that time Renoir had developed something of a classical formula for his portraits, especially for children.

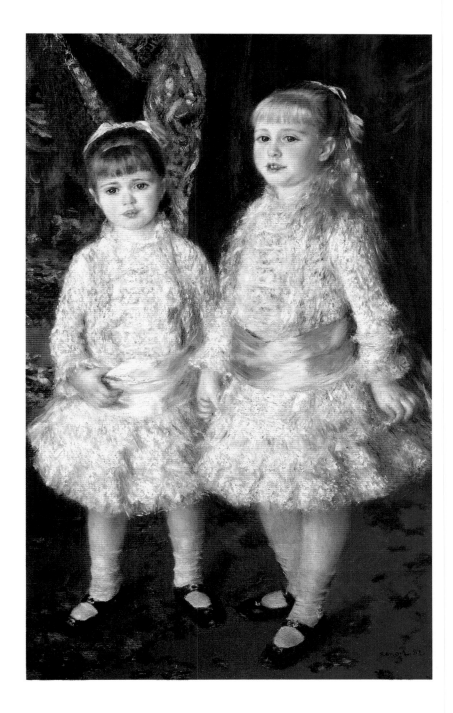

Pink and Blue, The Two Cahen d'Anvers Girls
1881; *oil on canvas*; 46 5/8 x 29 1/8 in. (119 x 74 cm.).
São Paulo, Museu de Arte, Assis Chateaubrianz.
The two girls are the younger sisters of Irène Cahen d'Anvers, whom the artist had already painted. Elisabeth is dressed in blue and Alice is in pink. Their finely-modeled faces—almost like porcelain—are distinct from the looser and more sensuous brushwork of their lace dresses and sashes. A Titian red floor and drapery reveal the traditions upon which the artist was drawing.

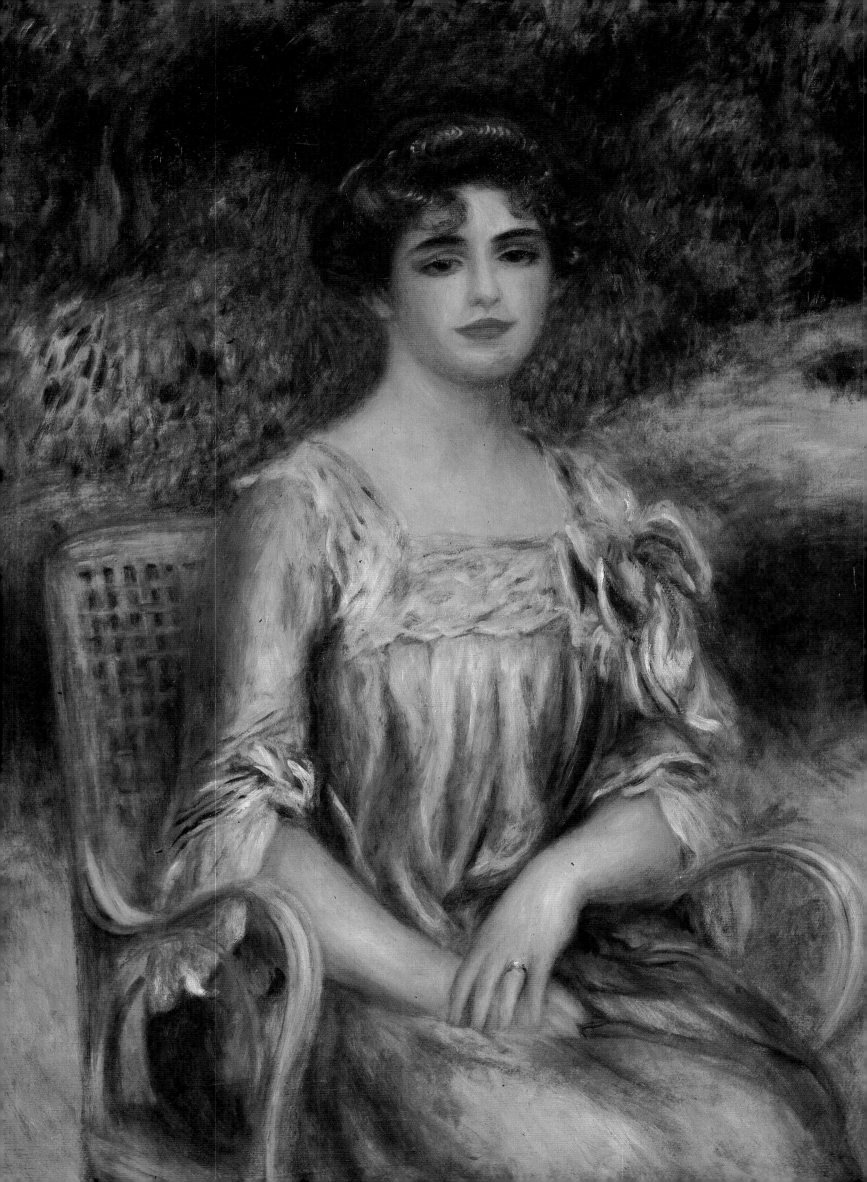

Usually placed in a luxurious environment or in a garden, his children often look like precious little dolls dressed up for an important occasion. Most of them have large, black eyes and faces of a porcelain quality. In most cases, however, Renoir was able to imbue them with some personal expression.

Difficult Portraits

Renoir's relations with his patrons were not always as perfectly smooth as his soft-spoken character would perhaps make one believe. Referring to a portrait he painted of Albert Cahen d'Anvers, for which he was paid five months late and less than promised, Renoir wrote to Deudon: "As for the fifteen hundred francs from the Cahens, let me tell you that I find that hard to swallow. How stingy can you be? I definitely give up with Jews. . . . I'm not going to sue the Cahens." (Other instances of anti-Semitism by Renoir are known from his negative stand during the Dreyfus affair.) Too, his personal manners and habits were not always appreciated by his upper-class patrons. Jacques-Emile Blanche, for example, reports one incident:

"Renoir came to see us yesterday. Mother kept him for dinner. We were at the table for a little less than three-quarters of an hour (usually it takes us fifteen or twenty minutes). Mother got so impatient that she said it would be impossible for her to have dinner with him. She says he is humorless, a dauber, slow in eating, and makes unbearable nervous movements."

The portrait of one particularly difficult sitter turned out to be a rather interesting moment in Renoir's career. During his visit to Palermo in 1882, Renoir managed to contact the German composer Richard Wagner, who was just about to finish his *Parsifal*. After several unsuccessful attempts, the maestro conceded to a meeting with the painter. According to Renoir they had a lively and open conversation despite his own nervousness. In the end, Wagner offered him one session for a portrait. Renoir finished the painting in about thirty-five minutes, and when the composer finally saw it he said he thought he looked like a Protestant minister. In any event, Renoir was rather pleased with the outcome of this meeting, carrying with him a little souvenir of this extraordinary man.

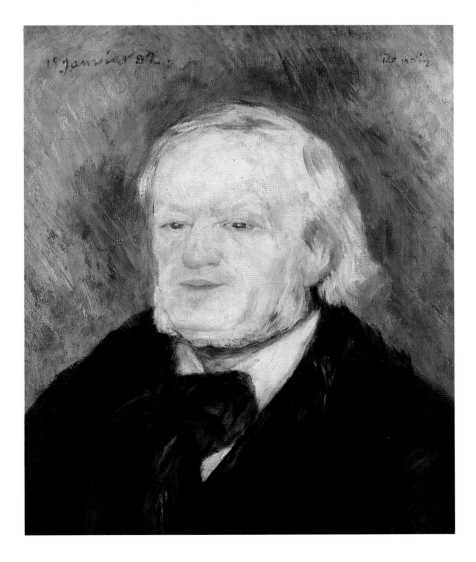

Portrait of Richard Wagner
1882; oil on canvas;
20 1/2 x 17 3/4 in. (52 x 45 cm.).
Paris, Musée d'Orsay.
Renoir sketched this portrait of the composer in Palermo. The maestro conceded only half an hour for the session and was eventually dissatisfied with the result. However, considering the circumstances, the artist captured the sitter's features astonishingly well. Wagner died one year later in Venice.

Madame Bernheim de Villiers
1901; *oil on canvas;*
36 5/8 x 28 3/4 in. (92.8 x 73 cm.).
Paris, Musée d'Orsay.
The woman's striking blue dress dominates this portrait. Sitting in a garden, her pose appears somewhat stiff and pretentious, although her features appear more softened. Born Suzanne Adler, she was married to Gaston Bernheim de Villiers, director of a Parisian art gallery, who commissioned several works from Renoir.

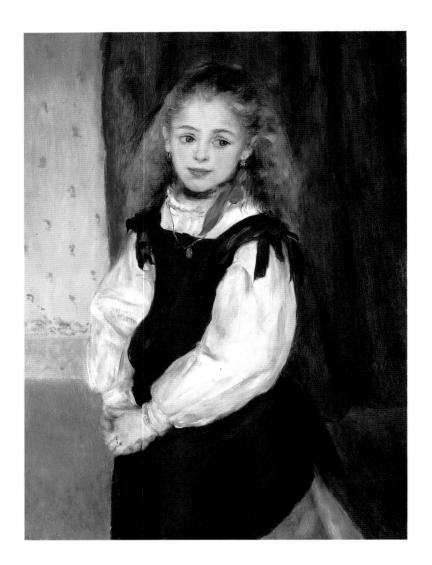

Portrait of Delphine Legrand

1875; *oil on canvas;* 31 3/4 x 23 1/2 in. (81 x 60 cm.).
Philadelphia, Museum of Art, McIlhenny Collection.
The daughter of Alphonse Legrand, a former employee of
the art dealer Durand-Ruel who had opened a small gallery
of his own, is certainly one of the commissions that helped
Renoir during times of extreme financial difficulty. The
girl's natural and spontaneous pose is particularly charming.

Jugglers at the Circus Fernando

detail; 1879; Chicago, The Art Institute.
The little acrobat and juggler Angelina is holding oranges in
her arms, which she has just used for a performance in the
arena before the audience. Her innocent, charming expression,
however, does not reveal the effort of her previous movements.

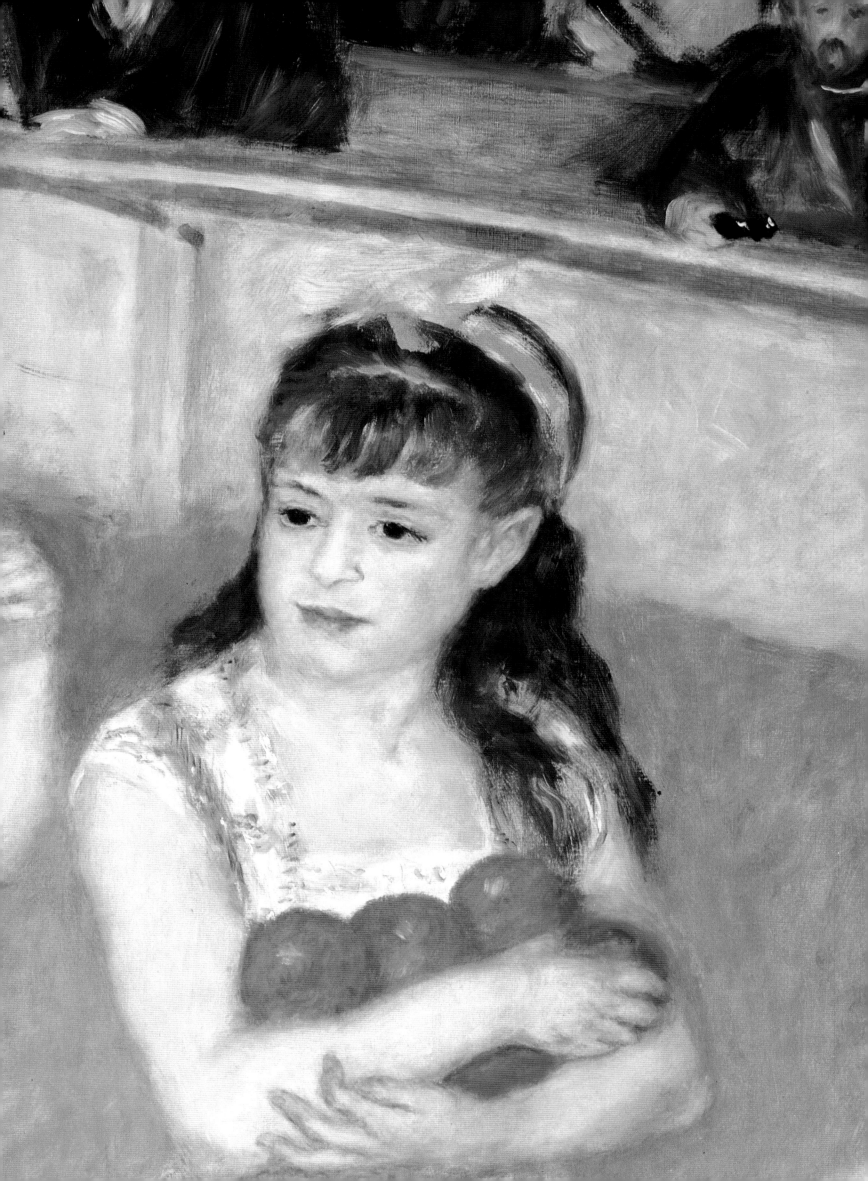

à mallarmé

Renoir

The Dance Triptych

Three important works, *Dance in the City*, *Dance in the Country*, and *Dance at Bougival*, were executed in 1883. They were possibly intended to be seen together as a triptych of the romantic pleasures of a couple of young Parisians. The format for all three paintings is vertical, the figures are life-size, and in all three instances Aline posed for the woman, and Paul Lhote for the man.

Dance in the City is the coolest work. Dressed in a precious satin evening gown, the woman dances with her partner, who wears a tuxedo. The couple's elegance and their distinguished movement, the palm tree in the background, and the gray-green color scale make this the noblest—yet the most distanced—work in the group. *Dance in the Country* is full of warmth and intimacy. A middle-class couple is dancing in an outdoor location on a platform. On the far left one can see another couple sitting on a lower level. The woman wears a pretty, but less elegant, dress and a red hat. The fan, which she is holding to cool the summer heat, balances the weight of her partner's straw hat, which has fallen on the ground during a vehement swirling movement. The remnants of their meal are still on the table to the right. The figures here have more volume than the previous canvas and their relationship reveals a greater intimacy. In the third panel, *Dance at Bougival*, a petit-bourgeois couple is dancing under the trees of an outdoor café. Other couples are sitting in the background at wooden tables with glasses of drinks. The clothes of the dancers are pretty, but of decidedly less expensive material than in the previous two pictures. The man is holding his partner firmly around her waist in order to perform dramatic movements. The woman appears to have lost a small bouquet of violets during their dancing and she is trying to look over her shoulder for it. Both figures wear hats of complementing colors—hers red, his yellow. The man's anonymity—his eyes are invisible—make his gestures appear somewhat more aggressive and daring.

Dance in the City and *Dance in the Country* were first shown at a one-man show at Durand-Ruel's gallery which opened on April 1, 1883. *Dance in Bougival* was apparently not yet completed and was shipped to a show in London at the end of the month.

Madmoiselle Charlotte Berthier

1883; *oil on linen*;
36 1/4 x 28 3/4 in. (92 x 73 cm.).
Washington, D.C., National Gallery of Art,
Gift of Angelika Wertheim Frink.
*Ingres's influence is manifest here
in the smooth face, the static posture,
and the sharp outlines of the forms.
Painted during a visit to Argenteuil,
the sitter was the mistress of the
painter Gustave Caillebotte, who
bought several of Renoir's paintings.*

Stéphane Mallarmé

1892; *Oil on canvas*; 19 5/8 x 15 3/4 in.
(50 x 44 cm.). Versailles, Chateau
*Renoir painted the portrait of the
eminent poet Stéphane Mallarmé
between February and April of 1892.
The artist's poor health required
various interruptions in the execution
of the work, which Renoir later
gave to the sitter inscribing it
with a dedication to Mallarmé.*

In 1888 Durand-Ruel opened a New York branch of his gallery. Although Renoir was initially opposed to this move, he decided to paint a group portrait for the spring opening of the gallery. As sitters he chose the three stepdaughters of his friend the poet Catulle Mendès. The eldest, Haguette, is seated at the piano. Standing next to her with a violin under her arm is Claudine, while the third daughter, Helyone, who was perhaps still too young to play an instrument, is leaning against the piano. The colors and forms here are softer than in *The Children's Afternoon at Wargemont*, although the feeling of arrested movement is quite similar.

In *Two Girls at the Piano* (1892) Renoir again took up the motif of children musicians. The image is more direct and more intimate than the portrait of the Mendès girls. It was immediately purchased by the state for the Musée du Luxembourg for the price of four thousand francs. This was the first work by Renoir to enter a public collection.

One late portrait was *Madame Bernheim de Villiers* (1901). Renoir knew the important art dealer Alexandre Bernheim and his twin sons, Josse and Gaston, who had changed their last names to Bernheim-Dauberville and Bernheim de Villiers respectively. Both sons asked Renoir to paint portraits of their fiancées. Sitting in a garden chair in a strongly colored purple dress, Suzanne Bernheim de Villiers (née Adler) is the quintessential lady of Parisian society, beautiful and with a touch of cool charm.

Portraits became less and less important for Renoir after his career had been firmly established. In his later years most of them were of his family and some close friends. His frail health did not permit long painting sessions, nor was traveling easy for him. He retired from public life in Paris to the south of France and dedicated the last two decades of his artistic production to the figures of bathers.

Marthe Bérard (Girl with Blue Sash)

1879; *oil on canvas;* 51 1/4 x 29 1/2 in. (128 x 75 cm.).
São Paulo, Museu de Arte, Assis Chateaubrianz.
In 1879, during his first visit to Wargemont in Normandy, near Dieppe, Renoir painted numerous portraits of the family of his patron Paul Bérard. The sharp contours, firm facial structure, and the precision of execution suggests that Renoir might have used a photograph as a back-up for this painting of Marthe.

Girls Dressed in Black

1881; *oil on canvas;* 31 1/2 x 25 1/2 in. (80 x 65 cm.).
Moscow, Pushkin Museum of Fine Arts.
Renoir experimented here with various shades of black as the dominating color of a painting, as he would do with Umbrellas *(1883). Two young women, possibly in a dance hall or café, are played off against each other. The figure on the left confronts the viewer with a thoughtful gesture, indicating hesitation. The girl on the right, in profile, appears to be less inhibited.*

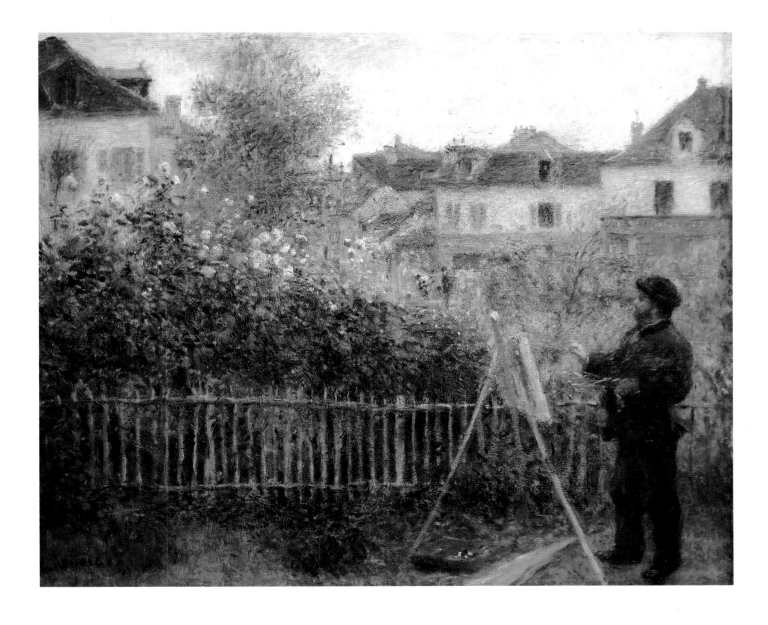

**Claude Monet Painting in his Garden
at Argenteuil**

1875; *oil on canvas;* 19 2/3 x 24 in. (50 x 61 cm.).
Hartford, Connecticut, Wadsworth Atheneum.
*Monet and Renoir often painted together out-of-doors
during the 1860s and 1870s. Dressed in his working
clothes, Monet is shown painting in his garden at
Argenteuil, a short train ride northwest of Paris.
He has placed a small canvas on his portable easel,
and a box of paints lies opened on the grass. The
dotted brushwork here recalls Monet's own technique.*

The Dancer

1874; *oil on canvas;* 56 1/8 x 37 1/8 in. (142 x 94 cm.).
Washington, D.C., National Gallery of Art, Widener Collection.
*Dressed in a light tulle skirt, a young blonde ballet
dancer poses gracefully toward the viewer. Her self-
conscious expression reveals a fine and nervous elegance.
The dreamlike quality of this figure, so much appreciated
today, was criticized when the painting was first
shown at the Impressionist exhibition of 1874.*

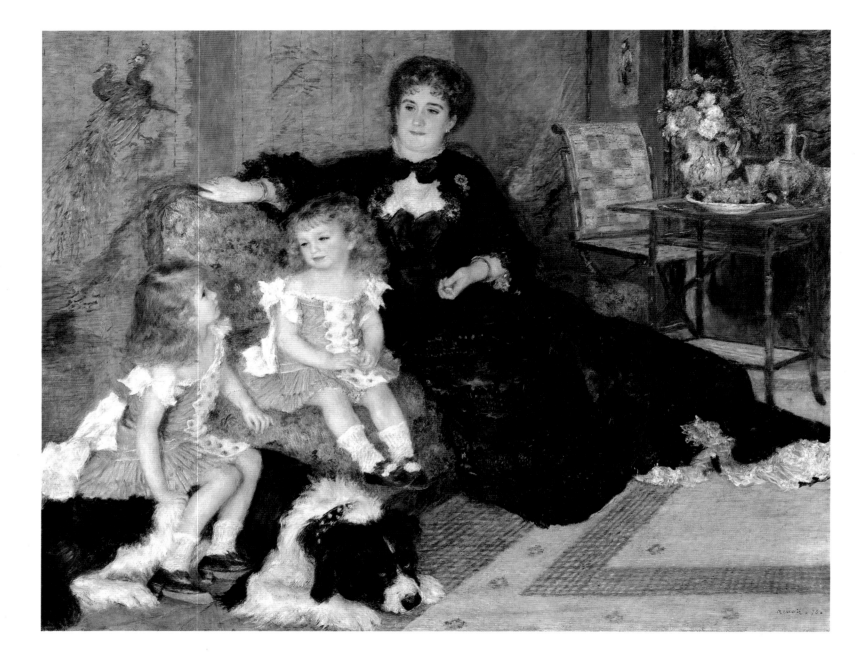

**Madame Georges Charpentier (Marguerite Lemonnier, D. 1904)
and Her Children, Georgette (B. 1872), and Paul (1875-1895)**

1878; *oil on canvas;* 60 1/4 x 74 3/8 in. (153 x 189 cm.).

New York, The Metropolitan Museum of Art.

*The wife of a well-known publisher, Mme. Charpentier is
seen together with her two children in a room with Japanese
decor, which was very fashionable in her day. The dominating
figure of the mother seems to protect the two, while the older
daughter sits on the back of a watchful Newfoundland.*

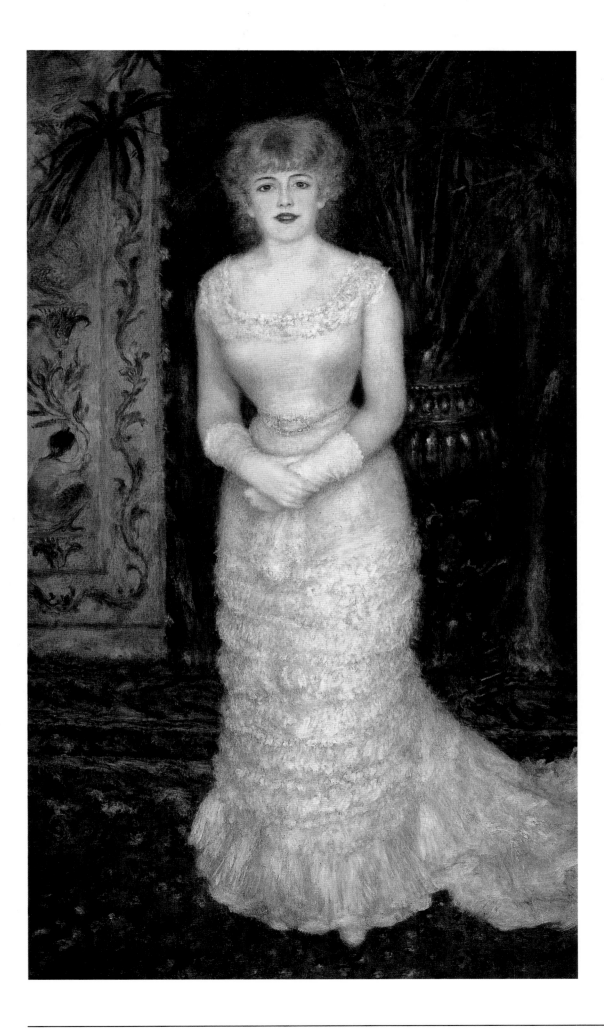

Jeanne Samary Standing
1878; *oil on canvas;*
68 x 40 in. (173 x 102 cm.).
St. Petersburg, Hermitage.
*Actress Jeanne Samary had
posed previously for the artist,
in the year prior to this portrait.
Dressed in a low-cut party
gown with white gloves, she
is standing in the foyer of the
Comédie Française, where she
performed. A palm tree behind
her provides a touch of luxurious-
ness to this portrait. The hues
of the white fabric contrast
masterfully with the saturated
colors of the wall and the floor.*

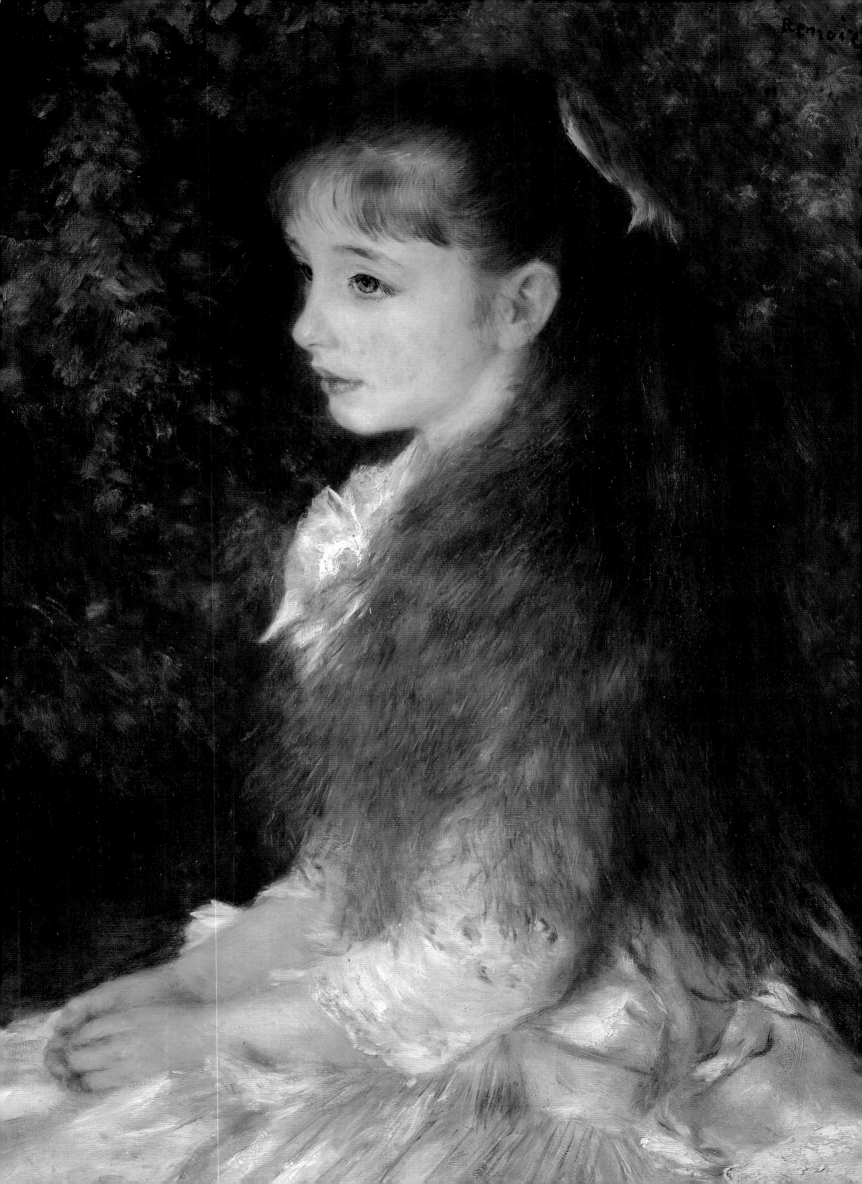

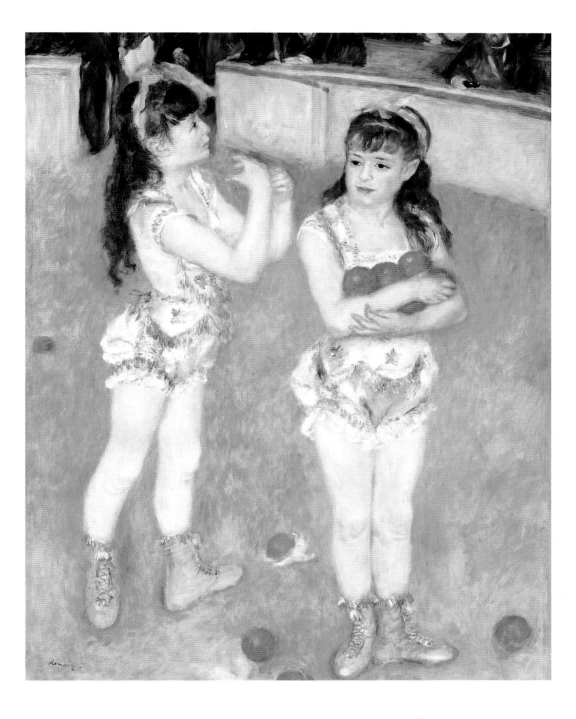

Jugglers at the Circus Fernando
1879; *oil on canvas,* 51 1/2 x 38 3/4 in. (131.5 x 99.5 cm.).
Chicago, The Art Institute.
This work is also known as Circus Fernando, *a popular institution in Paris at the time, where Renoir attended performances together with Edgar Degas. The two girls are Francisca and Angelina, daughters of Fernando Wartenberg, owner of the circus on the Boulevard Rochechouart in Montmarte. The space of the arena is as clearly defined here as in his earlier work* Pagliaccio.

Irène Cahen d'Anvers
1880; *oil on canvas;* 25 5/8 x 21 1/4 in. (65 x 54 cm.).
Zurich, E.G. Buehrle Collection.
This portrait was painted in only two sessions at the house of the girl's parents in Paris. Her gentle features, the beautiful long red hair falling over her shoulder, and her small hands folded on her lap are rendered with an extraordinary delicacy. Her father, the banker Louis Cahen d'Anvers, also commissioned portraits of other family members from the artist.

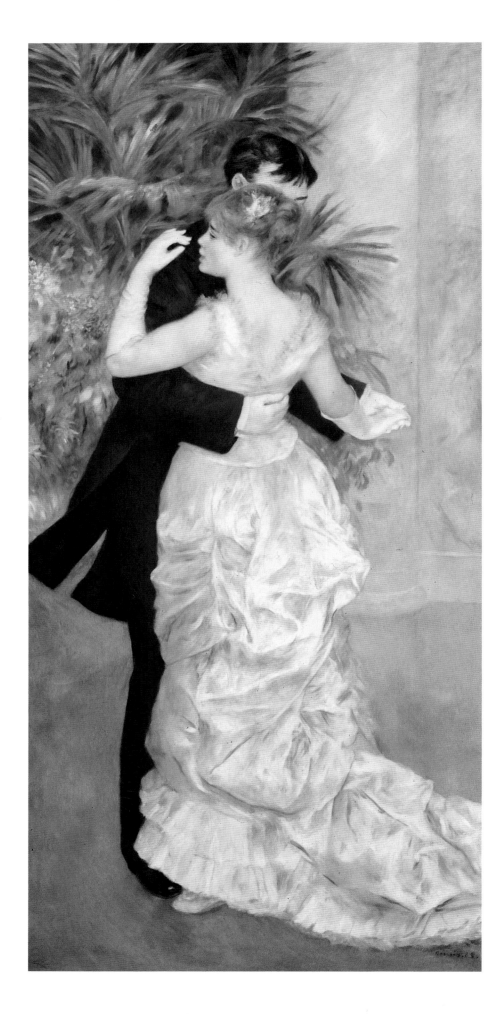

Dance in the City

1883; *oil on canvas;*
70 7/8 x 35 1/2 in. (180 x 90 cm.).
Paris, Musée d'Orsay.
*The present painting was
conceived with its counterpart,*
Dance in the Country, *in mind.
Renoir intended to contrast the
elegant lifestyle of city dwellers
with the simpler earth-bound
traditions of country people. Here,
the woman wears a sumptuous
satin gown while her partner
is dressed in a tuxedo. Aloofness
and distance seem to prevail
over intimacy and pleasure.*

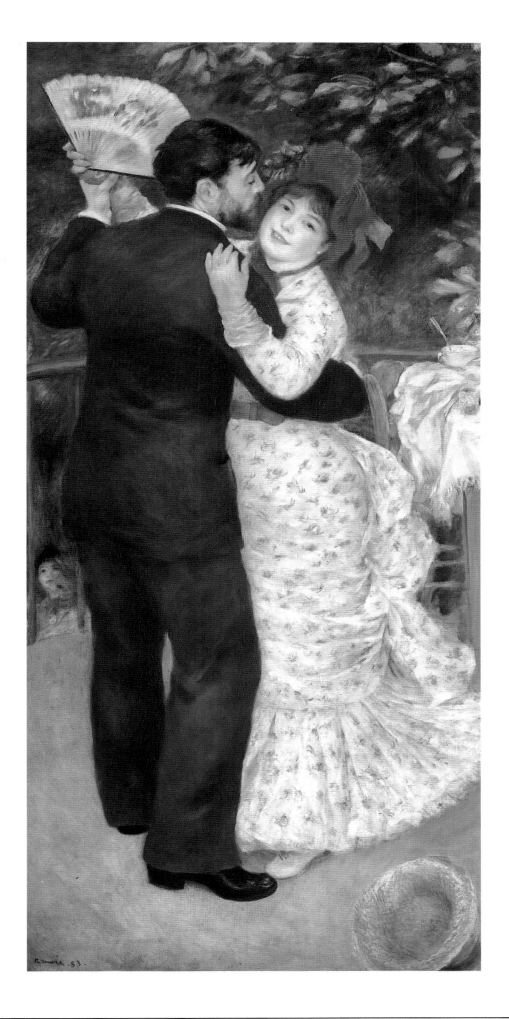

Dance in the Country

1883; *oil on canvas;*
70 7/8 x 35 1/2 in. (180 x 90 cm.).
Paris, Musée d'Orsay.
The artist's wife Aline posed
for this painting together
with their friend Paul Lhote.
Not shy about showing her
sympathy for her dance partner,
Aline is represented, as Renoir
must have known her, as
the perfectly harmonious and
loving woman. Pride and
dignity are paired here with an
obvious enjoyment of a pastime.

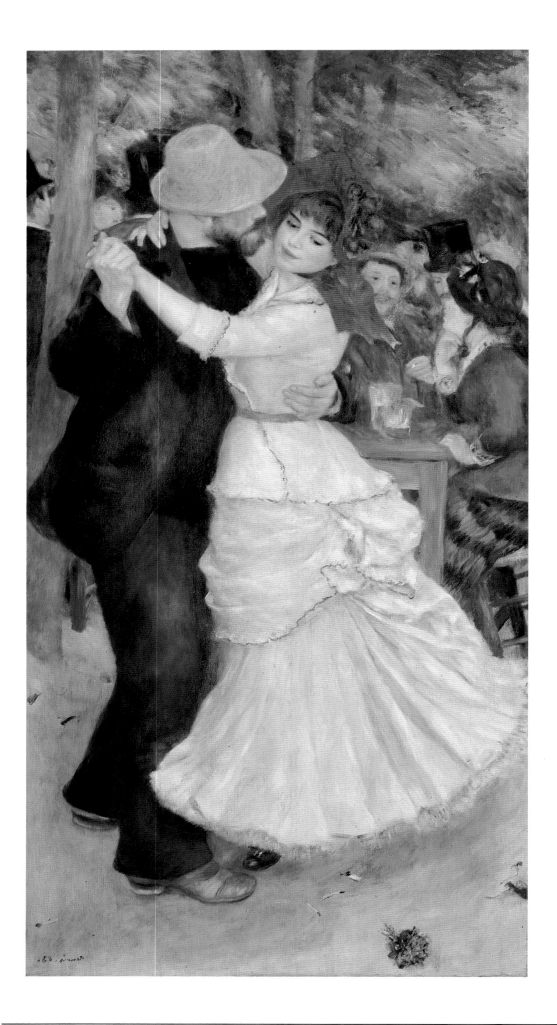

Dance at Bougival

1882-1883; *oil on canvas;*
71 1/2 x 38 1/2 in. (182 x 98 cm.).
Boston, Museum of Fine Arts.
*Related to two other works of the
same subject* (Dance in the City
and Dance in the Country), *this
painting was among Renoir's first
large-scale works after his return
to Paris from Algeria in 1882.
A couple is dancing at an outdoor
café-house in a rustic setting. A
small bouquet of violets and what
appear to be cigarette butts and
matches are strewn on the floor.*

Woman with a Fan

1880; *oil on canvas;*
25 1/2 x 19 3/4 in. (65 x 50 cm.).
St. Petersburg, Hermitage.
*The girl's frontal pose,
accentuated by the fan held
parallel to the picture plane,
is animated by her smile
and a slight inclination of
her head. It is through the
colors, however, that this
portrait displays its liveliness
and vibrancy. The fan is perhaps
a reflection of the popularity of
Japanese objects during this time.*

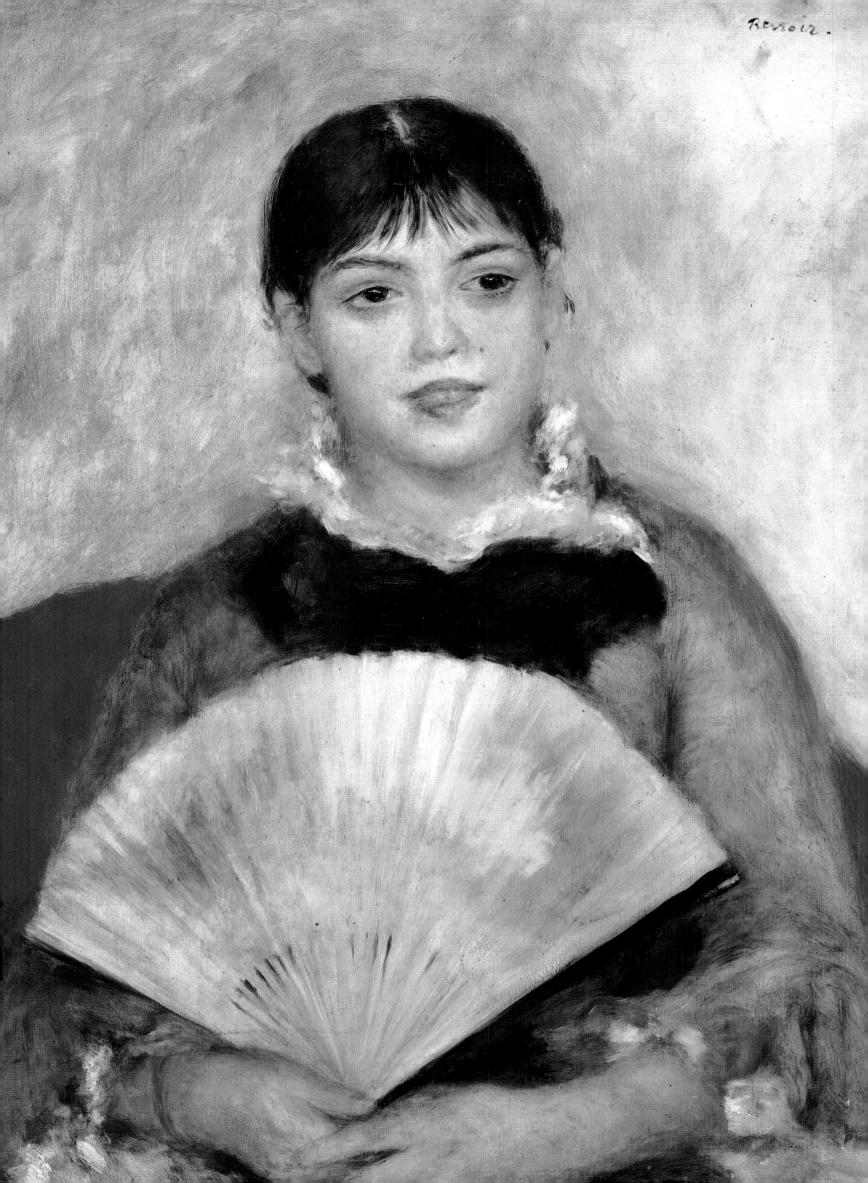

**The Children's Afternoon
at Wargemont**
1884; *oil on canvas;*
51 1/5 x 67 in. (130 x 170 cm.).
Berlin, Neue Nationalgalerie, Staatliche
Museem Preussischer Kulturbesitz.
*Depicted are the three daughters
of the banker Paul Bérard at the
family's summer house in Wargemont
in Normandy on the Channel coast.
Each of the girls is absorbed in her
own activity: reading, needlecraft,
and playing. The bright colors and
clearly defined shapes are indicative
of Renoir's visit to Italy, where
he had seen and appreciated
numerous decorative fresco cycles.*

Woman Reading (La Liseuse)

1874; *oil on canvas;* 17 3/4 x 14 1/2 in. (45 x 37 cm.). Paris, Musée d'Orsay.

*Judging from the smile on her face, a young woman reading a book apparently finds pleasure
in her activity. The close-up perspective and the intimate character of this well-known work makes
the viewer feel somewhat like an intruder, particularly as regards the small size of the canvas.*

Woman in Black

c. 1876; *oil on canvas*; 25 1/8 x 21 1/8 in. (63 x 53 cm.). St. Petersburg, Hermitage.
*A black dress contrasting with the white, open collar and sleeves frames the calm
smile of this young woman. Some scholars identified her as the model Anna, others
believe her to be Mme. Georges Hartmann, wife of a well-known music publisher.*

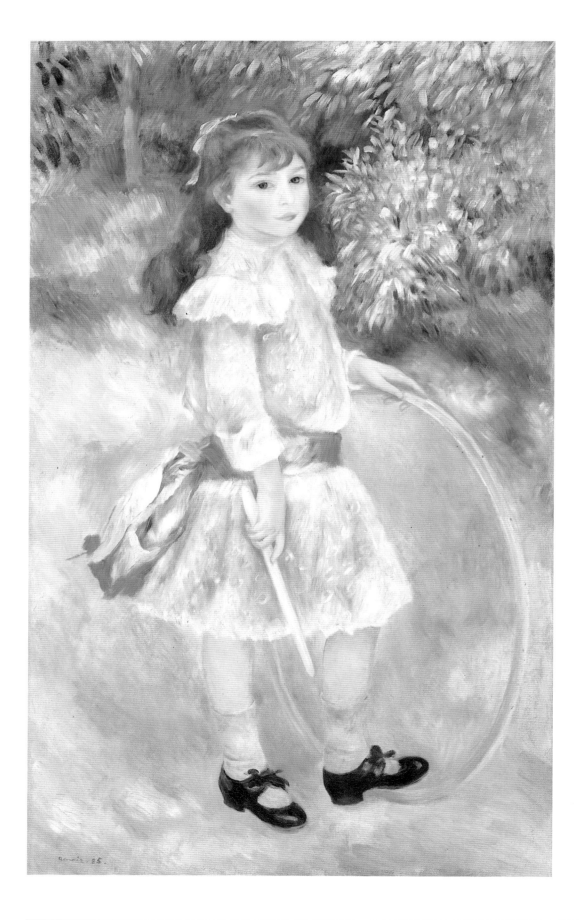

**Girl with a Hoop
(Marie Goujon)**
1885; *oil on canvas;*
49 1/2 x 30 1/8 in. (126 x 77 cm.).
Washington, D.C., National Gallery
of Art, Chester Dale Collection.
*Like her younger brother Etienne,
Marie Goujon is posing in a
garden with toys in her hands.
The two portraits were obviously
meant to be seen as a pair, since
both paintings were executed
in the same color range. Also,
hung next to each other, Marie's
likeness would have looked
toward that of her younger sister.*

**Child with a Whip
(Etienne Goujon)**
1885; *oil on canvas;*
41 3/8 x 29 1/2 in. (105 x 75 cm.).
St. Petersburg, Hermitage.
*Accepting the restraints of a
commissioned portrait, Renoir
nevertheless was able to achieve
a lively portrait of Etienne
Goujon by placing him in a
garden among the dappled
sunlight. The blue, green, and
white color of his attire are
repeated in the flower bed at the
left. The boy's charming face
follows the stylized features of
children in other Renoir portraits.*

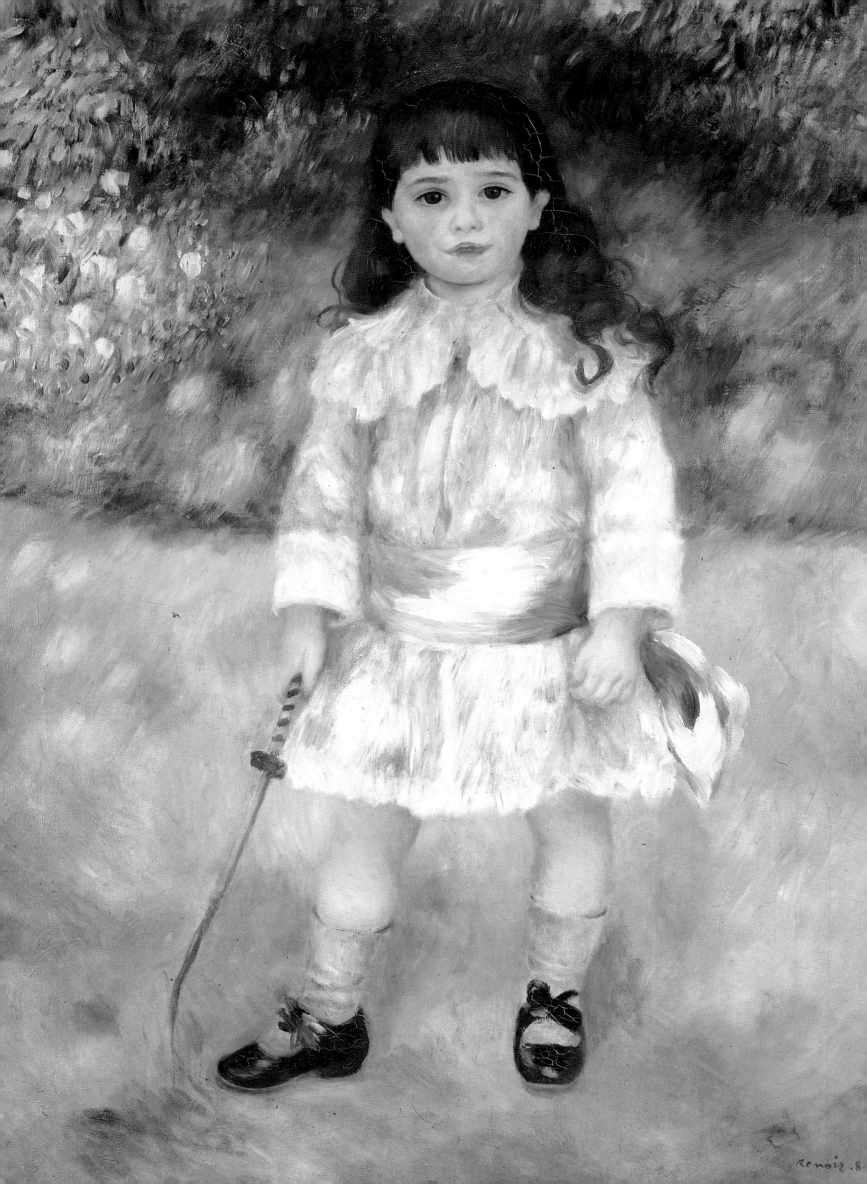

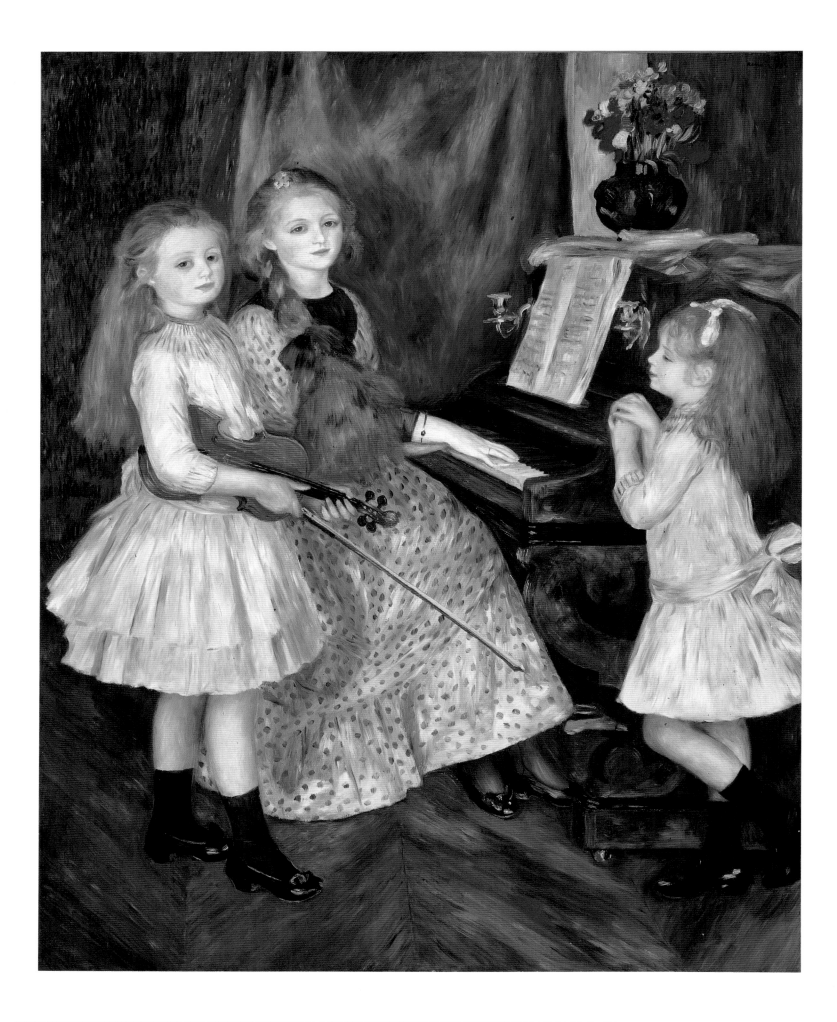

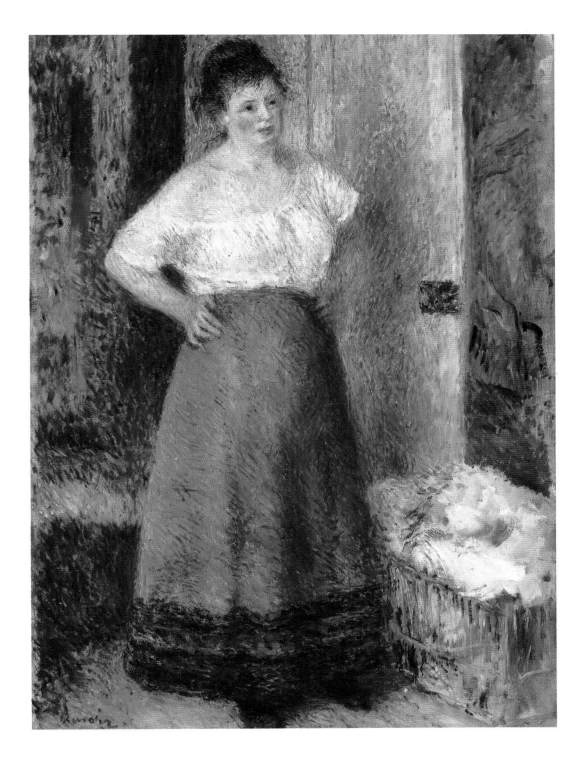

The Laundress

c. 1880; *oil on canvas*; 32 x 22 in. (81.4 x 56.5 cm.).
New York, Metropolitan Museum of Art,
Annenberg Collection.
*Unlike Degas, who analyzed with a mercilessly
sharp eye the world of working women, Renoir
always strived to emphasize the prettiness of
his subjects. This washerwoman has just set
down a heavy basket of laundry, but her face
does not show any sign of fatigue. On the contrary,
she proudly presents her youthful body akimbo.*

The Daughters of Catulle Mendès at the Piano

1888; *oil on canvas*; 63 7/8 x 51 1/8 in. (163 x 130 cm.).
From the Private Collection of the Hon. and Mrs. Walter H. Annenberg.
*Centered around a piano are the three step-daughters of the poet
Catulle Mendès. The eldest girl, Haguette, is seated at the piano against
which the youngest, Helyone, leans. Claudine at the center is holding
a violin. Renoir painted this work for the spring show of Durand-Ruel's
gallery in Paris. Although the forms have somewhat softened and
loosened up, the composition has the static feeling of an arrested moment.*

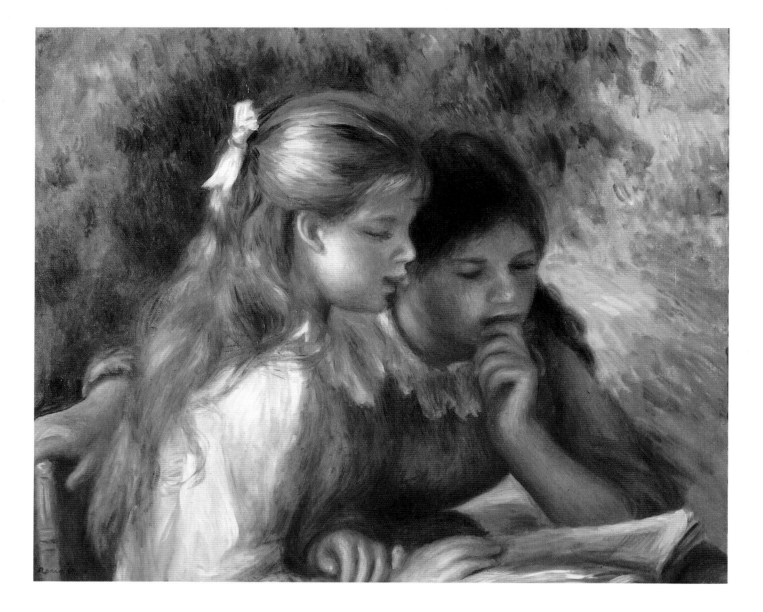

The Reading (La lecture)

c. 1890; *oil on canvas*; 21 1/4 x 26 in. (54 x 66 cm.). Paris, Louvre.
The two girls, absorbed in their reading, evoke a mood
of intimacy and friendship comparable to that of "Yvonne
and Christine Lerolle at the Piano," painted a couple
of years later. Himself father of two children, Renoir
was obviously fascinated by young models and repeatedly
depicted couples of young women in his later years.

The Artist's Family

1896; *oil on canvas*; 68 x 54 in. (173 x 140 cm.).
Merion, Pennsylvania, The Barnes Foundation.
This portrait of the artist's family was executed in the garden
of their house in Montmartre at 13 rue Girardon, a "little
paradise of lilacs and roses," as Jean later recalled. Next to
Aline is eleven-year old Pierre in a sailor suit. At the center,
Jean, not yet two years old, is being attended by his nurse
Gabrielle Renard, who became Renoir's most favourite
model. The girl to the right, who is flirting with Pierre,
might be the daughter of the neighbor Paul Alexis.

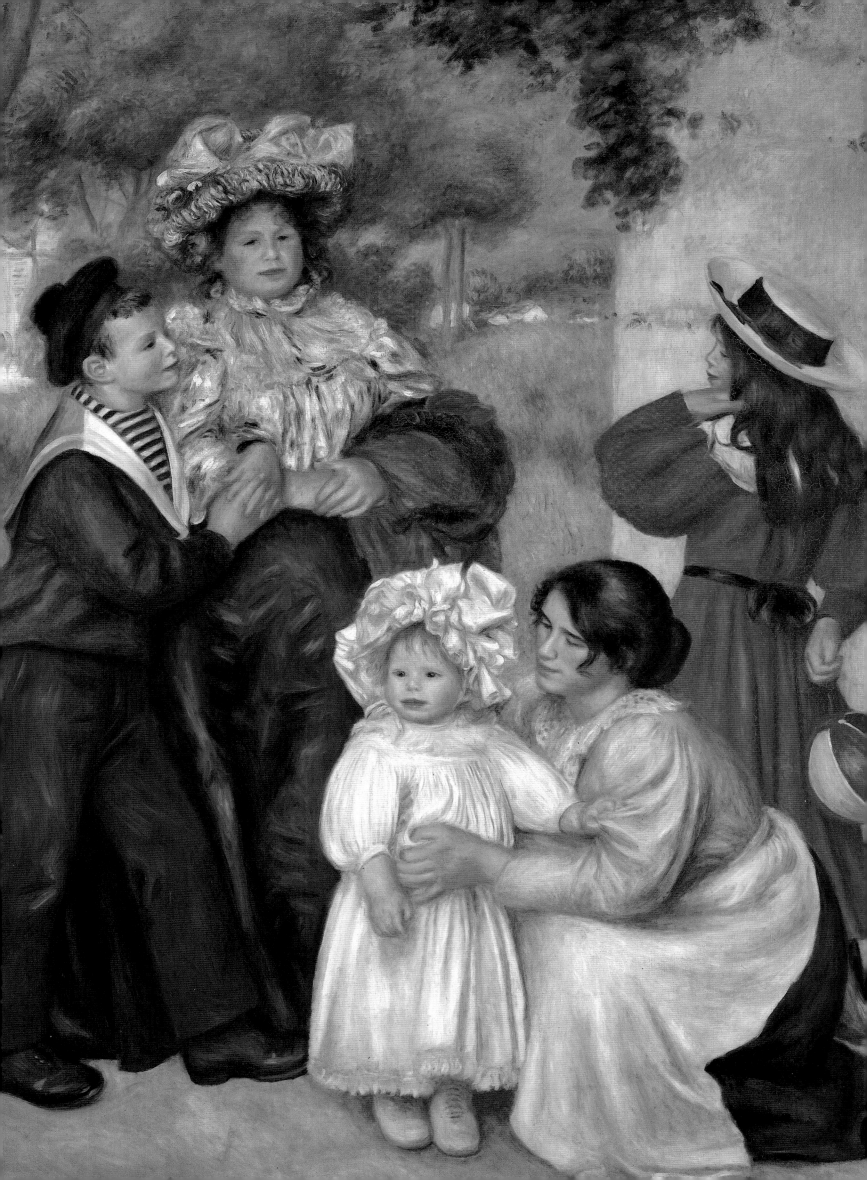

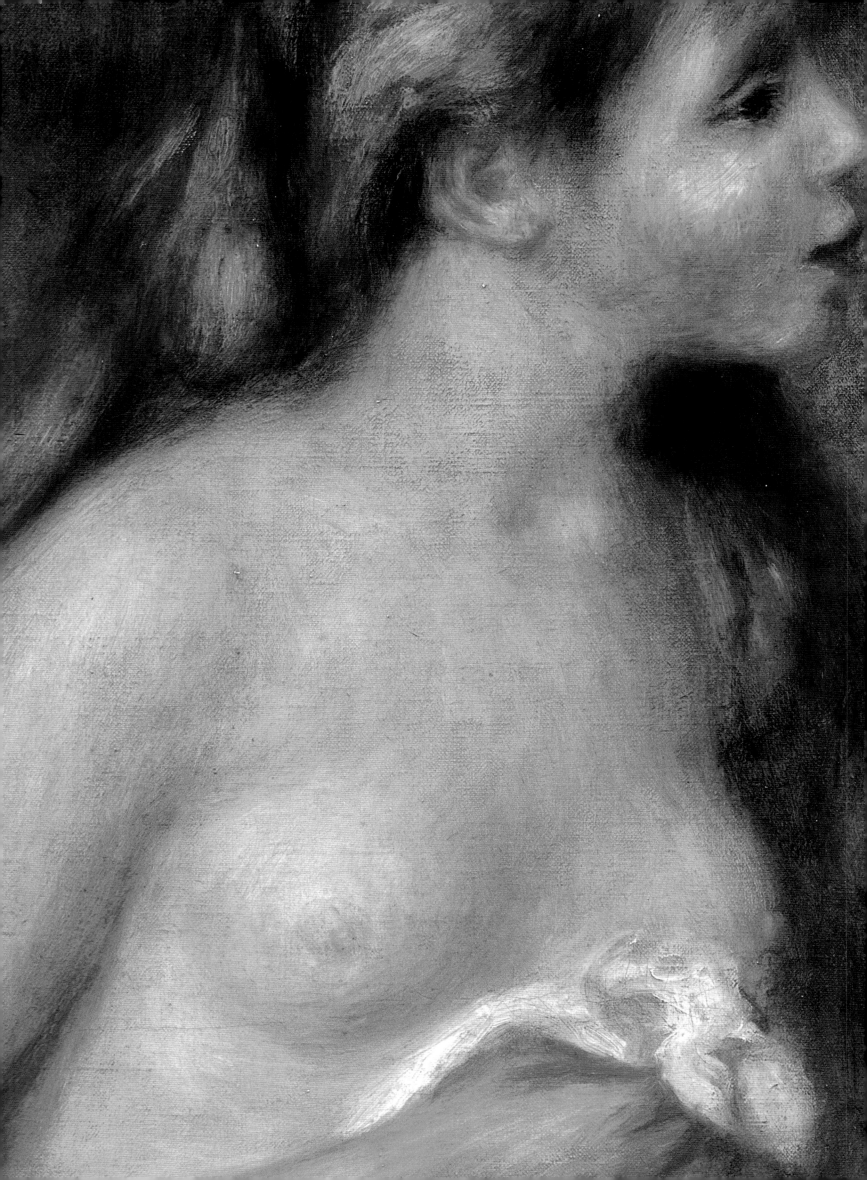

CHAPTER 4

BEYOND IMPRESSIONISM: THE PAINTERS

The role as head of a family occupied Renoir only relatively late in his life, but he turned out to be a caring father for his children. Pierre, his first son, was born in 1885, although he did not marry his companion Aline Charigot until April of 1890 when his financial situation was more stable and his reputation as a painter firmly established. It is also possible that Aline's peasant origin posed a problem for Renoir, who moved freely in the upper-class circles of his friends and patrons. Although it was not uncommon among artists to have a lower-class mistress and an illegitimate child, Renoir might have been concerned that Aline's presence in public could stigmatize him as immoral among people whose patronage he depended upon so heavily. He decided therefore to keep the existence of both Aline and his son a secret. Not even close friends like the painter Berthe Morisot or the poet Stéphane Mallarmé, whom Renoir saw regularly at Morisot's Thursday dinners, had any clue until they were finally introduced to them in July 1891, fifteen months after Renoir's marriage. By then his son Pierre was six years old. Shortly thereafter Morisot wrote to Mallarmé: "Renoir spent some time with us, without his wife this time. I will never be able to describe to you my amazement in the presence of this very heavy person, whom, I don't know why, I had imagined as resembling her husband's paintings. I'll point her out to you this winter." This double existence must have caused many strenuous emotional moments in Renoir's life.

Family Life of the Artist

Just before the birth of his second son, Jean, in the summer of 1894, a nursemaid was found—Gabrielle Renard, a cousin of Aline's from Essoyes. When she joined the Renoir household, she was fifteen years old. Renoir was immediately interested in painting her

likeness, and Gabrielle would continue to model for the artist for the next twenty years, until her marriage to the American painter Conrad Slade in 1914. Her presence revived to some extent Renoir's earlier Impressionist verve, but a new classical tangibility is also apparent at this time.

In a number of paintings, such as in *Gabrielle and Jean*, Renoir depicted his new model together with his children. Here, the already mature-looking young woman is playing with the infant Jean, who by the time of this painting was about one year old. Gabrielle appears here as a symbol of loving and caring motherhood as she tenderly embraces the child.

Venus Victorious
1914, cast c. 1916; *bronze;*
71 3/4 x 44 x 30 1/2 in.
(182.5 x 102 x 77.5 cm.).
London, The Tate Gallery.
This was the first large-scale sculpture the assistant Richard Guino made under Renoir's supervision. Venus, the Goddess of Love, holds the golden apple awarded to her by Paris as a token of her beauty. The model was named Marie Dupuis called La Boulangère, who also posed for a number of Renoir's later paintings. Work on the sculpture was partially executed out-of-doors under the olive trees in the artist's garden at Essoyes.

Bather with Long Hair
detail; 1895, Paris, Musée de l'Orangerie.
Renoir has modeled the flesh with a great variety of tonal degrees, stressing the body's physical presence. The voluptuous forms, which are reminiscent of Rubens's oeuvre, are a hallmark of Renoir's late figure style.

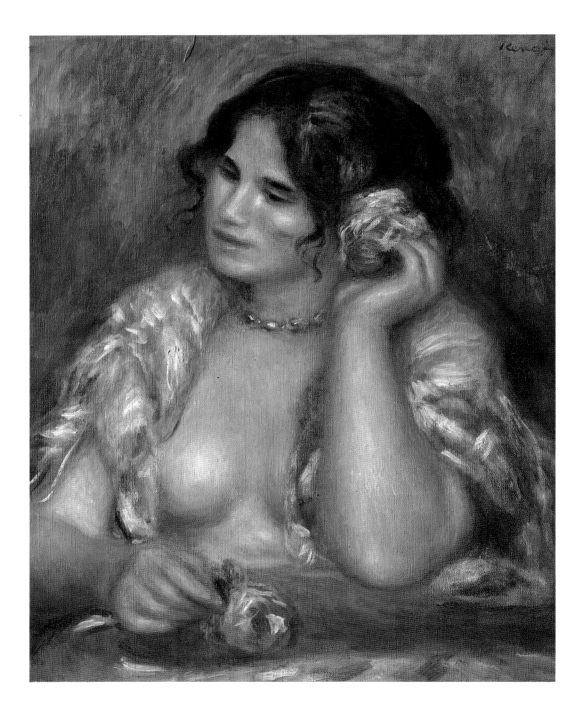

Gabrielle with a Rose
1911; *oil on canvas;*
21 7/8 x 18 1/2 in.
(55.7 x 47 cm.).
Paris, Musée d'Orsay.
*Gabrielle Renard, a
cousin of Renoir's wife
Aline, was the artist's
favorite model for about
twenty years. She had
entered their household
at the age of fifteen in
1894 and lived with
the family until her
marriage to the Ameri-
can painter Conrad
Slade in 1914. Here
she is a mature woman
in her early thirties.*

In a later work, *Gabrielle with a Rose*, painted in 1911, Renoir focused on the sensuousness of the young woman at her toilet. Her head almost completely fills the canvas and with a touching gesture she is about to fix a rose in her hair. As in most paintings from this period, Renoir idealized the eternally feminine in a timeless and private world.

To this one could add the element of ruralism when talking about Renoir's bathers. Although the subject itself is certainly not a surprising choice, especially since it reflects his earlier academic training of nude paintings, the intensity with which he pursued the subject must at least be called astonishing.

In 1887 he exhibited a first important painting of this subject, *The Large Bathers*, at the gallery of Georges Petit. By that time, Renoir had moved away from Impressionism and followed a new path of a more linear Classicism, with clearly defined forms. Conceived as a large-format presentation piece with many figures out-doors, Renoir prepared this ambitious painting with the same care and intensity as he had *Ball at the Moulin de la Galette* or *Luncheon of a Boating Party*. More than twenty preparatory drawings were made in order to find the cor-rect pose, form, composition, and technique. The most dominant and perhaps also surprising quality of *The Large Bathers* is its realistic appearance. The clientele of Petit's gallery was from the middle class and encouraged such tendencies. Pissarro wrote about the

exhibition: "I've had a lot of trouble with this damned exhibition, which stinks of bourgeois. . . . But you have no idea how one is a slave of that milieu, and how easy it is for the powerful to interfere with the freedom of others."

Durand-Ruel, the painter's long-time dealer, had shown disappointment with Renoir's latest achievements. For him, Renoir's departure from Impressionism was a mistake. But Renoir had as a goal the ability to capture the same qualities that he admired in paintings of Raphael, Ingres, and the Pompeiian frescoes: clear composition, firmly modeled forms, precise outlines of the figures, meticulous execution; in other words, the qualities of the masters. This eclecticism also corresponded to contemporary taste, and an additional motive for Renoir's change of style, besides inherent artistic reasons, might very well have been a financial one. Conservative paintings sold better than the works of the avant-garde. However, despite his efforts and expectations, the result is somewhat disappointing. The figures, which were painted in porcelain-smooth flesh tones, are isolated from the surrounding landscape. As a result, they appear almost like cut-outs.

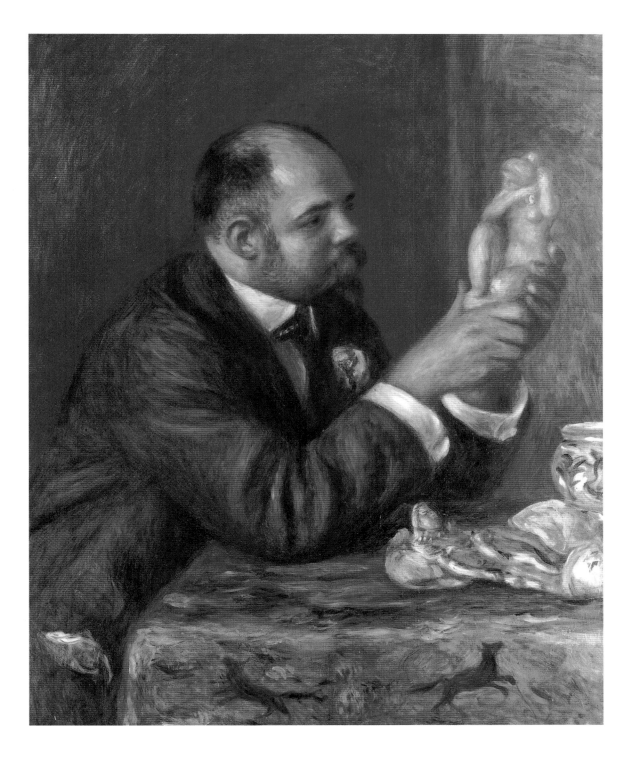

Ambroise Vollard
1908; *oil on canvas;*
31 1/8 x 25 1/2 in.
(81 x 64 cm.).
London, The Courtauld
Institute Galleries.
The sitter, Ambroise Vollard, was one of the most influential art dealers in Paris at the time and eventually became a strong supporter of artists like Picasso and Matisse. He met Renoir in 1894 or 1895 and influenced the artist during the final twenty years of his life. Here, Vollard is holding a plaster statuette made by the French sculptor Aristide Maillol.

The pervasive anemic orange has often been referred to as "acid" or "sour" and the overall impression is artificial and stiff. All this said, one can still admire the refinement of the female bodies, for which the dark-haired Aline and the blonde Suzanne Valadon had posed.

Renoir later distanced himself from this transitional period. When he painted a replica of the bathers for Ambroise Vollard in 1901 (today in the museum in Nice), the result was an integration of Classicism and Impressionism. The tangible forms are imbedded in a warm atmosphere created by expressive brushstrokes of vibrant colors and sparkling light. Idealization and universality are successfully blended with Impressionist feelings of movement and joyfulness. Naturalism and unity prevail over artificiality.

Final Masterpieces

The whole of Renoir's artistic endeavors and experience culminated in one of his last works, *The Bathers*. Painted as a symbol of triumph right after the signing of the armistice in 1918, it summarizes his experiments of the past through its synthesis of Classicism in form and composition on the one hand and Impressionism in the brushwork and light on the other. Its monumental dimensions suggest that Renoir made it as an exhibition or even a museum piece. Even without considering Renoir's advanced age and the fact that his hands were almost completely crippled by arthritis, one can not but admire the mastery with which the artist painted this symphony of voluptuous female flesh.

A visit to Munich in 1910, where Renoir saw the extensive collection of paintings by Peter Paul Rubens at the Alte Pinakothek, had revived his interest in the exuberant style of the great Flemish master. He had made his first copies after Rubens's canvases in the Louvre as far back as the early 1860s. Even now, fifty years later and himself an accomplished painter, he still extracted learned example from works of the past. As he confided to his artist friend Albert André earlier that same year: "I am so lucky to have painting, which even very late in life still furnishes illusions and sometimes joy."

Yet the artist's output diminished increasingly over his last years. Suffering frequently from excruciating arthritic pain, Renoir spent most of the time in his home in Cagnes in the warm climate of the south of France. Assistants and models would carry him in his armchair to the studio, where they had to place the paintbrushes into his hands since he could hardly move them any longer. Jean Renoir, who was to become a world-famous film director, poignantly described his father at seventy: "What struck outsiders coming into his presence for the first time were his eyes and hands. His eyes were light brown, verging on yellow. His eyesight was very keen. . . . As for their expression, imagine a mixture of irony and tenderness, of joking and sensuality. They always looked as though they were laughing. . . . Perhaps it was also a mask. For Renoir was extremely modest and did not like to reveal the emotion that overwhelmed him while he was looking at flowers, women, or clouds in the sky, the way other men touch and caress. His hands were terribly deformed. Rheumatism had cracked the joints, bending the thumb toward the palm and the other fingers toward the wrist. Visitors who weren't used to it couldn't take their eyes off this mutilation." Photographs of the ailing Renoir confirm his son's vivid description.

Following a suggestion by Ambroise Vollard, Renoir took an assistant of the sculptor Aristide Maillol named Richard Guino into his house to have him execute wax or clay models after his instructions, which would later be cast in bronze. *Mother and Child* was originally intended for Aline's tomb in Essoyes. She had died of a heart attack in 1915. Other works like *Venus Victorious* and *The Washerwoman* also celebrate the female body in voluptuous form in the tradition of Rubens. The portrait *Ambroise Vollard* shows the gallery owner holding and admiring a statuette by Maillol.

Fame arrived early enough for Renoir to be enjoyed, although he was too modest to go after honors and medals. Nevertheless, in 1900 he accepted the nomination of a Chevalier of the Legion of Honor. Monographs were dedicated to his oeuvre and famous colleagues like Auguste Rodin and the young Pierre Matisse came to visit him at Cagnes. Forgeries circulated during the painter's lifetime, which naturally very much annoyed him.

To this day Renoir's fame remains unabated, and his work continues to be enjoyed and appreciated on a grand scale the world over.

Nude in a Chair
1900; *oil on canvas;* 21 x 18 in. (55 x 46 cm.). Zurich, Kunsthaus.
The motif of this nude seated on a chair appears in other works of Renoir's late period, like in the "Bathers in the Forest" and is obviously executed in the studio. The color of flesh and the curvilinear forms of the body are echoed by the chair and the draperies around the figure.

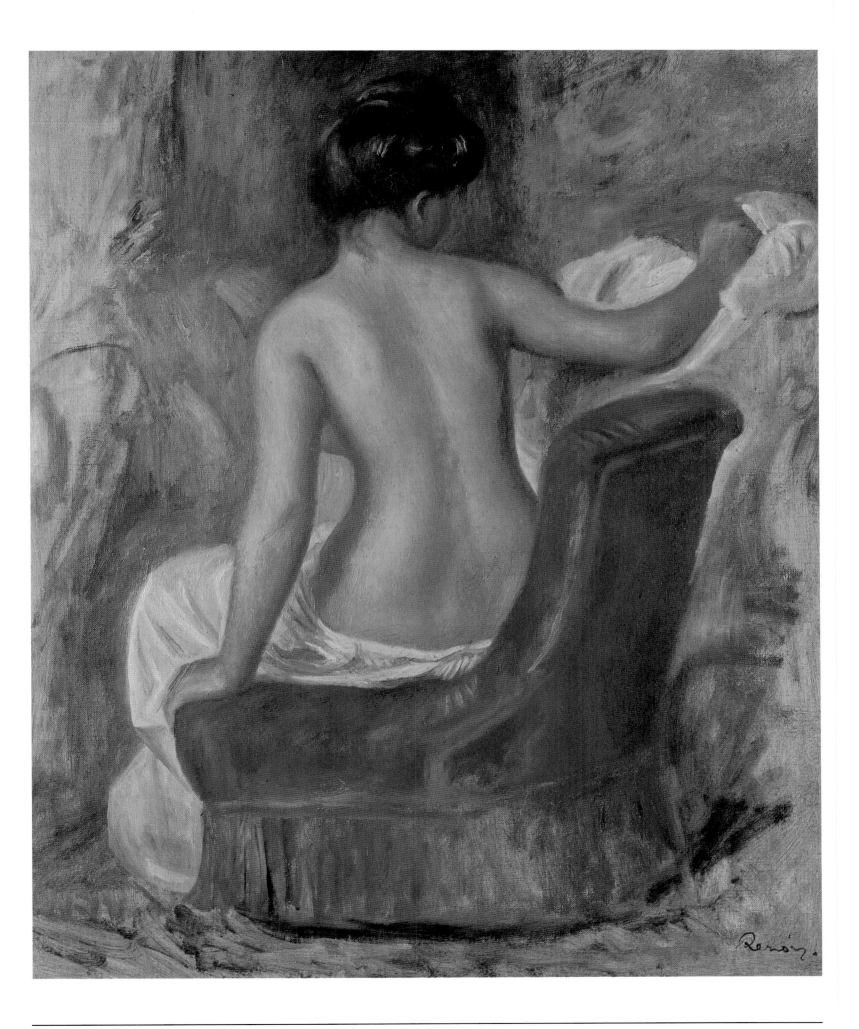

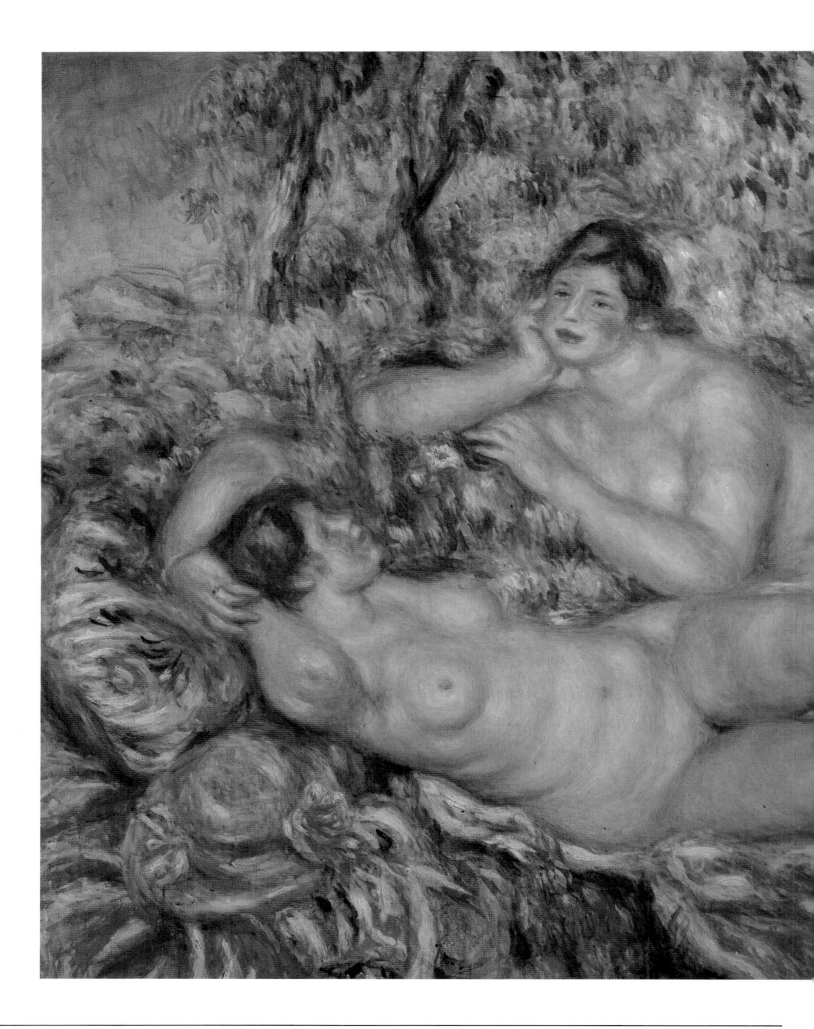

The Bathers
1918-1919; *oil on canvas;*
43 1/4 x 63 in. (110 x 160 cm.).
Paris, Musée d'Orsay.
*Painted shortly before
his death, at a time when
the artist's hands were
severely crippled by arthritis,
Renoir called this work the
culmination of his life's
work. The theme of nude
bathers had occupied Renoir
for several decades, but
rarely had he imbued
the figures with such
warmth and sensuousness.*

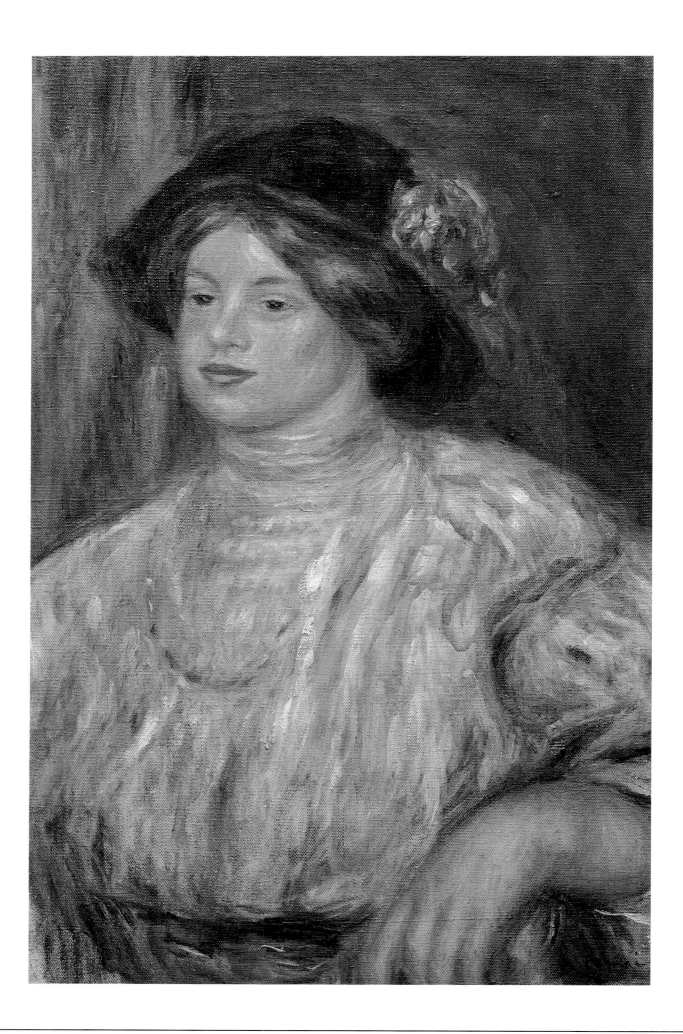

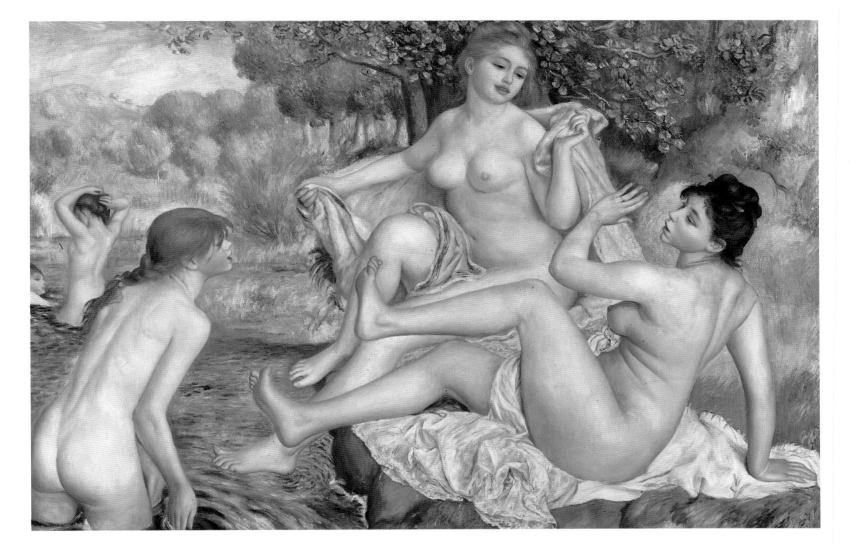

The Large Bathers

1884-1887; oil on canvas; 46 3/8 x 67 1/2 in. (117.8 x 170.8 cm.).
Philadelphia, Pennsylvania, Museum of Art.
During his visit to Italy, Renoir admired the fresco cycles of Raphael and the Roman frescoes in Pompeii, resulting in what is called Renoir's "dry" style. Bathers *was meant to be seen as a decorative painting, focusing on the sensuous treatment of the female bodies rendered in high keys. The carefully studied poses can be related to a variety of classical and contemporary sources.*

Gabrielle with a Large Hat

c. 1900; *Oil on canvas*; 21 5/8 x 14 1/2 in. (55 x 37 Cm.).
Grenoble, Musée des Beaux-Arts.
Gabrielle is the most frequently painted model in Renoir's oeuvre. Her presence in the artist's household was crucial both in the role as the painter's muse as well for his two children, who were taken care of by this young woman. Renoir painted her here still as a young woman wearing a straw hat, whose round shape corresponds to her stout figure.

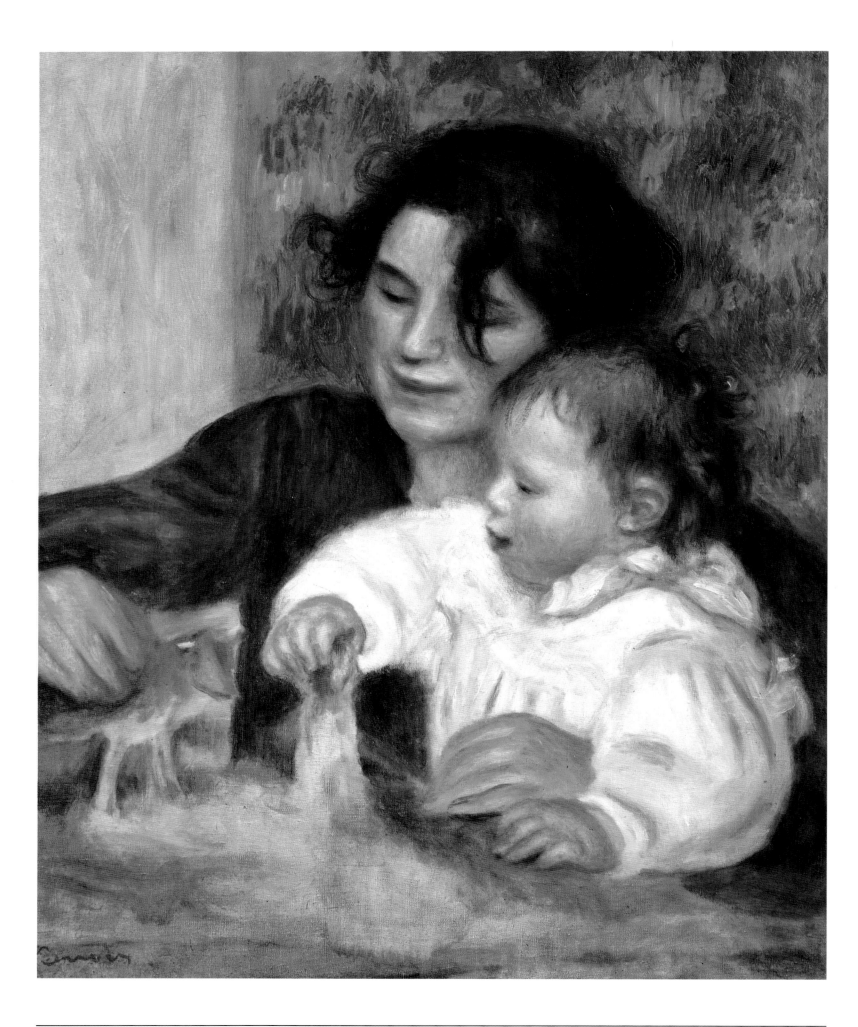

The Guitar Player
1896-1897; *oil on canvas*; 43 x 25 1/2 in. (81 x 65 cm.).
Lyon, Musée des Beaux-Arts.
*Renoir's later works are characterized by a return
to a classical style, which differs from the spontaneous
and contemporary look of his earlier paintings.
The carefully studied pose of the woman holding
a guitar on her knees as well as her folkloristic
Spanish costume—instead of an everyday sort of
dress—are signs of Renoir's change of approach.*

Gabrielle and Jean
1895; *oil on canvas*; 25 1/2 x 21 1/4 in. (65 x 54 cm.).
Paris, Musée de l'Orangerie.
*In a variety of paintings Renoir depicted his family
servant Gabrielle Renard together with his second
son Jean—born in 1894—who was to become a
world-renowned film director. The artist focused
on the smiling faces of his sitters, while the objects
with which they are playing are left undefined.*

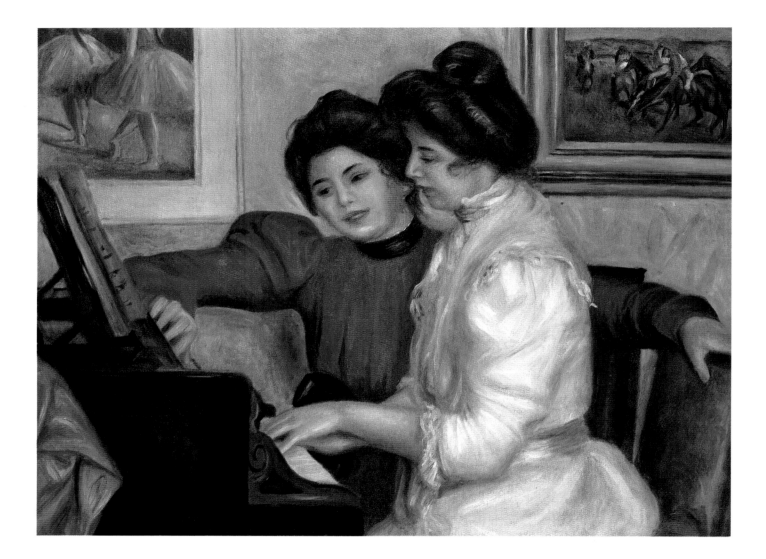

Yvonne and Christine Lerolle at the Piano
1897; *oil on canvas*; 45 2/3 x 35 1/2 in. (116 x 90 cm.).
Paris, Musée de l'Orangerie.
*The subject of two young girls at the piano seems
to have fascinated the artist, who returned to it
several times. Playing the piano had become a
fashionable part of a young woman's education
and was considered a practical form of entertain-
ment during private gatherings and celebrations.*

Head of a Girl
1898; *oil on canvas*; 10 5/8 x 7 7/8 in. (27 x 20 cm.).
London, The Tate Gallery.
*The exact reference for this picture is not clear.
Renoir might have made it as a study of a servant
girl since he often used them as models in his later
years. The girl's striped blouse is a lively counterpoint
to the twisted hair. Her face expresses a natural modesty.*

Peaches and Almonds
1901; *Oil on canvas*; 12 1/4 x 16 1/4 in. (31.1 x 41.3 cm.).
London, The Tate Gallery
*This late still life exemplifies Renoir's unabating
sensitivity to the surface texture of the objects.
Since he suffered increasingly from arthritis
and rheumatism, Renoir focused in his later
years on interior scenes and the still life.*

Red Pagliaccio
1909; *oil on canvas*; 50 3/8 x 34 5/8 in. (128 x 88 cm.).
Paris, Musée de l'Orangerie.
*The artist's youngest son, Claude, wears the traditional
carnival costume of Pagliaccio, an Italian character.
"Coco"'s immobile pose in this painting seems to contradict
the gaiety established by the red color of his outfit.*

Claude Renoir Playing
c. 1905; *oil on canvas*; 18 1/8 x 22 in. (46 x 55 cm.).
Paris, Musée de l'Orangerie.
*Absorbed in play with his little tin figurines,
Claude, the artist's third son, was the most
frequently painted child in the family. Born in
1901 in Essoyes, "Coco," as he was affectionately
called, is dressed in a garment of bright red,
Renoir's favorite color during this period. The
close-up point of view heightens the sense of intimacy.*

Little Girl with Straw Hat
c. 1908; *Oil on canvas*; 18 1/8 x 14 in. (46 x 35 cm.).
Paris, Musée d'Orsay.
*Throughout his lifetime, but particularly in his later
years, Renoir made numerous quick studies of models or
occasional sitters like this little girl. Her head and the
straw hat she is wearing are enough to serve as a motif.
Rather than depicting the girl's individual features, it is her
physical presence alone which Renoir expressed in this work.*

Bather with Long Hair

c. 1895; *oil on canvas;* 32 x 25 1/2 in. (82 x 65 cm.). Paris, Musée de l'Orangerie.

The woodland setting, the summarily suggested space, the diffused lighting, and the soft gradations of tone and color are characteristics of Renoir's style in the 1890s. The influence of Camille Corot is most evident in the limited color range of beige, yellow, and muted greens.

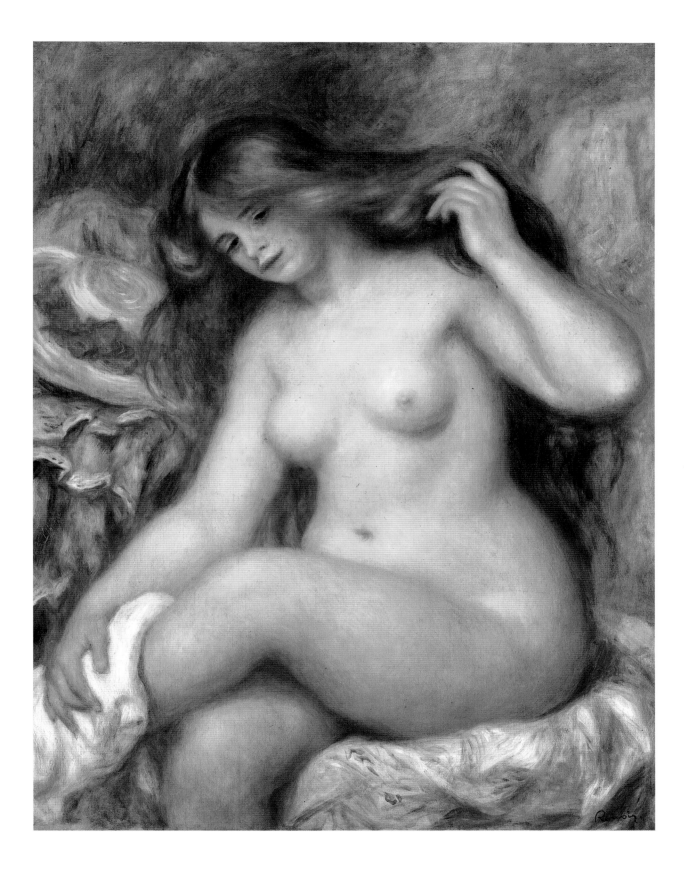

Bather with Blonde Hair

1904-1906; *oil on canvas;* 36 1/4 x 28 3/4 in. (92 x 73 cm.). Vienna, Neue Galerie.

After a two-month period of paralysis, during which Renoir was incapable of painting at all, he did a number of paintings of bathers that are among his most sensual nudes, voluptuous in form and fresh in their youth. This palpably rich-fleshed model captures a most powerful sexuality in the tradition of Titian or Rubens.

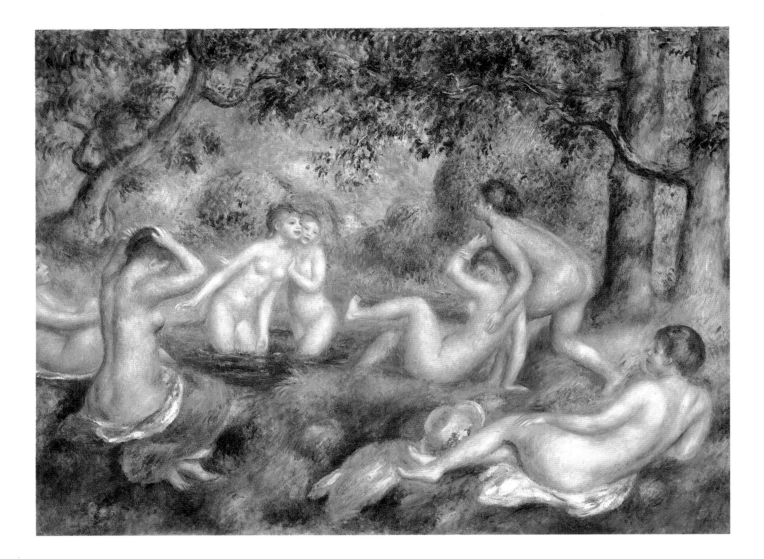

Bathers in the Forest

c. 1897; *Oil on canvas*; 29 x 39 1/4 in. (73.7 x 99.7 cm.).
Merion, Pennsylvania, The Barnes Foundation.
Renoir treated repeatedly the subject of bathers both in
groups and individuals. Here a number of preparatory
paintings and studies have been combined into a large
scale composition, arranging the figures in a circle.
Although compositionally separate, the bathers relate
to each other through gestures or glances. The high keys
of the palette express the rejuvenating forces of nature.

The Toilette: Woman Combing her Hair

1907-1908; *oil on canvas*; 22 x 18 1/4 in. (55 x 46 cm.).
Paris, Musée d'Orsay.
Standing in front of a mirror and washstand, the
young woman is shown arranging her long black hair,
which is falling all the way down her back. The close-up
view of the subject makes this a highly intimate scene.
The energy of the woman combing her hair is expressed
in the artist's vigorous treatment of her bare arms.

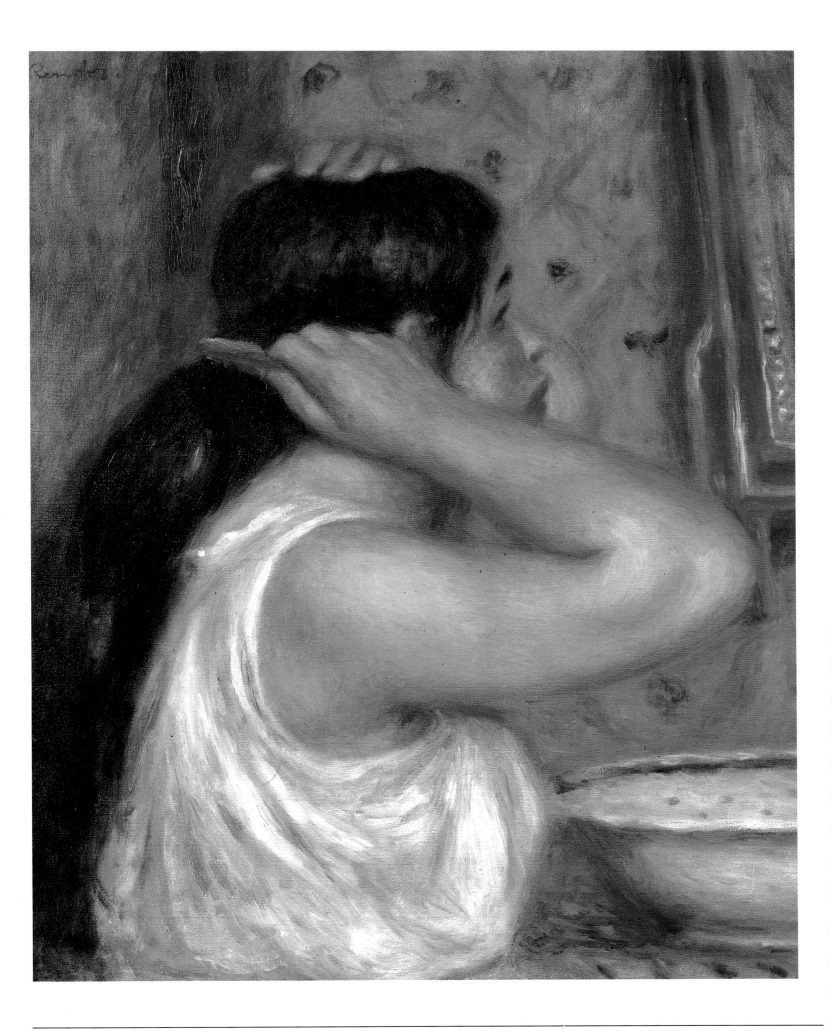

Terrace at Cagnes
1905; *oil on canvas;*
18 x 22 in. (46 x 55.5 cm.).
Tokyo, Ishibashi Collection.
*When Renoir's arthritis began
to severely hamper his work,
he decided to leave Paris during
the winter months for the
warmer climate in the south
of France. He rented a house
in Cagnes-sur-Mer, where he
stayed periodically with his
family for a number of years.
This view of Cagnes was painted
during the winter of 1905.*

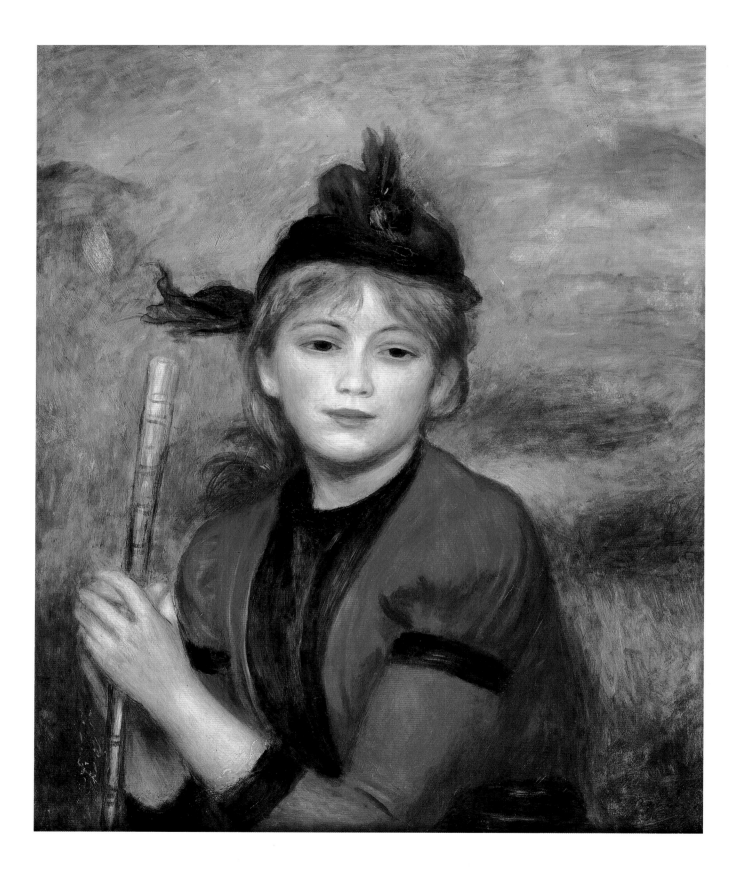

The Rambler

c. 1895; *Oil on canvas*; 24 1/4 x 19 3/4 in. (61.5 x 50 cm.). Le Havre, Musée des Beaux-Arts, André Malraux.

The twisted body of this woman, who is holding a walking stick, expresses energy and movement generally associated with a rambler. Her pose, however, is graceful, and her gentle look reveals a sympathetic character. The sportif dress fits tightly around her narrow waist thus underlining her vigorous appearance.

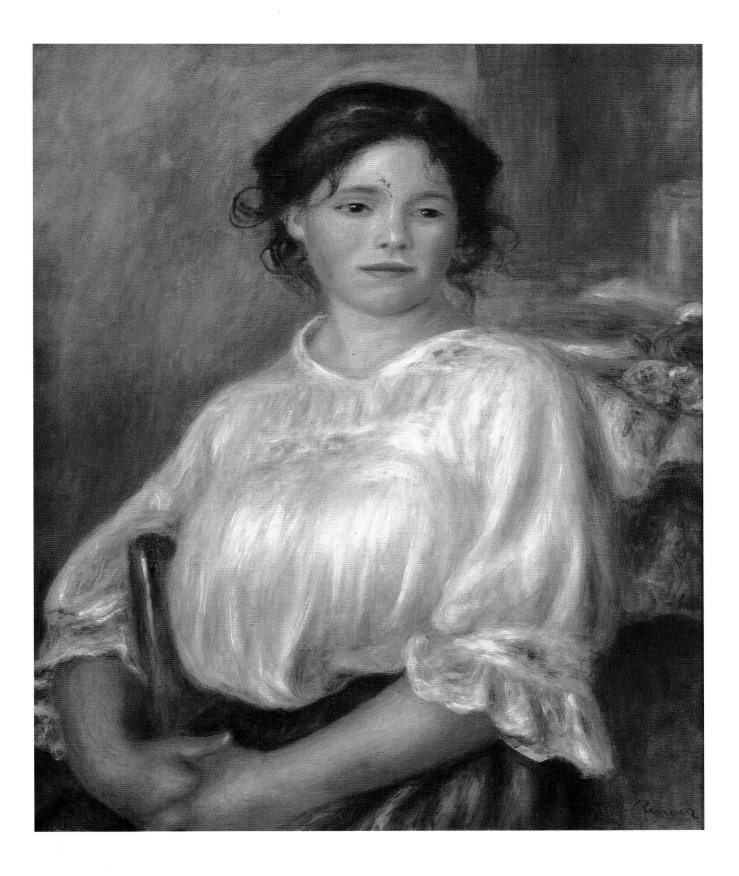

Young Woman Sitting (Hélène Bellon)
1909; *oil on canvas*; 25 3/4 x 21 1/2 in. (65.5 x 54.5 cm.). Paris, Musée d'Orsay.
*Hélène Bellon was the sitter for this painting, executed in 1909 and donated
to the Louvre two years later by its owner Count Isaac de Camondo. Her
melancholic eyes under a crop of black hair contrast well with her white blouse.*

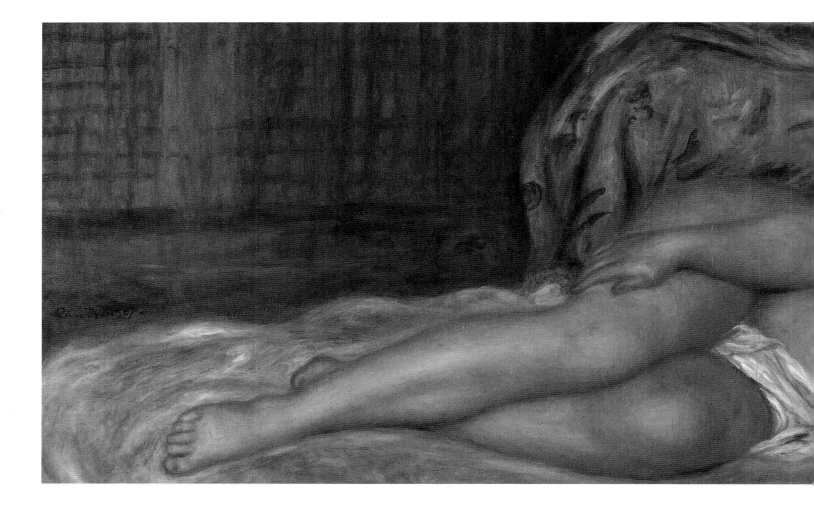

Large Nude

1907; *Oil on canvas*; 27 1/2 x 61 in. (70 x 155 cm.). Paris, Musee d'Orsay.
In his old age, Renoir, crippled by a severe case of arthritis, seemed
to have become obsessed with voluptuous figures of female nudes.
The fact that his wife Aline was also stoutly built, might very well
have contributed to the painter's preference for the full body type.

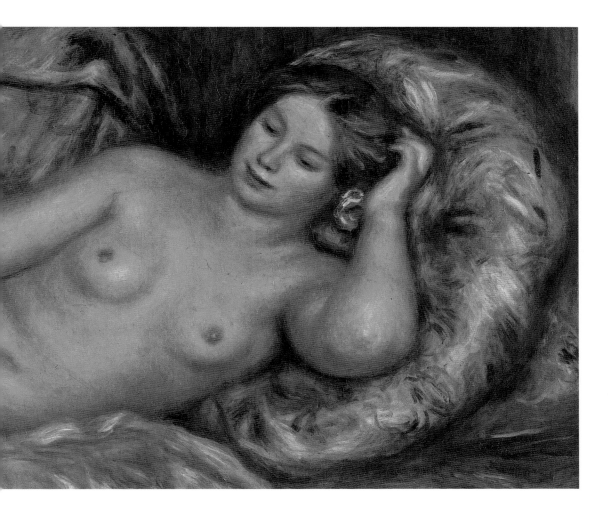

**Reclining Woman,
Seen from the Back**
1909; *oil on canvas;*
16 x 20 1/2 in. (41 x 52 cm.).
Paris, Musée d'Orsay.
*Nudes on a couch or a chair are
a frequent motif during Renoir's
late period. The models display
their bodies with a natural
nonchalance. The high keys
have been toned down to a
harmony in yellow and brown.
The pose of this nude seen
from the back recalls Velazquez'*
Venus looking into the mirror.

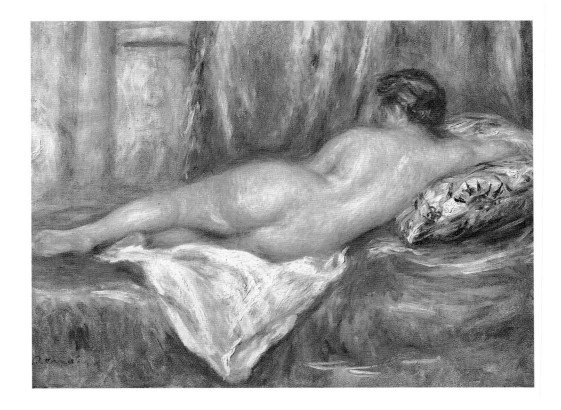

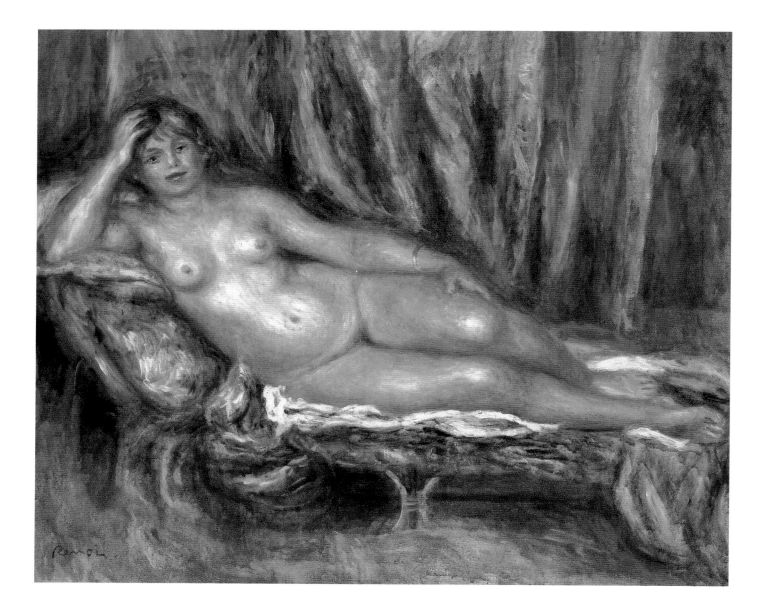

Nude on a Couch

1915; *oil on canvas;* 20 3/8 x 25 5/8 in. (51.8 x 65.2 cm.).
London, The Tate Gallery.
Stretched out on a chaise longue, her head resting on
her arm, this nude is actively looking out at the viewer.
Green, yellow, brown, and some blue hues dominate
the coloristic impression, which relates to the experience
of Rubens's paintings in the Louvre, copied by Renoir
on numerous occasions during his earliest years of study.

Bather Drying her Leg

1910; *oil on canvas;* 33 x 25 1/2 in. (84 x 65 cm.).
São Paulo, Museu de Arte, Assis Chateaubriand.
Renoir's bathers are voluptuous figures in the
tradition of the master Rubens. The palette is
toned down to flesh colors and a yellow-brown
background, and the bather fills virtually the
whole canvas, leaving little room for decor.

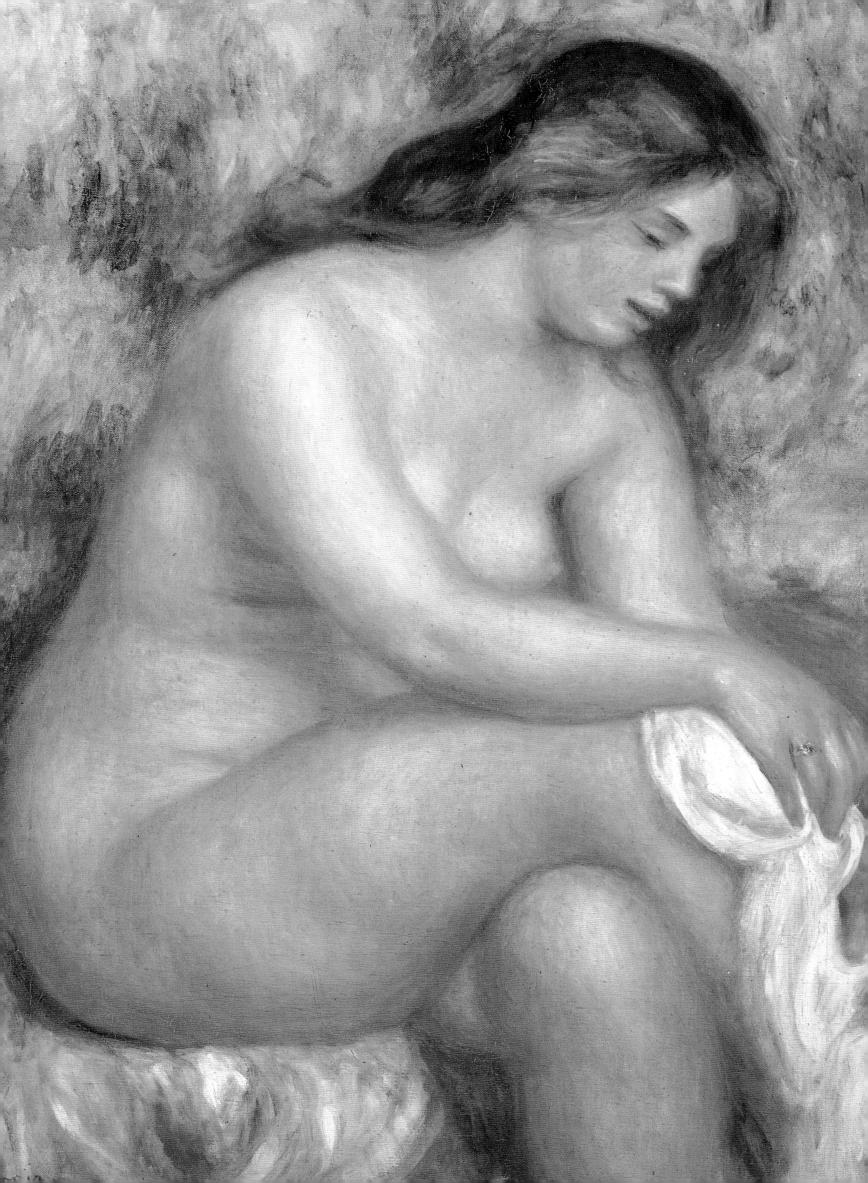

CREDITS

Kunsthalle, Hamburg, Germany, Art Resource, New York, p. 44

Kunsthaus, Zurich, Switzerland, Giraudon/Art Resource, New York, pp.51, 117

The Metropolitan Museum of Art, New York, NY, p. 86 ©1993, p. 95 ©1990, p.96 ©1989/1990, p. 101 ©1993 Wolfe Fund, 1907, Catherine Lorillard Wolfe Collection (07.122), pp. 76 (detail), 94

Musée de l'Orangerie, Paris, France, Giraudon/Art Resource, New York, pp. 112 (detail), 122, 124, 126, 129, 130

Musée des Beaux-Arts, Grenoble, France, Art Resource, New York, p. 120

Musée des Beaux-Arts, Le Havre, France, Giraudon/Art Resource, New York, p. 136

Musée des Beaux-Arts, Lille, France, Art Resource, New York, p. 63

Musée des Beaux-Arts, Lyon, France, Art Resource, New York, p. 123

Musée d'Orsay, Paris, France, Art Resource, New York, pp. 21; Giraudon/Art Resource, New York, pp. 11, 15 (detail), 30, 43, 49, 61, 66, 67, 68, 80, 81, 104, 128, 138-139, 139 (right); Erich Lessing/Art Resource, New York, pp. 6-7 (detail), 8, 10 (detail), 20 (bottom right), 22-23, 36, 58, 59, 84, 98, 99, 114, 118-119, 137

Musée du Louvre, Paris, France, Art Resource, New York, pp. 110, 111

Musée du Petit Palais, Geneva, Switzerland, Art Resource, New York, p. 12

Musée Marmottan, Paris, France, Giraudon/Art Resource, New York, p. 27

Museu de Arte Assis Chateaubriand, Sao Paulo, Brazil, photograph by Luiz Hossaka, p. 90; Art Resource, New York, pp. 17, 19, 25, 83, 141

Museum of Fine Arts, Boston, MA, Julia Cheney Edwards Collection, p. 50; Gift of Arthur Brewster Emmons, p. 69; Picture Fund, p. 100; Courtesy, Museum of Fine Arts, Boston.

Narodni Gallery, Prague, The Czech Republic, Erich Lessing/Art Resource, New York, p. 42

The National Gallery, London, England, Reproduced by courtesy of the Trustees, p. 48

National Gallery of Art, Washington, D.C., © 1993, Chester Dale Collection pp. 24, 31 (detail), 41, 106; Gift of Sam A. Lewisohn, p. 62; Gift of Mr. and Mrs. Benjamin E. Levy p. 79; Gift of Angelika Wertheim Frink p. 89; Widener Collection, p. 92

Neue Galerie, Vienna, Austria, Art Resource, New York, p. 131

Neue Nationalgalerie, Staatliche Museum Preussischer Kulturbesitz, Berlin, Germany, pp. 74, 102-103

Neue Pinakothek, Munich, Germany, p. 75

Philadelphia Museum of Art, Philadelphia, PA, From the Private Collection of The Hon. and Mrs. Walter H. Annenberg, p. 108; The Henry P. McIllhenny Collection in memory of Frances P. McIllhenny, p. 86 (left); Mr. and Mrs. Carroll S. Tyson Collection, p. 121

The Phillips Collection, Washington, D.C., pp. 70-71

Private Collection, Geneva, Switzerland, Art Resource, New York, p. 13

Pushkin Museum of Fine Arts, Moscow, Russia, Art Resource, New York, pp. 45, 82, 91, 144

Oscar Reinhart Collection, Winterthur, Switzerland, Art Resource, New York, p. 5

Rijksmuseum Kroeller-Mueller, Otterlo, The Netherlands, p. 77

Staedelsches Kunstinstitut, Frankfurt, Germany, p. 60

The Tate Gallery, London, England/Art Resource, New York, pp. 9, 125, 127, 140

Wadsworth Atheneum, Hartford, CT, Bequest of Anne Parrish Titzill, pp. 26 (detail), 93

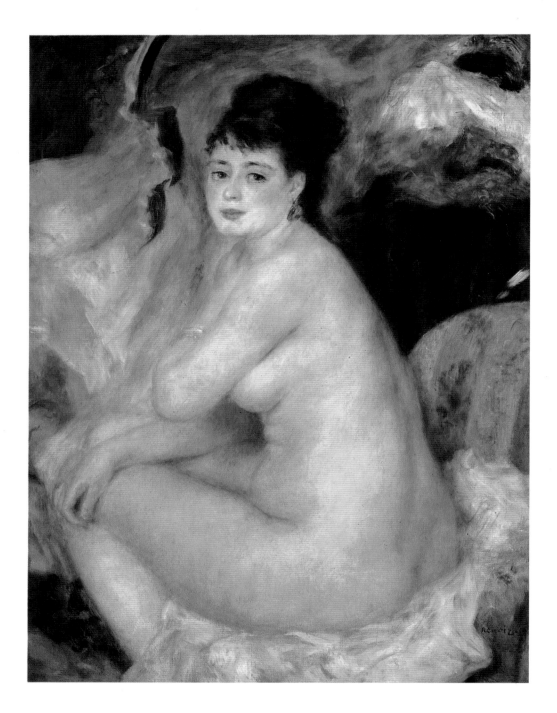

Nude Woman Sitting
1876; *Oil on canvas*; 36 x 28 3/4 in. (92 x 73 cm.).
Moscow, Pushkin Museum of Fine Arts.
*This sensuous image of a young woman displayed in her
natural beauty on a sofa has also been called "The Pearl"
because of the preciousness of the presentation. It is one of
the rare nudes that Renoir painted during the 1870s.
In his later years this became one of his favorite subjects.*